Butterflies of the World

Photographs by **Gilles Martin**

Butterflies of the World

Text by Myriam Baran

Translated from the French
by Simon Jones

Abrams, New York

Contents

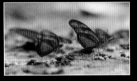
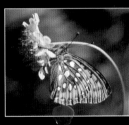

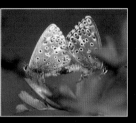

The World of Butterflies and Moths115

Lepidoptera and Humans163

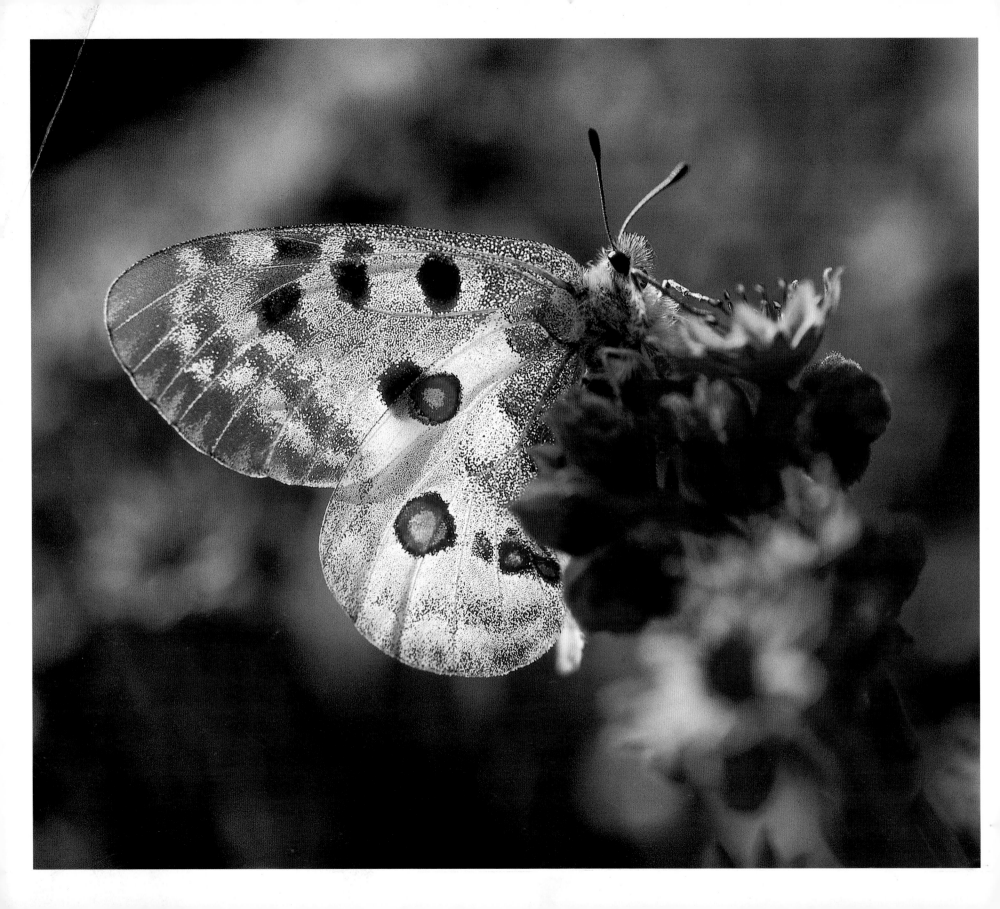

Introduction

What would summer be like without the scent of flowers and the fluttering of butterflies? Ephemeral and graceful, they are unquestionably the best known of insects—as well as the most coveted, admired, sought after, hated, studied, and bitterly fought. One insect in every ten is a butterfly or moth. The world of the Lepidoptera, infinite in its diversity and richness, is a microcosm when viewed from a distance, and it is a whole universe for those involved with it.

In many eras and civilizations the butterfly has been a pivotal figure, giving rise to many myths. Three aspects of this insect have inspired humans: the almost magical succession of its different bodily forms; the evanescence of this small, aerobatic creature; and the fascinating behavior of the countless species of butterfly and moth.

In prehistoric times the symbol of a butterfly, depicted in stylized fashion as a double horizontal triangle, was associated with the cult of the goddess of rebirth. Itzpapalotl, the Aztec goddess of agriculture—the life cycle of plants—was known as the "butterfly of obsidian."

In antiquity the Greeks considered the butterfly a representation of the human soul: The Greek word *psyche* means both soul and butterfly. This unity appears in the story of the creation of humans as well as in the mythology of death. After Prometheus fashioned the human body out of clay, Pallas Athena placed a butterfly inside it to give it life. Thanatos, the deity of death, is depicted

Parnassius apollo
Apollo butterfly
France

with an urn and a butterfly; the urn contains a person's ashes, and the butterfly, taking flight, symbolizes the hope for another life.

These ancient myths are the foundations of powerful symbols in our collective unconscious. When the concentration camps of Nazi Germany were liberated, drawings of butterflies were found by the beds of many child inmates. The psychiatrist working with the young survivors at first thought that the children saw the butterfly as a symbol of group affiliation, much as the persecuted early Christians had used the image of the fish. The children informed her, however, that they simply identified with the image of a butterfly. Their terrible suffering led them to imagine their bodies as an intermediate stage of existence: "One day, our soul will fly away from all this filth and pain. In drawing it, we are reminding each other of this. We are butterflies, and soon we will take flight."

The Luala people of Zaire regard the human life cycle as similar to that of butterflies. Between childhood and adulthood we are caterpillars, growing and undergoing successive molts. In old age we pupate, and the cocoon becomes a tomb. The soul then escapes from the cocoon, in the form of a butterfly.

In addition to the various forms that this "odd bird" takes, the butterfly's behavior has also amazed and fascinated. The behavior of moths inspired a long philosophical poem in Sanskrit, which says of them that they "hasten to their death in a bright flame, just as men rush to their doom." A Hindu legend says

that the Death's Head Hawk moth is the reincarnation of a monk who died of starvation because his fellow monks refused him food. Returning to haunt the place where he lived, he is the harbinger of imminent death. This frighteningly named moth has inspired evil legends wherever it is found.

Many Japanese legends refer to butterflies, which are seen as symbols of femininity, grace, beauty, and love. When two butterflies are joined together, they symbolize conjugal happiness. However, in the West the insect's endless quest for nectar evokes infidelity, fickleness, and even adultery. The very insubstantiality of this "love letter folded in two [seeking] a flower's address" can have two very different meanings. The unbearable lightness of being. . . .

The writer Paul Claudel once observed, "To learn about roses, some people use geometry. Others use butterflies." Throughout this book we will endeavor to become acquainted with the butterfly, in order to discover the rose.

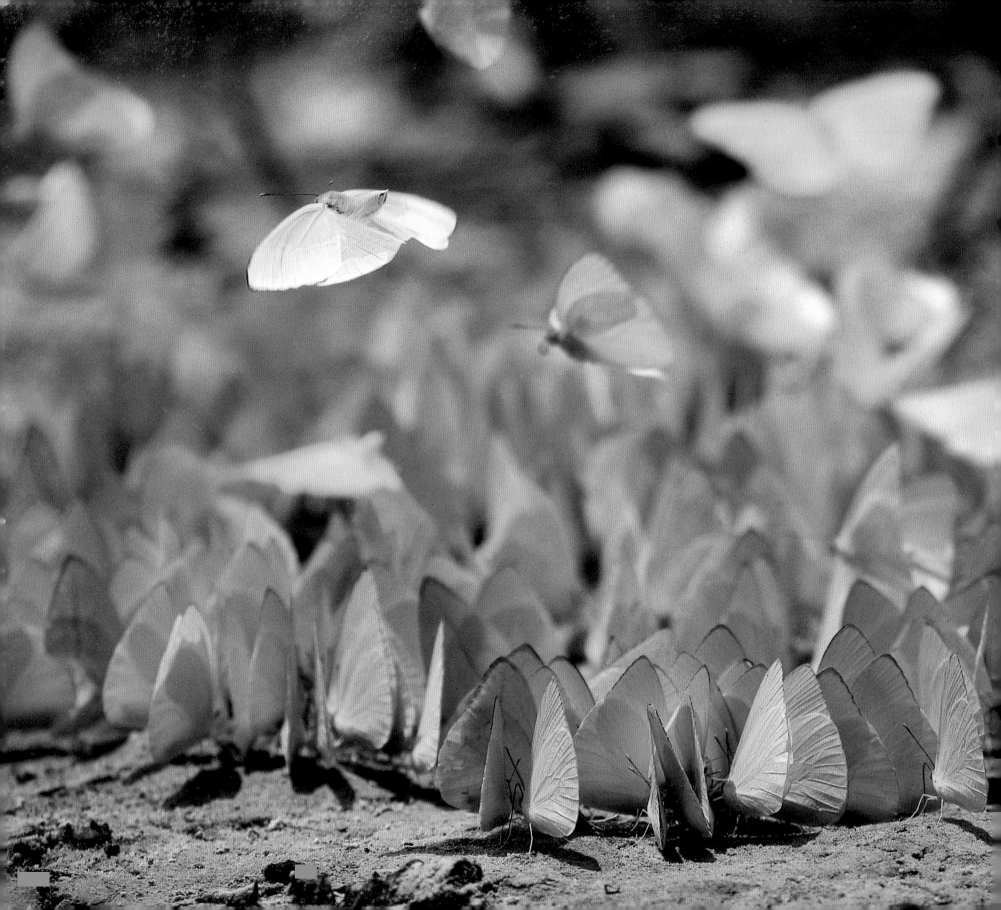

The Genius of Diversity

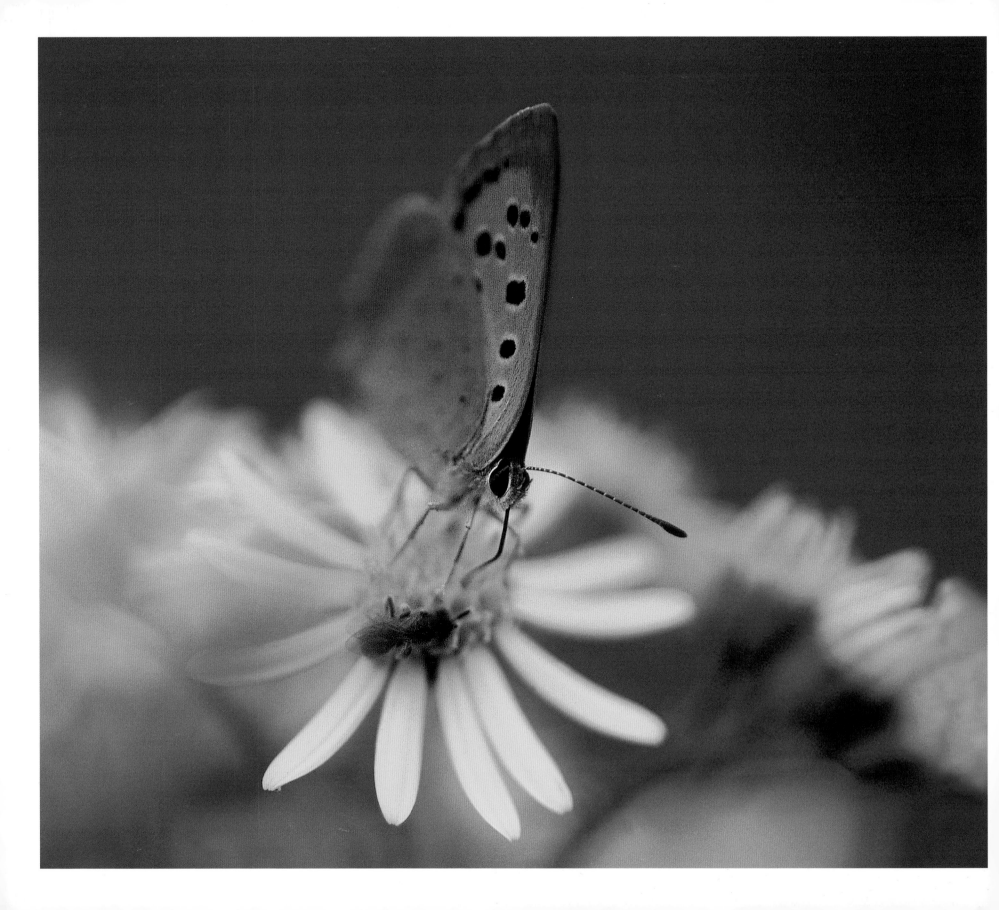

The Genius of Diversity

Symbols of lightness and grace, butterflies are the best-known insects thanks to their spectacular beauty and allure as they flutter through the air. Scientists call them Lepidoptera, from the Greek words for "scale" and "wing." Butterfly and moth wings are covered in scales—actually, broad, flat hairs—that overlap like tiles on a roof. The scales vary in shape and color from species to species.

Among insects, butterflies and moths are the largest in size. The greatest have a wingspan of 12 inches (30 cm), while the smallest hide their larvae inside leaves, buried between the upper and lower surfaces. Adorned with the sumptuous colors Mother Nature gave them, they transform daylight into diaphanous iridescence.

All is not beautiful in the world of butterflies and moths, however. Although most adore nectar, many of them are not above licking cattle droppings or other excrement. Butterflies are immensely deceptive. These are rather vulnerable creatures, but they hold one trump card: They are masters of camouflage and disguise. Some of them are highly poisonous and, fearing no predator, proudly display their colors. Others are not dangerous, but they imitate the poisonous butterflies' colors and self-protective behavior so perfectly that they fool birds and remain safe.

Lycaena phlaeas
American Copper or Small Copper
France

This small butterfly, which is fond of uncultivated land, is found in the Northern Hemisphere from the Maghreb to the Arctic Circle, and from Asia to America. The males are territorial and defend their patch of ground vigorously.

Previous pages:
Phoebis statira
Statira Sulphur
Brazil

The yellow butterflies of the *Phoebis* genus are numerous in the forests of the Americas. The males often gather in the hundreds on the banks of rivers at places where mammals come to drink; they may be attracted by the dissolved salts in the urine of these large animals.

Butterflies by Day, Moths by Night

Ithomiidae family of butterflies
French Guyana

Butterflies and moths are found on almost every continent, in a wide variety of habitats. The "imago" is the term for the adult insect, the final form it assumes, when it devotes itself to the search for a mate.

One in every ten insects in the world is a butterfly or moth. Few fossils of these fragile creatures have survived, but scientists believe that the first winged insects appeared between 300 and 400 million years ago, during the Devonian and Carboniferous periods. Of these primitive insects, only the dragonflies and ephemerids (mayflies) survive today; both are characterized by wings that cannot be folded parallel to their bodies. Butterflies appeared much later, and they are believed to be descended from scorpion flies. Some scientists, however, assert that they are descended from, or at least share a common ancestor with, the Phryganea (caddis flies), because of the venation and structure of their wings and similarities between their mouth parts. Moreover, Phryganea are hairy, and some have hairs that broaden out into a scalelike shape, fore-shadowing those of butterflies.

The most striking characteristic of the Lepidoptera is the close association many have with flowers, suggesting that the insects and plants have followed parallel evolutionary paths. If this theory proves to be correct, butterflies would have appeared during the Triassic period, between 150 and 200 million years ago. The oldest fossils of butterflies that have been discovered, from 30 million years ago, are strangely similar to the butterflies of today.

A Worldwide Expansion

Today more than 175,000 species of Lepidoptera have been found; they live all over the world, and the vast majority are moths. The only habitats they have not conquered are polar regions. Tropical and equatorial forests, which offer ideal conditions for insects, are home to the greatest number and to some of the most spectacular. The largest and most brightly colored species live in these regions. However, some members of Lepidoptera live north of the Arctic Circle, while others live on islands south of the Antarctic Circle. There are butterflies that live at an altitude of 16,000 feet (5,000 m) in the Andes, and others thrive at up to 20,000 feet (6,000 m) in the Himalayas.

Butterflies and moths can be recognized by their wings, which are usually highly developed. However, onto this basic model has been grafted an infinite variety of shapes and colors, which reflect the diversity of habitats in which these insects have evolved. Some display marked physical and behavioral differences between the sexes. For example, the females of many species live among the treetops and are rarely seen; in other species, the males tend to be diurnal in their habits, while the females are more active at night. Some species have even lost their wings, and they

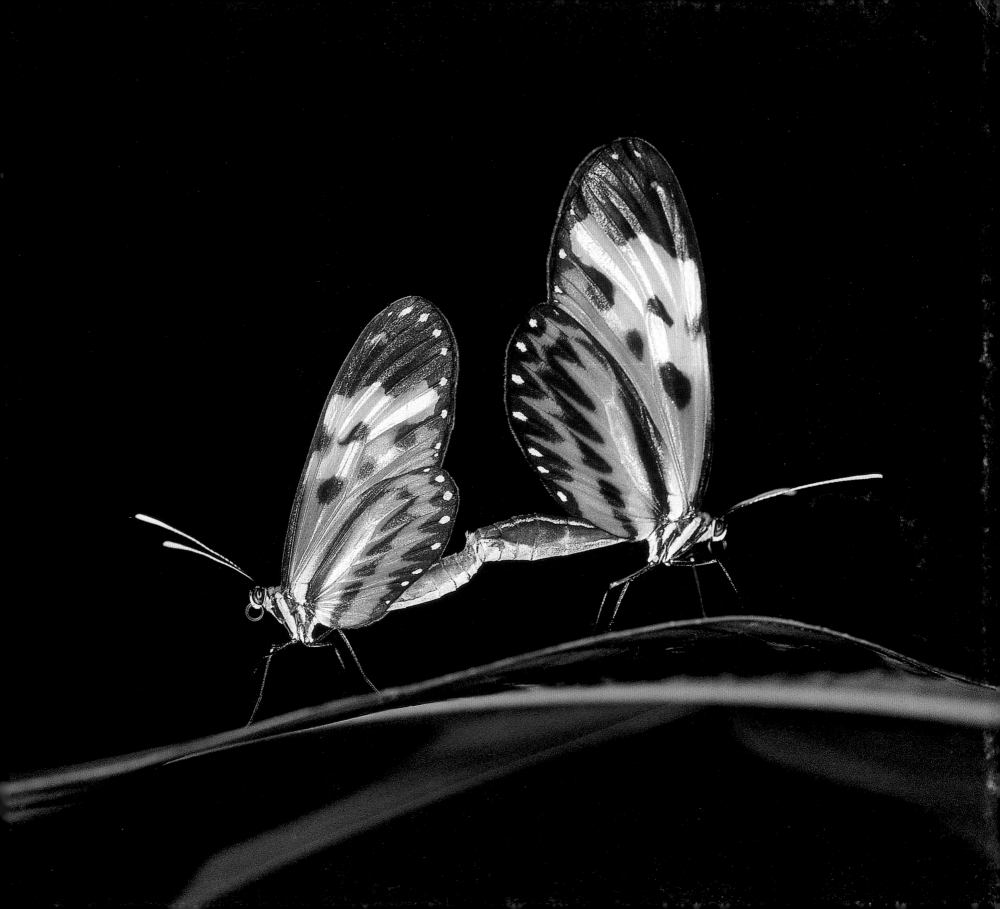

are condemned to living earthbound on the plants where they were born, and where they will lay their eggs after their mate has visited them.

An Artificial Distinction but a Practical One

The distinction drawn between butterflies and moths has no scientific basis, but it is habitual and hard to overcome. The greatest myth is that moths are drab, nocturnal creatures—yet some are brightly colored and fly by day. Some general differences do exist, although they do not always hold true. Butterflies can often be recognized by their club-shaped antennae, whereas moths have hairy antennae to help them perceive scents. When resting, butterflies hold their wings raised above their backs and closed so as to be less noticeable; the brightly colored upper surface of their wings only becomes visible when they take flight. Moths, by contrast, keep their wings stretched out to the sides, or folded above their bodies like a roof. Moths are far more numerous than butterflies but, because they are more difficult to observe, are far less well-known. According to scientists, countless more species remain to be discovered.

In the popular imagination, the moth is the poor relation of the splendidly colored creature that offers itself up to the rays of the

Saturnia pyri
Great Peacock moth
France

The distinction between diurnal butterflies and nocturnal moths is generally accurate—but not always. Many moths fly by day and are brightly colored.

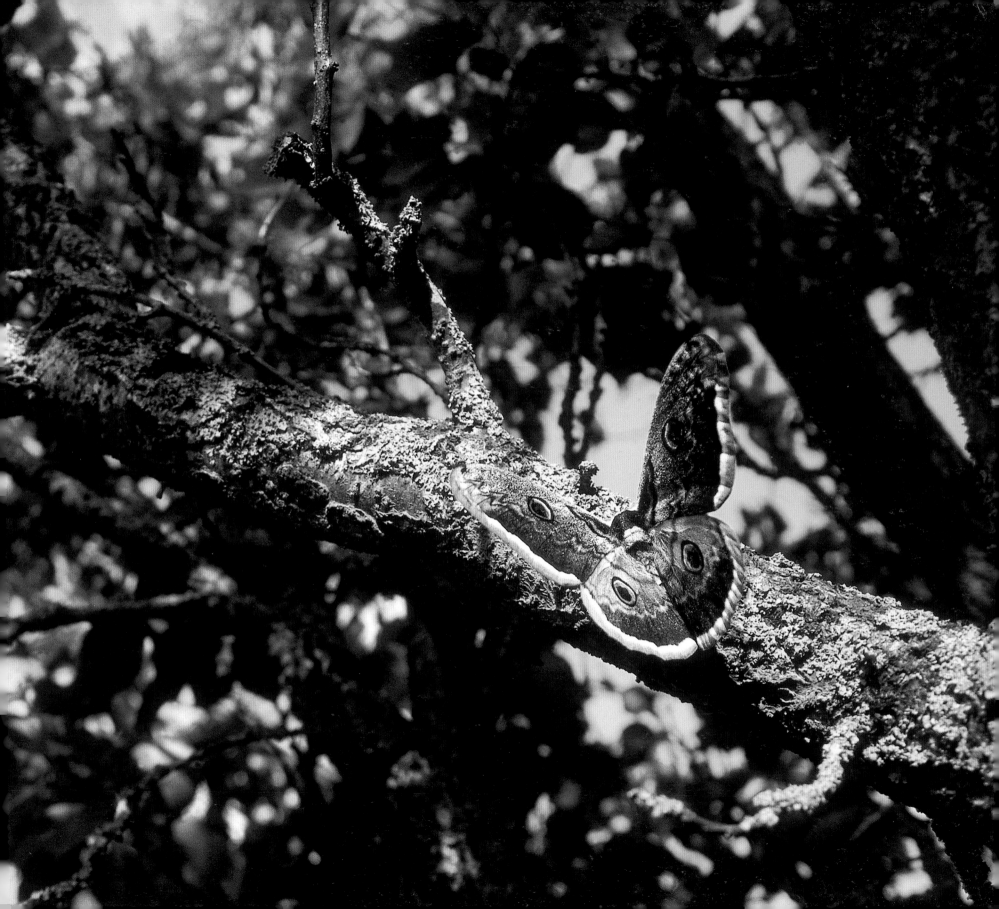

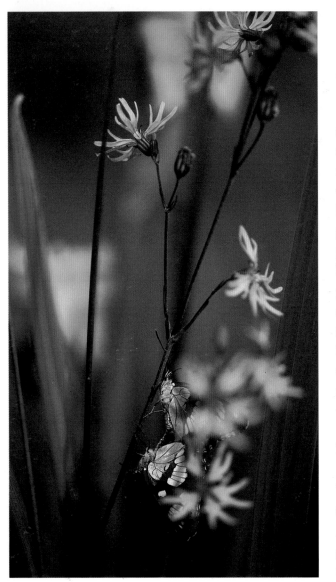

Limenitis reducta
Southern White Admiral butterfly
France

This butterfly is fond of scrubby unculti-
vated land and forest trails, where the
adults like to suck nectar from bramble
flowers. The caterpillars spend the winter
hibernating in a small silk shelter built on
a plant, which, come spring, will be their food.

sun. And yet, what ingenuity the moth has had
to use to overcome the limitations imposed by
the night! Low nighttime temperatures are coped
with by a whole series of adaptations. Their hairy
bodies are well insulated. Their thorax, where the
powerful wing muscles are situated, has extra
protection: It is separated from the abdomen
by air-filled sacs that form an insulating barrier,
preventing cold air from passing through. This
system is complemented by a special arrange-
ment of the main blood vessels, so that there
is no heat loss. Moreover, those species most
exposed to cold also produce a kind of natural
antifreeze in their body fluids, which prevents
them from freezing.

Supreme Masters of Color

The world of butterflies and moths is above all
a world of color. From the drab to the dazzling,
it is a stunning demonstration of the creative
genius of which nature is capable. Most butter-
flies and moths are experts at camouflage, but
some display colors of a brilliance normally seen
only in crown jewels. While the purpose of cam-
ouflage is obvious, the same cannot be said of
these ostentatious hues. However, we shall see
how both brilliant and dull colors play an impor-
tant part in these creatures' survival. Color is one
of the means butterflies and moths have employed

to hold their own in the great scheme of evolu-
tion ever since the Triassic period, 150 to 200
million years ago. Colors are produced in two
complementary ways: Some are chemical in
origin, produced by pigments; others are
purely physical, created by light reflected off
the complex wing scales.

Pigments: A Useful Waste Product

Pigments are large molecules that are often the
product of the decomposition of metabolic
waste; sometimes they are also vitamins that aid
growth. Most are derived from preexisting com-
pounds. Pigment molecules are often toxic and
are stored in the wings, dry organs that can with-
stand contact without being damaged. However,
their toxicity is counterbalanced by various
advantages, such as resistance to wear—which
explains why the vulnerable edges of butterfly
wings are often black, while patterns appear only
away from the edges. Aside from their two pre-
eminent functions of deterring predators and
attracting a mate, colors can also play a part in
maintaining body temperature. Butterflies and
moths, like all insects, cannot maintain a con-
stant body temperature without the aid of their
immediate surroundings. Takeoff and flight
require an ambient temperature of at least
96.8° F (36° C) around the muscles of the thorax.

Aporia crataegi
Black-veined White butterfly
France

The voracity of this butterfly's caterpillar,
which attacks fruit trees, has made ene-
mies of farmers, and the use of insecticide
has led to its disappearance from many
places.

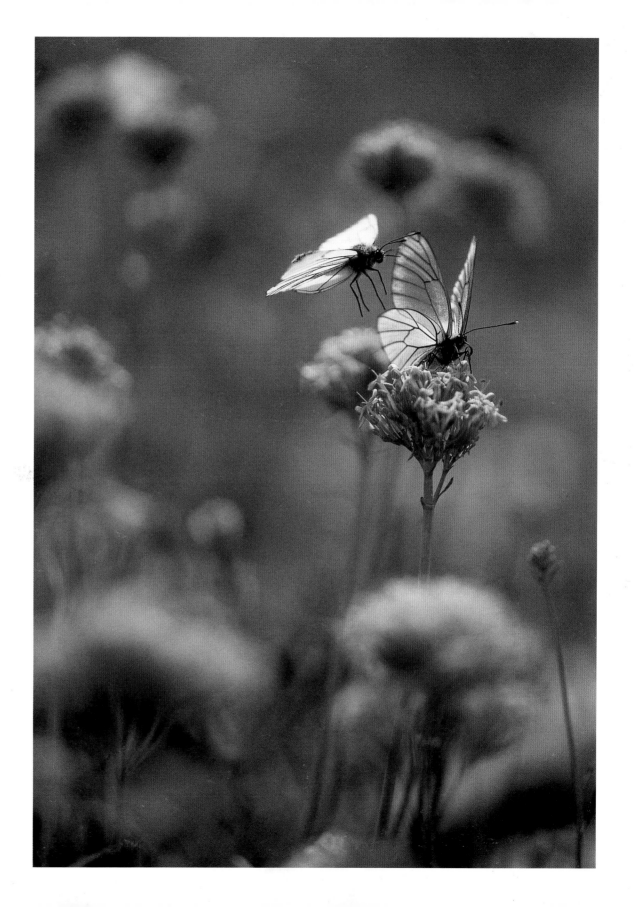

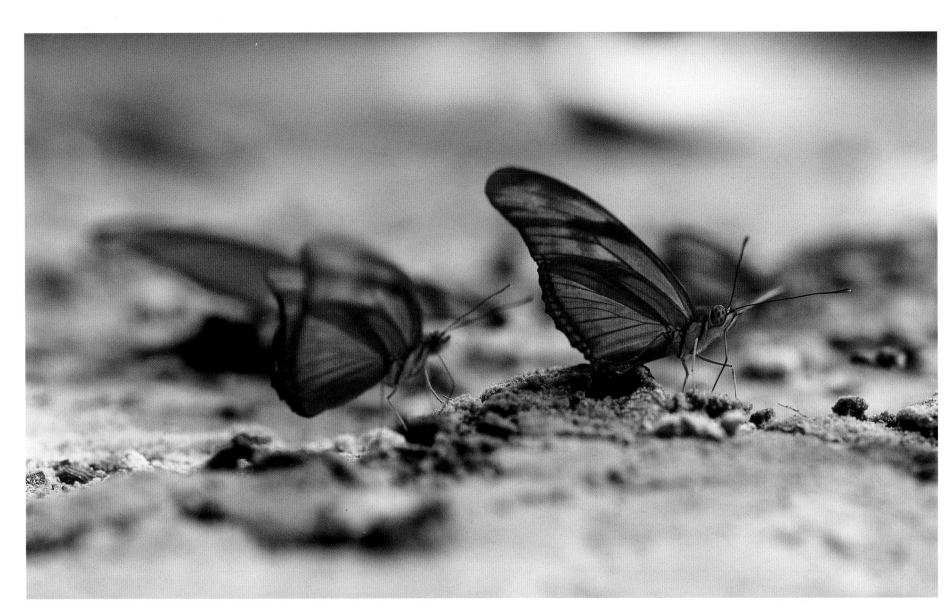

Dryas julia
Julia Heliconian or Julia butterfly
Brazil

The Heliconiidae family, to which this butterfly belongs, is typical of South America. They have very long elliptical wings.

Opposite:
Marpesia sp.
Brazil

As this butterfly sucks liquid from the ground, a drop of water gradually forms at the end of its abdomen, then drips off.

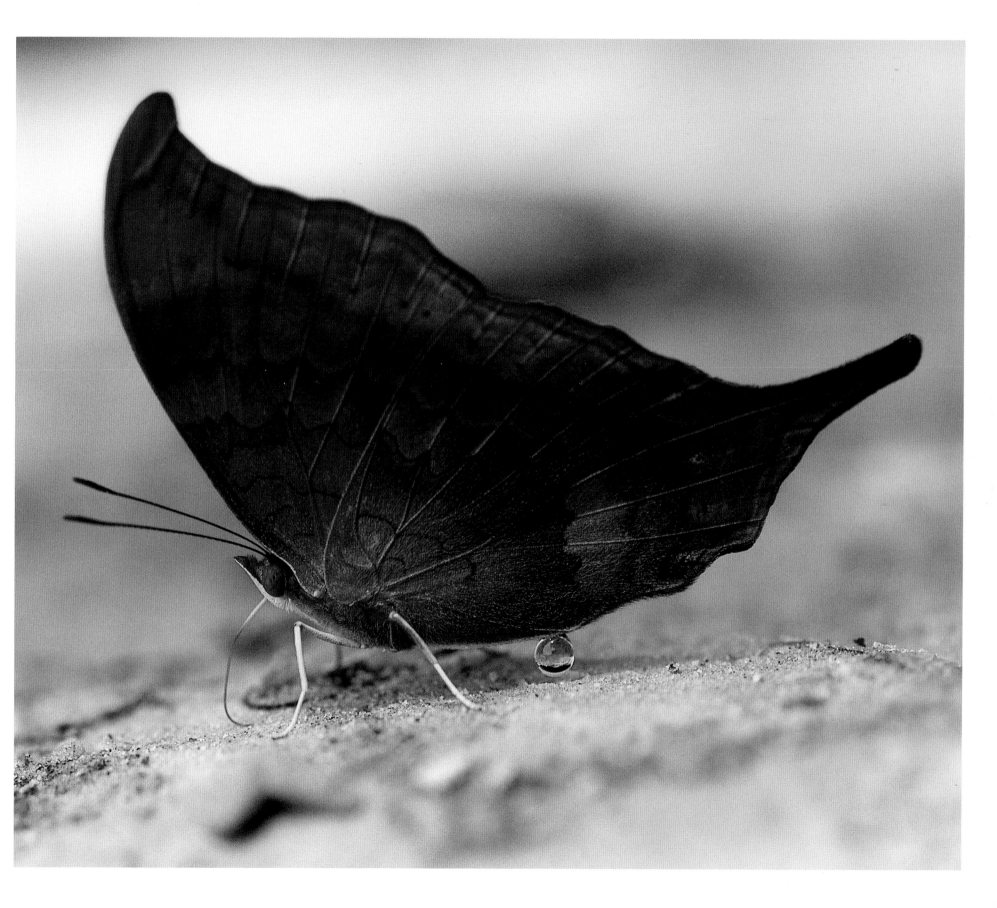

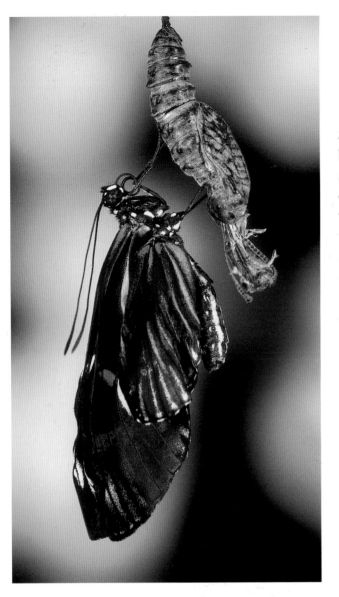

Heliconius doris
Doris Longwing or Doris butterfly
South America

The imago is very vulnerable when it emerges from the chrysalis. It will be hours before its wings are completely unfolded and it can take flight.

Such a temperature can be achieved by rapidly beating the wings, because muscular activity itself produces heat, but it can also be achieved directly from the sun's rays. Black or dark-colored wings directly capture solar energy and warm the body, whereas pale or white wings reflect it. Dark pigments also protect from ultraviolet radiation, which is why butterflies that live in mountainous habitats are often darker than their lowland counterparts. Wings are therefore superb tools for collecting energy. However, they also need to do the reverse—that is, dissipate the excess energy produced during flight, because the heat produced in this way can lead to the butterfly's death if the temperature reaches 104° F (40° C). The wings reduce this excess heat by means of convection or radiation.

The most widespread pigment is melanin, which occurs in all species in various forms and defines the basic wing designs; melanin produces shades of brown and black. In addition to melanin, each butterfly family is characterized by its own particular type of pigment. These mostly produce "warm" colors, ranging from red to yellow; blues are rare in the animal world—but they do exist in butterflies. Colors that range from ultraviolet to blue-green are structural colors: They are produced by the physical structure of the butterfly as opposed to simply being chemical compounds. Structural colors are created in two ways. The first is through diffusion: The scattering of short-wave colors, blue and violet, by submicroscopic particles. The blues of the human iris and the Silver-studded Blue butterfly (*Plebejus argus*) found in Europe are created in this manner. When the particles are larger, all light wavelengths are given off, and a butterfly appears white, as in the case of the Pieridae, a family that includes the Small White and the Brimstone.

Light: The Source of Color

However, the most fascinating component of butterflies' colors is the metallic, iridescent quality found chiefly in tropical species. These magnificent butterflies appear to constantly change color as we watch them fly. Iridescence, the second type of structural color, is produced through interference, i.e., multiple reflection; the scales of iridescent butterfly wings are even more complex than the usual.

Structural colors often combine with pigmentary colors, putting at butterflies' disposal the entire range of colors that nature offers—within the human visible spectrum and beyond, into ultraviolet. The color green, which is in the center of the spectrum, is often the result of a combination of structural and pigmentary effects. These colors of mixed origin—both

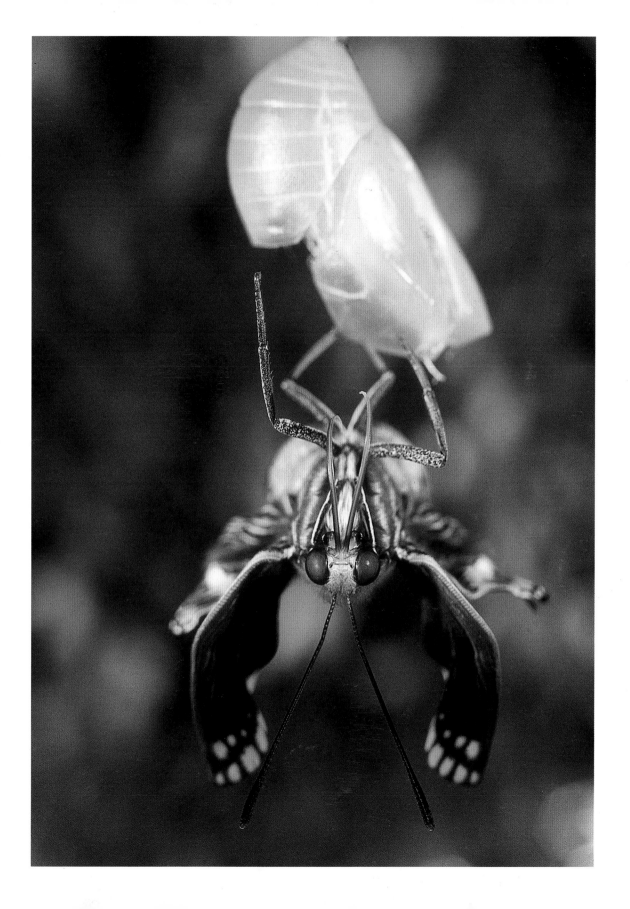

Charaxes jasius
Two-tailed Pasha butterfly
France

The chrysalis appears static, but within
it the insect's entire body is in upheaval.
This anatomical reordering is triggered
by the insect's juvenile hormone as well as
by external stimuli such as temperature and
amount of daylight.

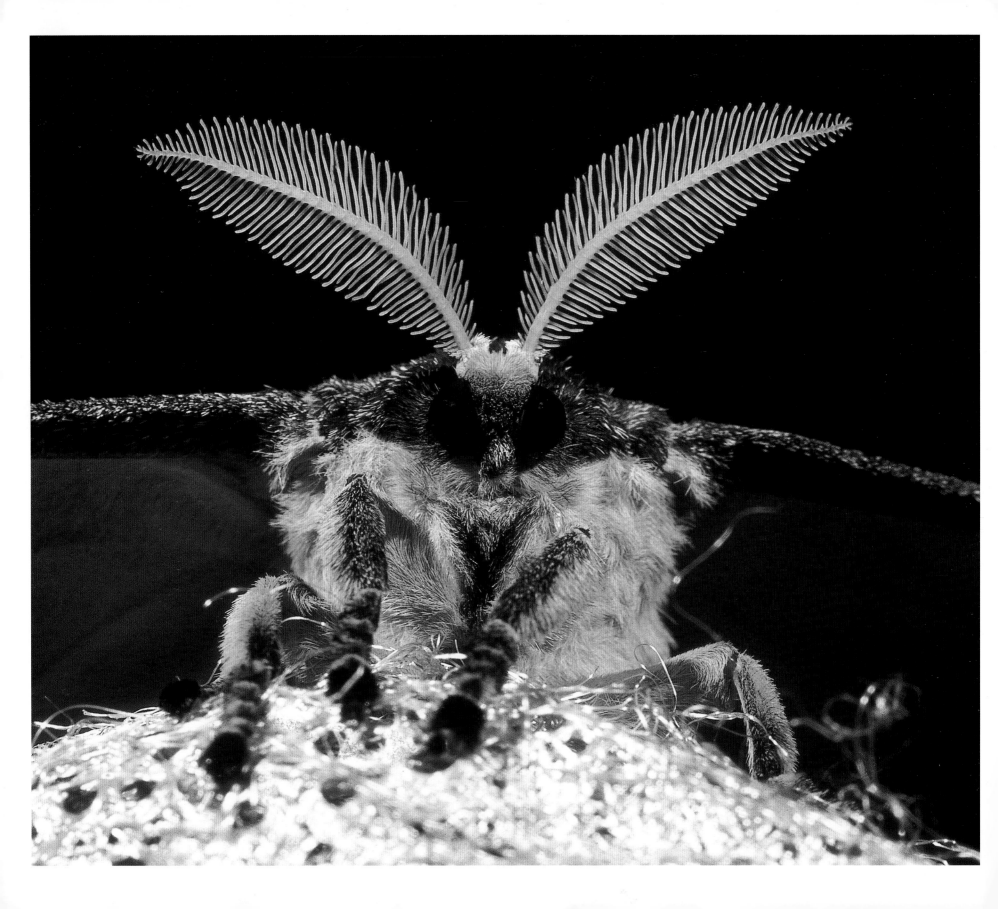

chemical and physical—offer an extraordinarily varied range, through which nature can express all her creative genius with ease. Starting from a few basic elements, this combination of effects produces an infinite palette of colors, from the drabbest to the most iridescent. No butterfly or moth, from the dullest to the most shimmering, uses only one means of producing color. Quite the opposite: All cleverly manipulate the combination of physical and chemical elements, with an unmatched conjuror's skill, to either disappear or attract attention, depending on their needs.

Fast Fliers

Like birds, butterflies and moths have several different modes of flight: with beating wings, with vibrating wings, and gliding. Most use the first, although there are differences depending on the size and shape of the wings involved. As a general rule, the frequency of wingbeats is inversely proportional to the wing surface. Large species fly with slow, majestic wingbeats, whereas small ones beat their wings rapidly. Gliding is confined to the biggest butterfly species, which appear as though they are sliding through the air. Certain very small species, which have large wings bearing fringes, cannot fly against air currents and use an intermediate mode, partly beating their wings and partly gliding as they are borne along by the wind. The most powerful fliers are without doubt the Hawk or Sphinx (Sphingidae) moths and noctuids (Noctuidae), another family of large moths. Their long, slender wings vibrate at high speed. The Sphinxes have a perfectly aerodynamic shape, enabling them to reach speeds of 30 miles per hour (50 km/h), which is remarkable for such a small insect. Some hover like hummingbirds, gathering nectar from flowers without settling on them. They are miniature acrobats of flight.

Argema mittrei
Madagascar Moon moth
or Giant Comet moth
Madagascar

Damp tropical habitats are the richest in butterflies and moths, but these insects are actually found everywhere except at the North and South Poles. Both dwarf and giant species exist, and the smallest and largest are moths. The smallest is a European species with a wingspan of just one-tenth of an inch (3 mm), whose caterpillar is so tiny that it lives inside a leaf, between the plant's upper and lower surfaces. The largest is a noctuid of tropical Africa, with a wingspan of more than 12 inches (30 cm).

Versatile Mouths

A charming image in popular imagination is that of a pretty butterfly sucking nectar from the heart of a flower. However, this bucolic vision disregards a large part of reality. Often the most magnificent specimens, such as the Ornithoptera, delight in feeding on the fresh droppings of large mammals or in foraging through garbage dumps. Many large butterflies of the Nymphalidae family are attracted to rotting vegetables and decomposing carcasses, and the beautiful insects drink their fetid liquids for hours on end. The males, especially, gorge on them, because the intake of mineral salts is essential for the production of pheromones. However, butterflies and moths also seek out pure water to drink, and in the furnacelike heat of high summer they gather in large numbers in sandy or muddy wetlands to quench their thirst. Damaged trees, which ooze sap, also provide a feast for butterflies and moths as well as beetles and hornets.

A Highly Specialized Mouth

Sucking up organic liquids requires a suitable mouth. Those of moths and butterflies consist of two maxillae whose inner surface is hollow, containing a groove. The mouthparts are joined with interlocking spines, forming a channel (or "straw") through which the insect can ingest nutritive fluids. This special, tonguelike organ is known as a proboscis, and it allows the butterfly to sip nectar from flowers, juice from fruit, and various other liquid foods. When not in use, the proboscis is curled up under the insect's head, like a watch spring. But when a flower titillates its appetite, the proboscis uncoils, due to the flow of blood in the grooves. This sudden increase in blood pressure in the organ produces a veritable gustatory erection—and the butterfly can sip its food.

Not all butterflies and moths, however, are endowed with such a sophisticated system. Some possess a very short proboscis, or even none at all, and they do not feed during their brief life as adult insects. Others have two maxillae of normal length that are not joined. In the Yucca moth, for example, the two sides of the proboscis are separate, and the moth uses them like arms to carry balls of pollen from one plant to another, aiding the process of fertilization. The most primitive moths, which make up the family Micropterigidae, have no proboscis; however, they have two mandibles with small, horny teeth designed to grind up food. Caterpillars have strong jaws for chewing leaves, but these tiny, dull-colored moths are the only adult Lepidoptera

Argynnis paphia
Silver-washed Fritillary butterfly
France

This large butterfly, with its 2½-inch (6 cm) wingspan, is found throughout France, in Italy, from Turkey to Yakutia (in Russia), and in the northern half of the Iberian peninsula. The adults fly from June to September. In the morning they descend from the tops of the trees, where they spend the night, to sun themselves on flowers.

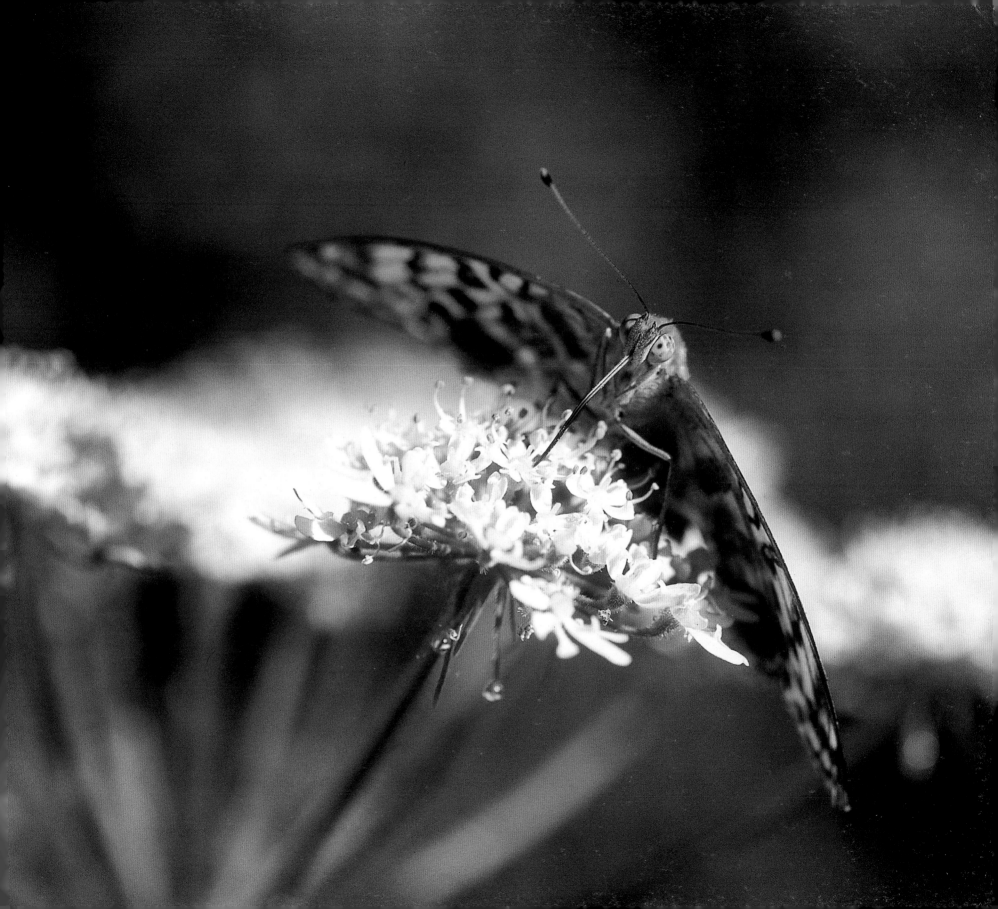

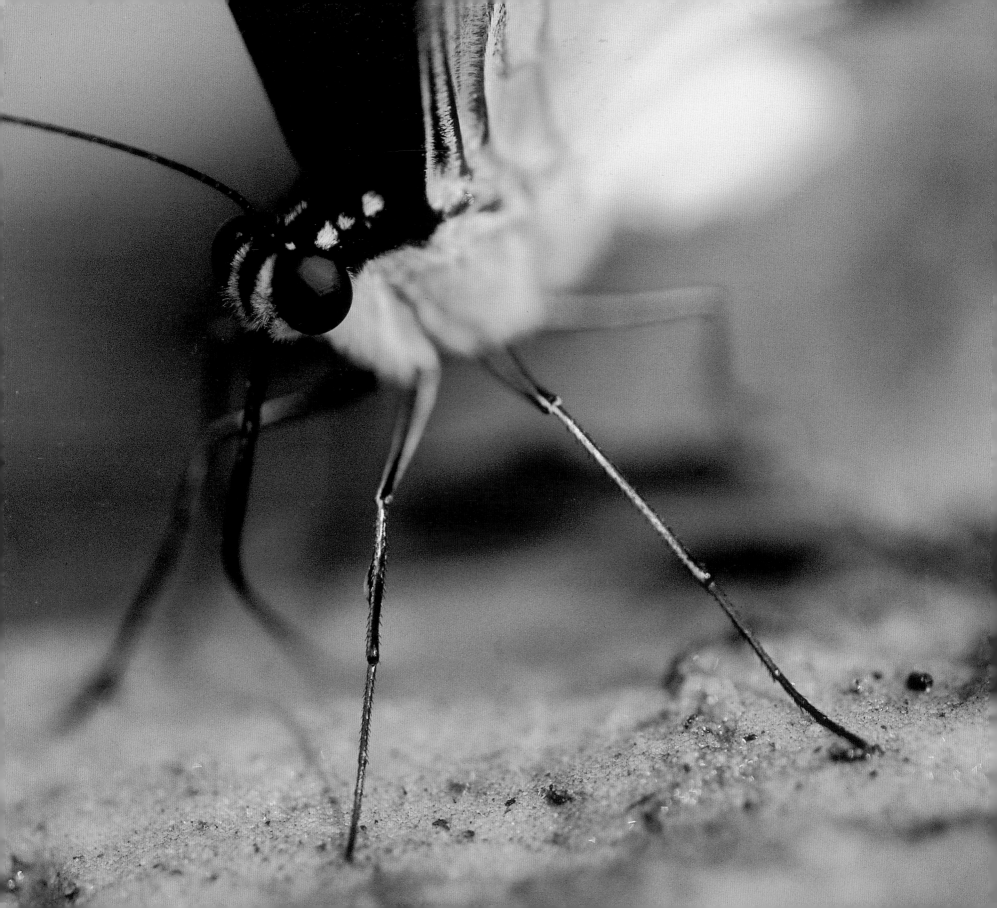

Heraclides androgeus
Citrus Swallowtail
or Queen Swallowtail butterfly
Brazil

A butterfly's or moth's proboscis usually
takes the form of a central channel
of a pair of grooved maxillae. This erectile
proboscis is used exclusively for taking in
liquid nourishment. In the right-hand pho-
tograph a small jet of liquid, clear as water,
issues from the butterfly's abdomen. While
the insect is sucking liquid from the moist
ground—for hours at a time—it ejects the
watery excess every ten seconds or so.
Its rudimentary digestive system and small
body mean that the absorption of fluid
is immediately followed by excretion.

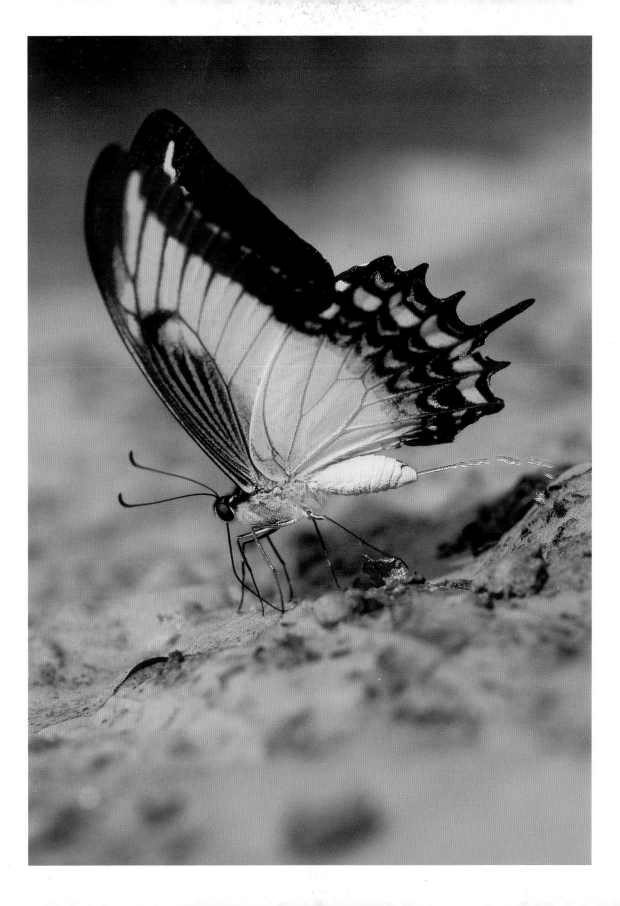

that eat solid food. However, these moths eat only pollen grains.

The Flowers' Favorite

The story of butterflies is inseparable from that of flowers. Most butterflies need to feed to gain the energy required for flight. Their preference is for the nectar of flowers, which is high in sugar and therefore in energy. Flowers use their colors to attract butterflies, who will fertilize them. Flower growth can sometimes even account for population movements in butterflies. For example, the spectacular migration of the American Monarch, which has always intrigued observers, can be explained by the very close relationship this butterfly has with its favorite flower, milkweed. The Monarch and milkweed both originate from the mountains of Mexico. The weed has adapted to new living conditions and has extended its territory in the process. The butterfly has followed it, where climatic conditions have allowed, returning to its original range during the cold season. For this reason, only the northern populations of this butterfly are migratory. Mexican Monarchs live in the same region all year round.

In fact it is more through the sophistication of flower forms, rather than through the expansion of the ranges of plants, that nature's wonderful ingeniousness finds its fullest expression. Flowers exist only because they are the best way plants have found to meet the requirements of sexual reproduction. And sexual reproduction is the most efficient tool nature has at its disposal to ensure the survival of a species. Its aim is to produce, with each new generation, individuals similar to their parents but unique in terms of their genetic makeup. Although it is easy for animals to come together, even just for a few hours, to fulfill the needs of sexual reproduction, the process is less straightforward for plants with little mobility. They have therefore been obliged to develop a system that allows them to reproduce without moving—a process known as animal pollination. To do this, plants have developed flowers, which are not only beautiful but tasty, thanks to the delicious nectar that they secrete in the hollow of their corolla. As insects and other creatures drink the nectar, they rub against the flower's sexual organs. The visitors emerge from the flower laden with pollen, which they then deposit on the next plant they drink from. However, it is not in a flower's interest to exhaust

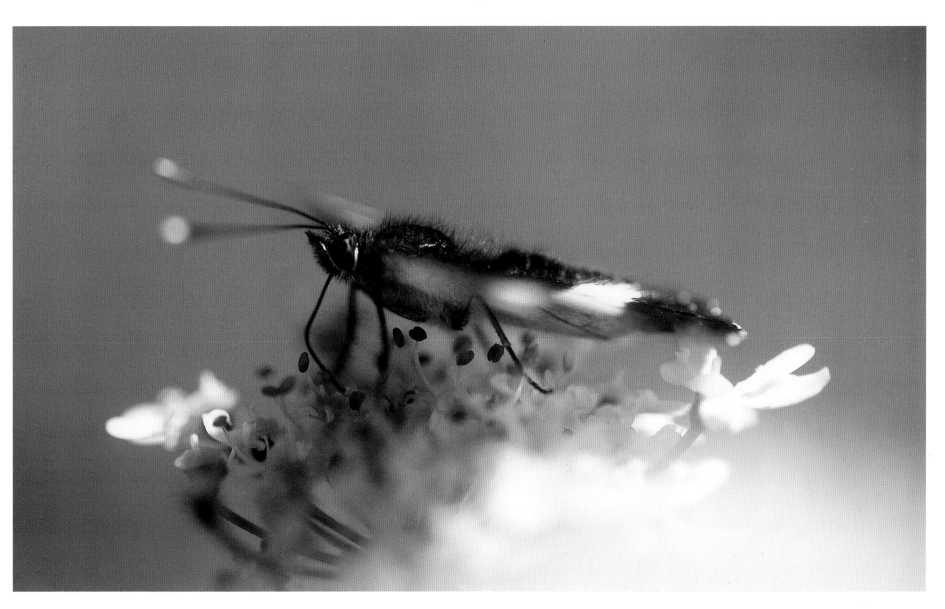

Limenitis reducta
Southern White Admiral butterfly
France

The image of a butterfly on its flower charms the imagination. Flower nectar— high in sugar and therefore in energy— is a highly sought-after food because flying consumes large amounts of energy.

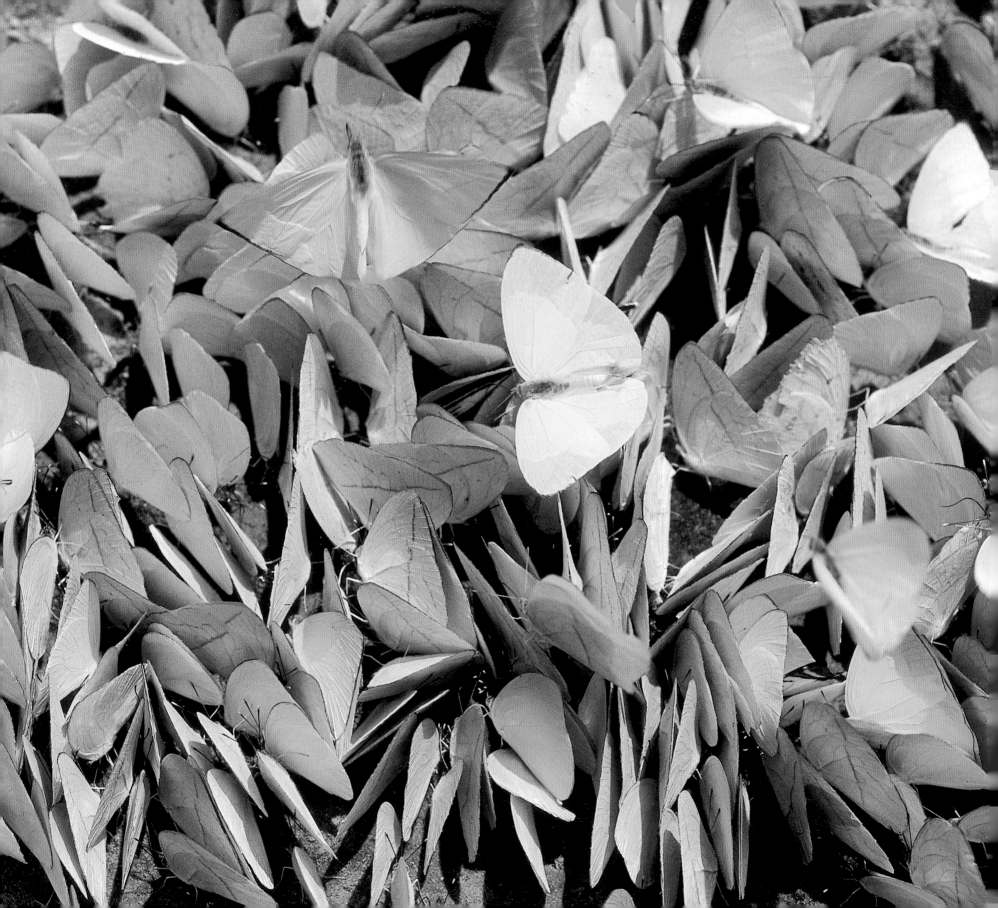

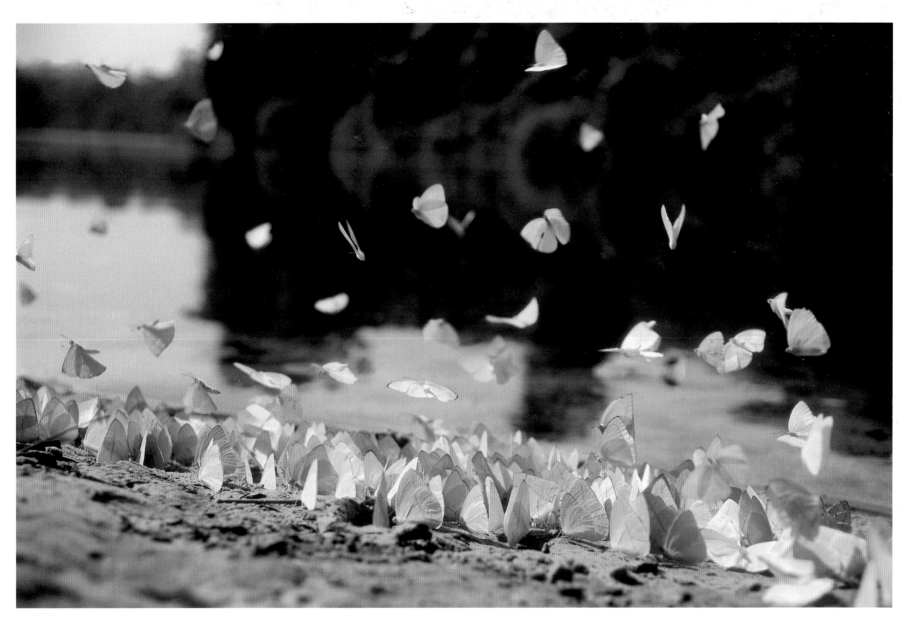

Phoebis statira
Statira Sulphur
Brazil

Butterflies and moths do not feed only on flower nectar. Some prefer decomposing organic matter such as bird droppings or the urine of mammals. The edges of pools are very popular with butterflies, which flock in the hundreds to feed on the excrement found nearby.

Fabriciana adippe
High Brown Fritillary butterfly
France

This attractive reddish-brown butterfly can be seen from May to August, enjoying the nectar of flowers that grow abundantly on uncultivated open land, shrub-covered hillsides, and the edges of open woodland.

itself in the production of nectar for all comers. Flowers have gradually become selective, allowing only certain authorized creatures to penetrate to the heart of their organs. They have developed methods to restrict their nectar to only those pollinators that suit them: Some flowers open solely at night, for bats and moths; some are adorned with specific, indicative colors for butterflies; others have decoy decorations that deceive unwelcome visitors. Flowers are highly efficient advertisers, making use of ultraviolet light that can be perceived by pollinating insects.

The Long-Lasting Marriage of the Sphinx Moth and the Orchid

The Sphinx family marvelously demonstrates the astonishing collaboration between flowers and butterflies and moths. Apart from the disturbing and very famous Death's Head Hawk moth (*Acherontia atropos*), which takes its name from the skull-like markings on its thorax, this family comprises the species with the longest proboscises, which in some cases are several times the length of the insect's body. The Death's Head Hawk moth, however, has a short proboscis, no more than a centimeter in length; but it is especially strong and stiff and bears a very sharp

point at its end. Like those of most other butterflies and moths, this allows the Death's Head Hawk moth to suck nectar that is not too deep within flowers and to lick sap from damaged trees. The moth also uses its sharp proboscis to attack beehives, piercing the wax of honeycombs to drink their honey, to which it is especially partial. When a hive is attacked by several dozen of these pirates, the poor bees' entire harvest is annihilated, and the damage irreparable. This proboscis is also a highly effective defensive weapon that can inflict painful stings on an attacker.

Other species of Sphinx moth, which have less evil-sounding names, are content to sip nectar from their favorite flowers. No one who has seen a Sphinx moth feeding, hovering in midair, will forget it; the moth is sometimes at first mistaken for a Hummingbird Hawk. Skilled in flying with vibrating wings, these moths suck nectar from flowers without ever landing, plunging their immense proboscises with tapered ends into the center of the nectar.

Every flower has a matching butterfly or moth. Deep flowers aim to attract insects with a long, slender proboscis; curved ones are aimed at butterflies whose proboscises have the same angle of curve. In 1862, when Charles Darwin first saw the Comet Orchid (*Angraecum sesquipedale*) of

Macroglossum stellatarum

Hummingbird Hawk moth
France

Moths of the Sphinx or Hawk family (Sphingidae) plunge into the depths of flower organs to suck out their nectar. The Hummingbird Hawk moth has a very long proboscis, and it hovers in the air as it drinks, making a humming noise—for this reason it is sometimes mistaken for a hummingbird. Many biologists believe that the evolution of pollinating insects precedes that of nectar-bearing flowers: The latter adapt gradually until only one insect is able to pollinate each type of flower.

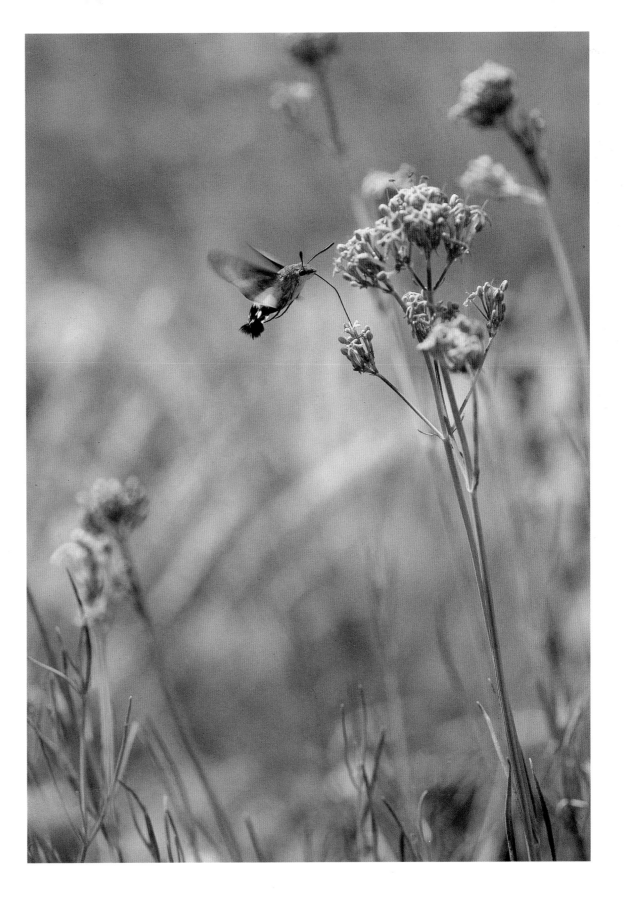

Iphiclides podalirius
Scarce Swallowtail butterfly
France

The proboscis remains coiled beneath the head when not in use. When an insect is stimulated by the smell of food, or has tasted it with its feet, an increase in blood pressure causes the proboscis to unfurl.

Opposite:
Hemaris fuciformis
Broad-bordered Bee Hawk moth
France

Sphinx moths have the longest proboscises: That of the Convolvulus Hawk moth (*Agrius convolvuli*) is 6 inches (15 cm) long, and some tropical species have proboscises that reach 12 inches (30 cm).

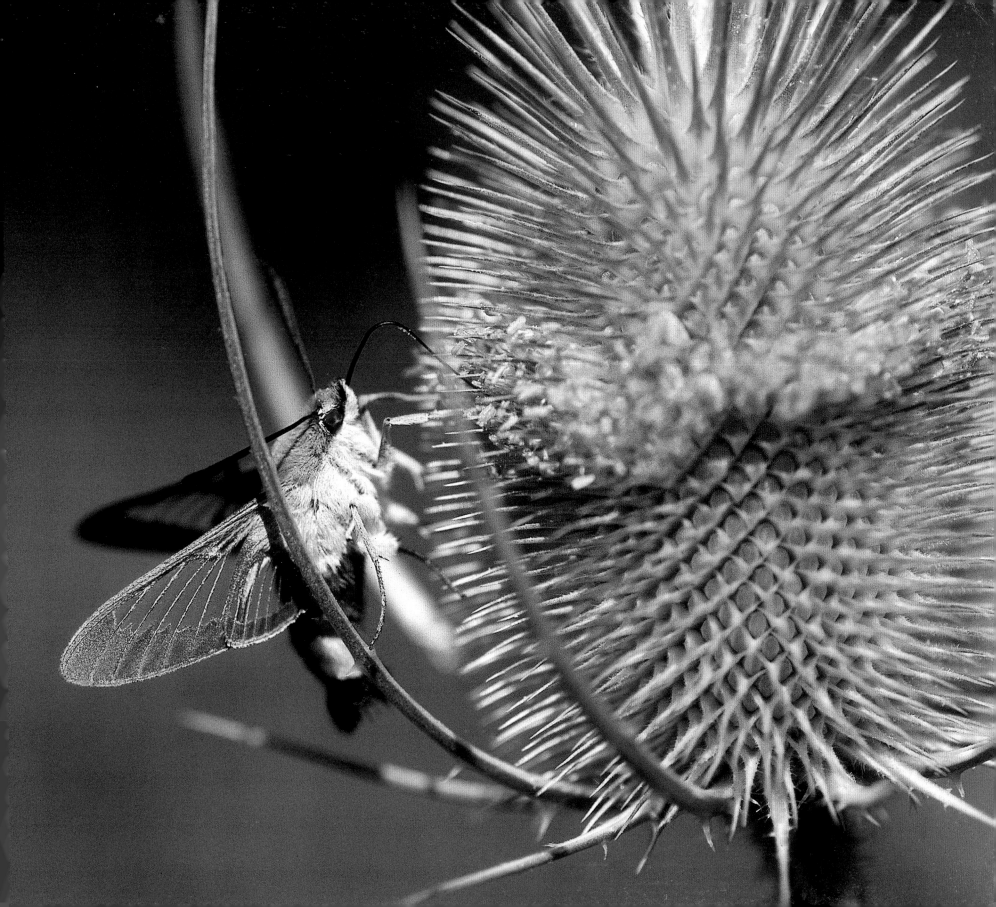

Argynnis aglaja
Dark Green Fritillary butterfly
Croatia

The relationship between plant and insect is not a one-way street. In yielding its nectar, the flower also transfers some of its pollen onto the thirsty insect, which will deposit it on another flower. Thus, through a number of flights, the plants' sexual reproduction takes place.

Madagascar, which hides its nectar glands at the bottom of a 12-inch (30 cm) corolla, he asserted that one day a moth would be discovered with a proboscis long enough to reach this nectar. Forty years later, after Darwin's death, a subspecies of Morgan's Sphinx moth (*Xanthopan morganii*) was discovered on Madagascar—with a 12-inch proboscis. The subspecies was given the name *praedicta* to commemorate Darwin's famous prediction.

South America, however, is home to a Sphinx moth with a 10-inch proboscis, even though there is no known plant in this region with flowers of such depth. This example has led evolutionary biologists to believe that flower-feeding insects are one step ahead of the flowers themselves, offering the latter the opportunity to adapt and become more restrictive.

Proboscises and Tricks

The proboscis, which can reach 12 inches (30 cm) in length in some species, is also an excellent defense against the cunning attacks of spiders. These crouch in the hearts of flowers, perfectly camouflaged, lying in wait for an innocent insect to settle, whereupon they

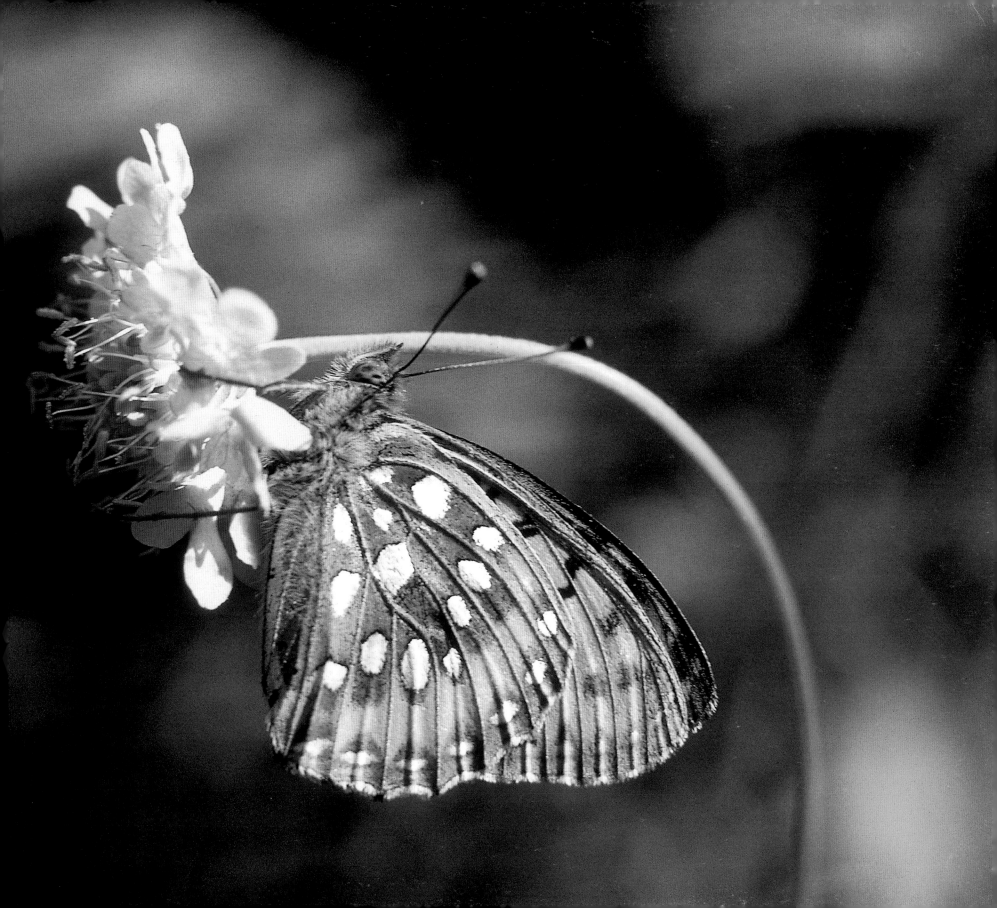

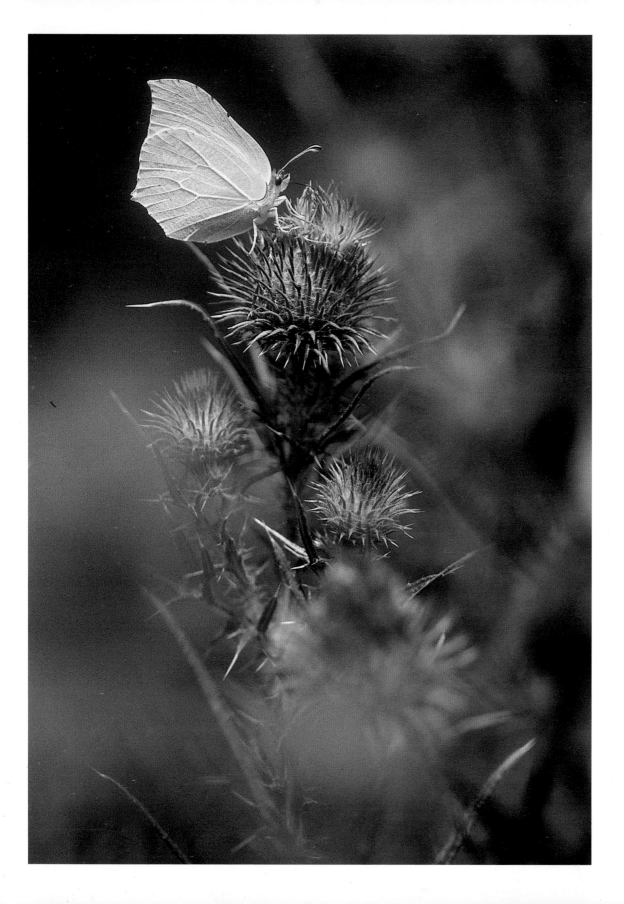

Gonepteryx rhamni
Brimstone butterfly
France

This is one of the first butterflies to emerge in the spring, sucking liquid from willow catkins. The males, especially, are well known for being active on sunny days at the end of winter.

pounce upon it and devour it. The Sphinx's immense proboscis allows it to sip nectar from a distance, thus escaping the sharp chelicerae of spiders.

Some butterflies, which lick droppings, are not so lucky and fall victim. Attracted by the moisture and nitrogen salts found in bird droppings, they settle on what they take to be such droppings; but these suddenly come to life and devour them. The culprit is a crab spider, whose body is white, striated with black. The spider spins a whitish, asymmetrical web around itself, which perfectly mimics the splashes of bird droppings that land on dead leaves. The fearsome hunter need only wait: The trap is formidable.

Despite all this diversity, the most extraordinarily improbable feeding technique found among butterflies and moths is that of those in the families Phalaenidae, Notodontidae, Tineidae, and Geometridae. Their preference is for the tears of large mammals, humans included. Some are content to lick the tears from the eyes of deer and suck the secretions that ooze from their tear ducts. Others, however, are armed with a tongue that bears protrusions like the teeth of a saw. These tongues can irritate and pierce mucous membranes, reaching capillaries and making them bleed. In other words, these insects are not feeding on tears at all but on blood. As a result, these miniature vampires, which ravage herds of livestock in tropical regions stretching from Africa to India, are classed as parasites. A strange feast for a butterfly!

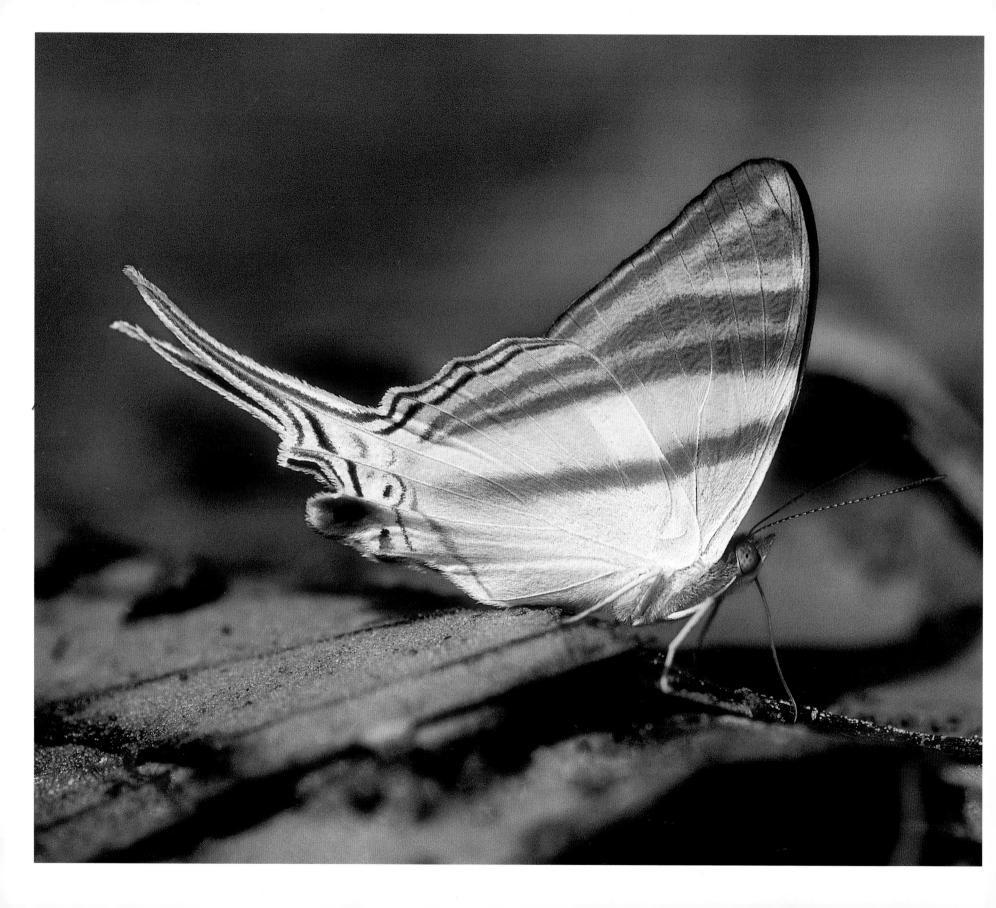

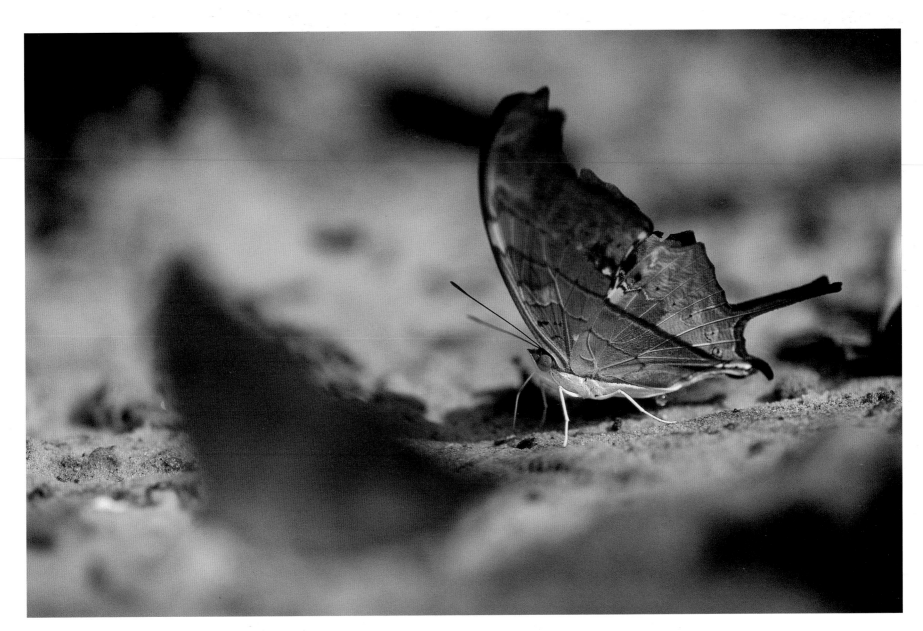

Opposite:
Marpesia sp.
Amazon rain forest, Brazil

In very hot conditions, butterflies must drink a great deal. Some species have a stiff proboscis, which enables them to pierce the peel of fruit and drink the juice; others have an atrophied proboscis or even none at all, and are thus unable to feed.

Marpesia petreus
Ruddy Daggerwing butterfly
Amazon rain forest, Brazil

The sap that oozes from damaged plants is another food source tapped by many Lepidoptera. Some tropical noctuids drink from the tears of large mammals, plunging their proboscis into their eyes. The most terrifying is *Calyptra eustrigata* (Vampire moth), which pricks the skin of animals to drink their blood.

The Colors and Shapes of Survival

Gonepteryx rhamni
Brimstone butterfly
France

The male Brimstone, which is more brightly colored than the female, is not only camouflaged by its color but also by the shape of its wings, which exactly mimics that of the leaves among which it likes to hide.

The beauty of butterflies and moths is a defensive weapon. The splendid butterflies of the genus *Morpho* use their iridescent colors to escape predators. The upper surfaces of its wings are brilliantly iridescent, while the undersides are more camouflaged with its surroundings; thus, with every wingbeat the Morpho offers a totally different image of itself. This disruptive picture could be described as "Now you see me, now you don't!" The regular eclipse of a bright spark by a discreet shadow disconcerts pursuing predators enough to give this creature time to vanish into the depths of the forest canopy, which is generally dense in the tropics where it lives.

How to Show Everyone That You Are Inedible

The best protection against predators is to be inedible. This is the case with the Monarch, as with the many members of the large Danaidae family. The Monarch combines all the defense techniques used by Lepidoptera. The female starts by laying eggs on plants belonging to the milkweed family; these, which produce a milky juice, are toxic and therefore not eaten by herbivores, which might have accidentally eaten the eggs. The caterpillar that emerges from them

also eats the plant, thus concentrating the toxic chemicals in its body and becoming poisonous itself. This toxicity follows the insect throughout its life, and the adult is extremely poisonous. It is also extremely tough: Its thorax can withstand pressures that would prove fatal to any other butterfly. A bird can seize it, chew it, and prick it, without it suffering any damage. The butterfly resumes its flight, unhurt. This also protects the bird, for the poison carried in the butterfly's blood acts on the heart muscle and could cause the death of an imprudent predator. But the Monarch's strongly contrasting colors send a clear message: "Danger! Take care!" Whereas most highly colored butterflies only show their colors in flight—because the undersides of their wings, which are all that can be seen at rest, are dull for better camouflage among vegetation—the Monarch can afford the luxury of bearing bright colors on both surfaces of its wings. Thus, whether in flight or at rest, its warning is visible.

A Royal Usurper

Mother Nature is full of practical jokes. Alongside the Monarch exists a pretender to the throne, the Viceroy. This butterfly, which is also American and goes by the Latin name of

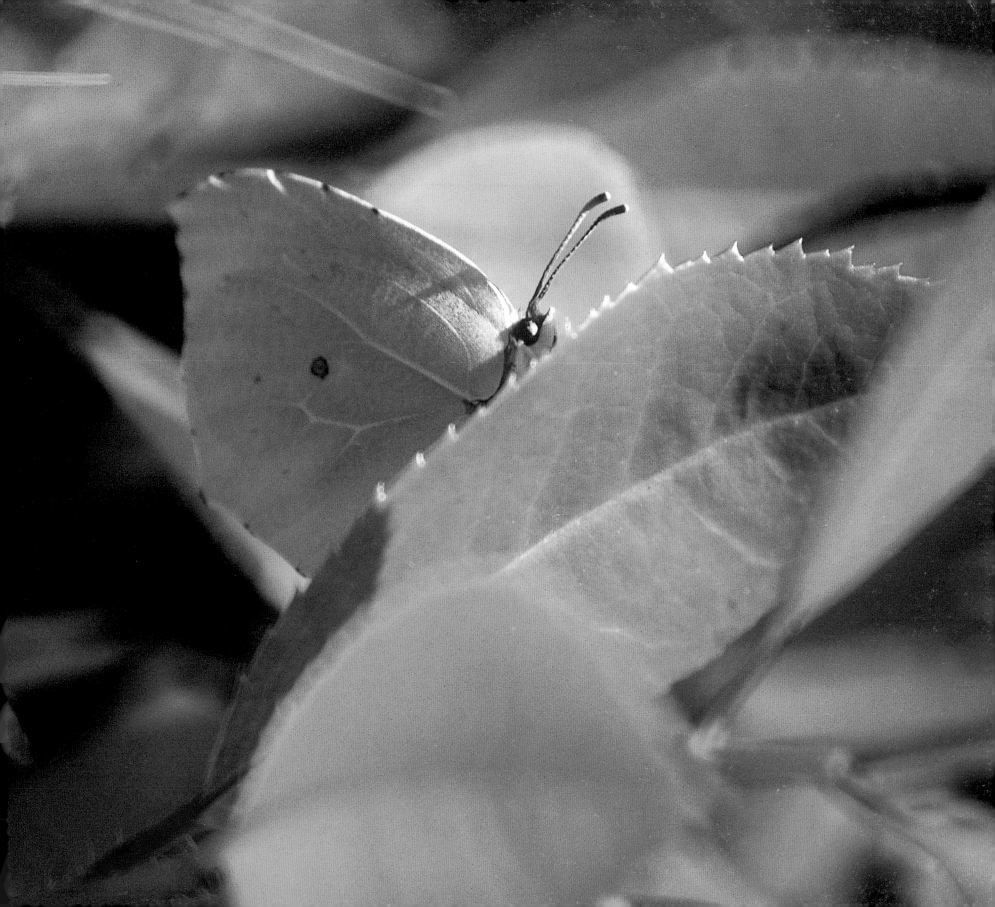

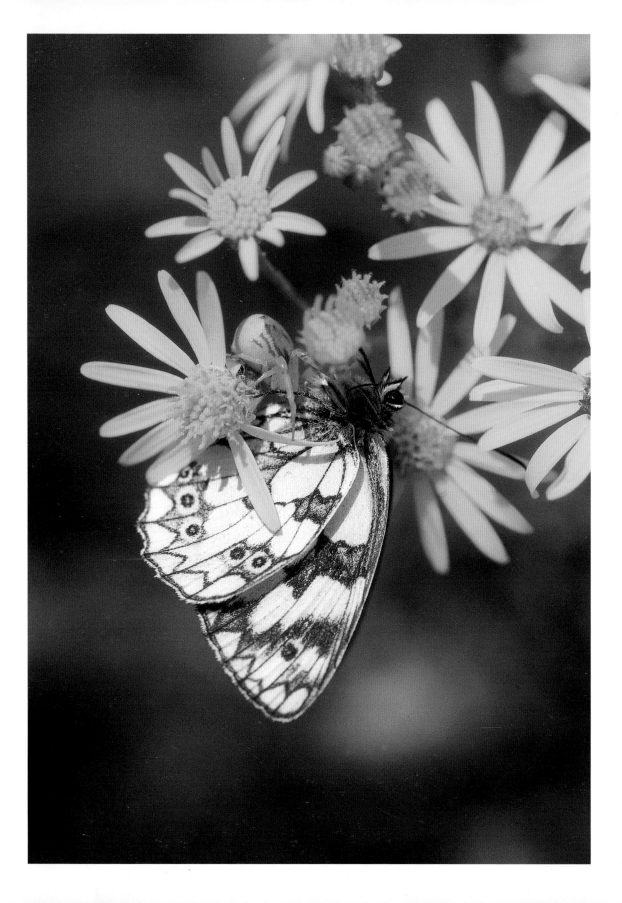

Melanargia galathea
Marbled White butterfly
France

In the great survival game played out between predators and prey, it is not always the latter that is camouflaged. A crab spider here waits for its prey, lurking on a flower where it is perfectly invisible. Some members of this spider family (Thomisidae), such as *Misumena vatia*, can alter their color from white to deep yellow to match the flower where they lie in ambush.

Limenitis archippus, is perfectly edible. However, it has found an infallible way of not being eaten: It has simply disguised itself as a Monarch. Same size, same colors, same motifs on the wings—and presto, the pretender is safe from greedy birds. An experiment has proved this. Inexperienced jays were fed the usurper and ate it with relish. However, the same butterfly was left untouched once the jays had experienced contact with the Monarch. After the latter left a bitter taste in their beaks, they gave up the pursuit of its imitator, which was too risky, in favor of more reliable prey. However, this stratagem works only if the imitator is less numerous than the original. If there were many more usurpers than Monarchs, it would be worthwhile, in statistical terms, for predatory birds to try their luck. The name for this phenomenon is Batesian mimicry, after the English entomologist Henry Walter Bates. He was the first to describe the situation in which the model species is poisonous, while the mimicking species, identical in size and color, is edible. This phenomenon is widespread, especially among tropical butterflies.

Multiple Forms of Mimicry

Sometimes even within the same species, the adults can look very different from each other. The males of the African Swallowtail species, *Papilio dardanus*, for example, are typically lemon yellow. The females do not resemble them in any way: Instead, they closely resemble—to the point of being easily confused with—two poisonous species, one red, the other white. These two species differ strongly not only from each other but also from the male *Papilio dardanus*. This resemblance to other species is called mimetic polymorphism.

However, butterflies and moths are not content to practice only this type of mimicry. They also know how to disguise themselves as other types of insects. Some with transparent wings imitate wasps and sometimes even bumblebees—hornet moths of the family Sesiidae (also known as Clearwing) use their resemblance to a highly dangerous species of wasp as a defensive weapon. Slipping into a villain's clothes allows an insect to live a quiet, untroubled life while keeping undesirables at a respectful distance.

Hipparchia fagi
Woodland Grayling butterfly
France

Preferring to settle on tree trunks rather
than leaves, this species of butterfly
blends in with its surroundings so well
that it is very difficult to spot.

Arethusana arethusa

False Grayling butterfly
France

This butterfly has numerous subspecies, with wing markings that vary in pattern and background coloring. Some can only be told apart by an examination of their reproductive organs. The dark forms predominate on acid soils, and the light forms on chalky soil.

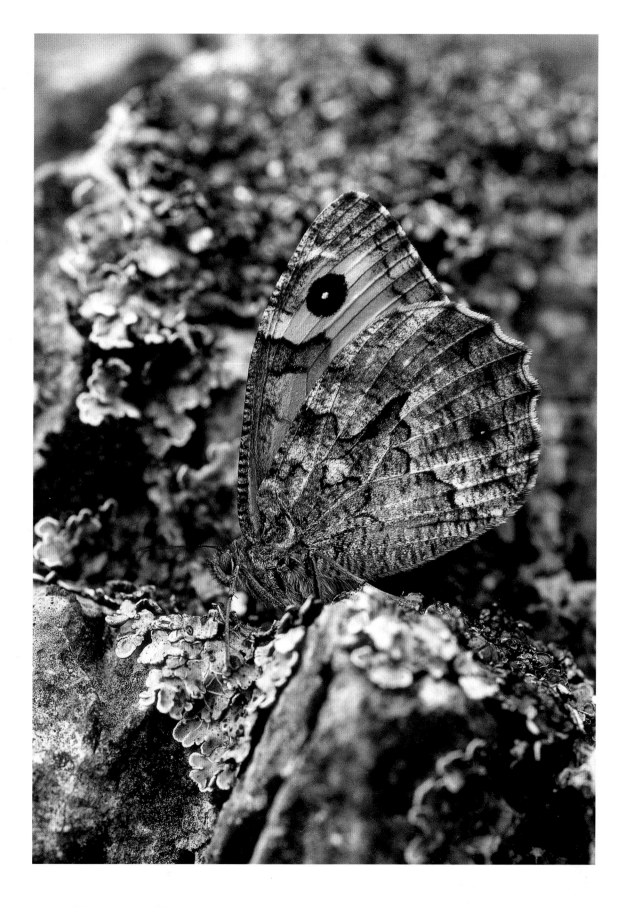

Papilio rumanzovia
Scarlet Mormon butterfly
Philippines

Red and black are chemical colors, produced by the presence of pigments. These are toxic molecules manufactured by the pupa's metabolism or ingested directly from the plants it eats. In all cases, they are transferred to the wings when metamorphosis takes place. This recycling protects the insect's vital organs.

How the Invisible Survive

Another self-protection technique that is widespread in nature is to become invisible to the eyes of predators. What is most impressive is the precision with which a species mimics details. The reason for this is that certain details deceive some predators, while different details fool others.

Many moths blend into the bark of the trees on which they settle. The Peppered moth (*Biston betularia*) is so good at this that it has served as an example to generations of students. This small moth, white with speckles, is completely camouflaged on the white bark of birch trees, and its caterpillar is virtually indistinguishable from a young birch twig. In industrial areas, however, the bark of birch trees exposed to factory smoke and exhaust fumes has turned black, which makes the moth highly visible to predatory birds. In this environment it has evolved to become a darker color. As a result, in a fairly short time almost all the Peppered moths living in urban areas have become black, completely replacing the original form and providing a magnificent example of adaptive evolution and survival of the fittest. Recently, with the arrival of

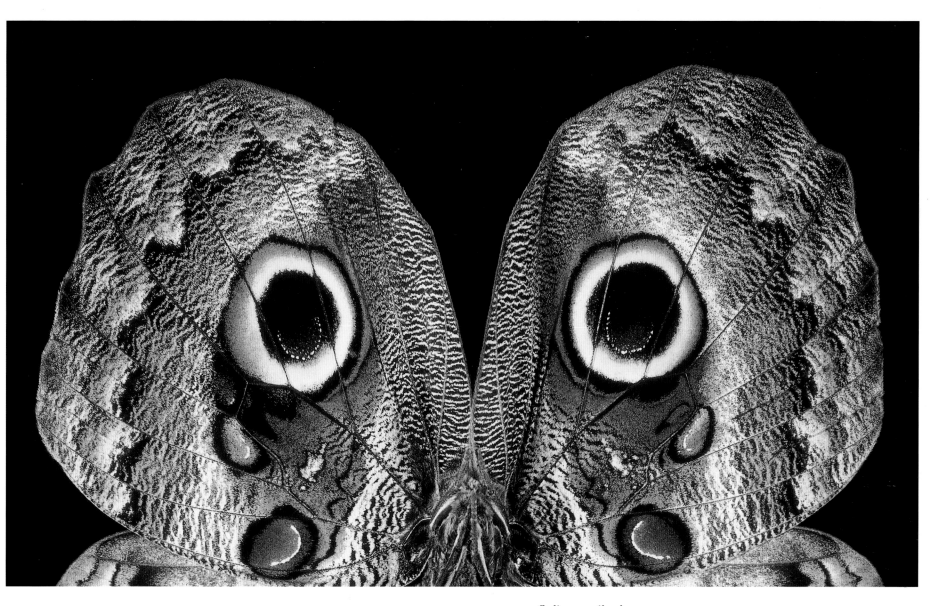

Caligo eurilochus
Owl butterfly
Amazon rain forest, Brazil

When the *Caligo eurilochus* is alarmed, it quickly opens its rear wings, revealing two large eyespots that make it look remarkably like an owl's face. This ruse is intended to give it a few seconds in which to escape from a predator—a small bird that might be frightened by an owl's hypnotic stare. The resemblance is even more striking when specimens are pinned in collectors' boxes. In the wild, under normal circumstances, the Owl butterfly hides its eyespots and is completely invisible where it has settled.

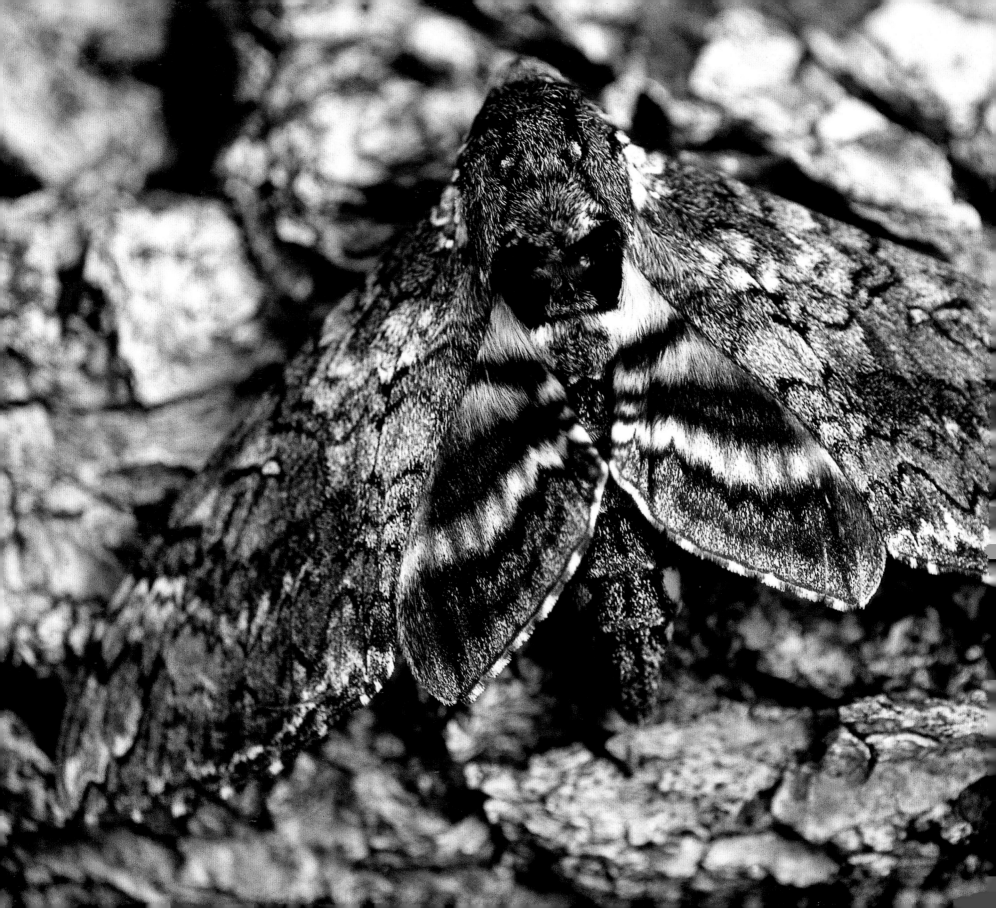

pollution control in large cities, the melanistic (black) form has reduced in number, giving way to the original (speckled white) form, showing how fast insects can adapt to conditions around them.

Surprise as a Last Defense

Passing unnoticed is an effective means of self-protection, but it becomes useless as soon as the camouflaged insect is discovered. There is one final strategy left: to frighten the aggressor. This technique is widespread among insects, especially among butterflies and moths. Many moths that are often perfectly camouflaged in their surroundings reveal, when attacked, a pair of eyespots on the back of their wings. At rest, the upper pair of wings hide these strong markings, but when threatened the wings part to expose what looks like the eyes of a large animal on the lower pair of wings. The contrast is striking. Many scientific experiments have confirmed that this trick works. The markings frighten birds, who think they are facing a predator. The closer the resemblance, the more effective the markings prove to be. The placement of the eyespots, side by side, mimics the position of predators' eyes: Predators

Manduca sexta
Carolina Sphinx moth or Tobacco Hornworm
North America

Sphinx moths are remarkable not only for their powerful flight and impressively long proboscis; they also possess extraordinarily effective camouflage, which keeps them safe while they rest on tree trunks.

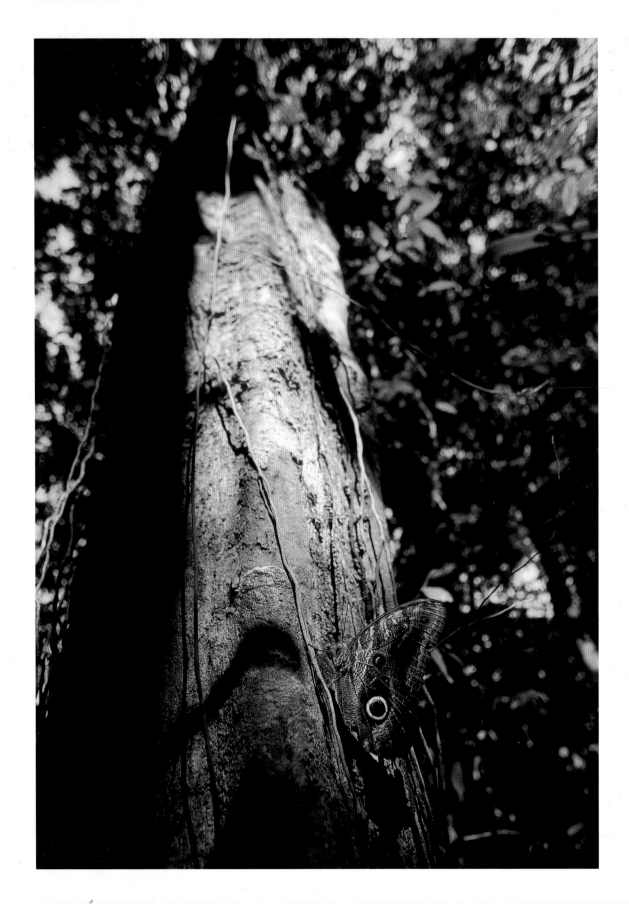

Caligo sp.
Amazon rain forest, Brazil

Eyespots on the wingtips also serve to deflect attention from the insect's vital body parts. In older individuals, the edges of the wings are often frayed, bearing witness to the sharp but vain pecks of birds that fell for the hoax.

Opposite:
Caligo sp.
Costa Rica

Birds are not the only predators that feed on butterflies and moths. This spider did not allow itself to be intimidated. Because the owl is not one of the spider's predators, the butterfly's ploy did not work.

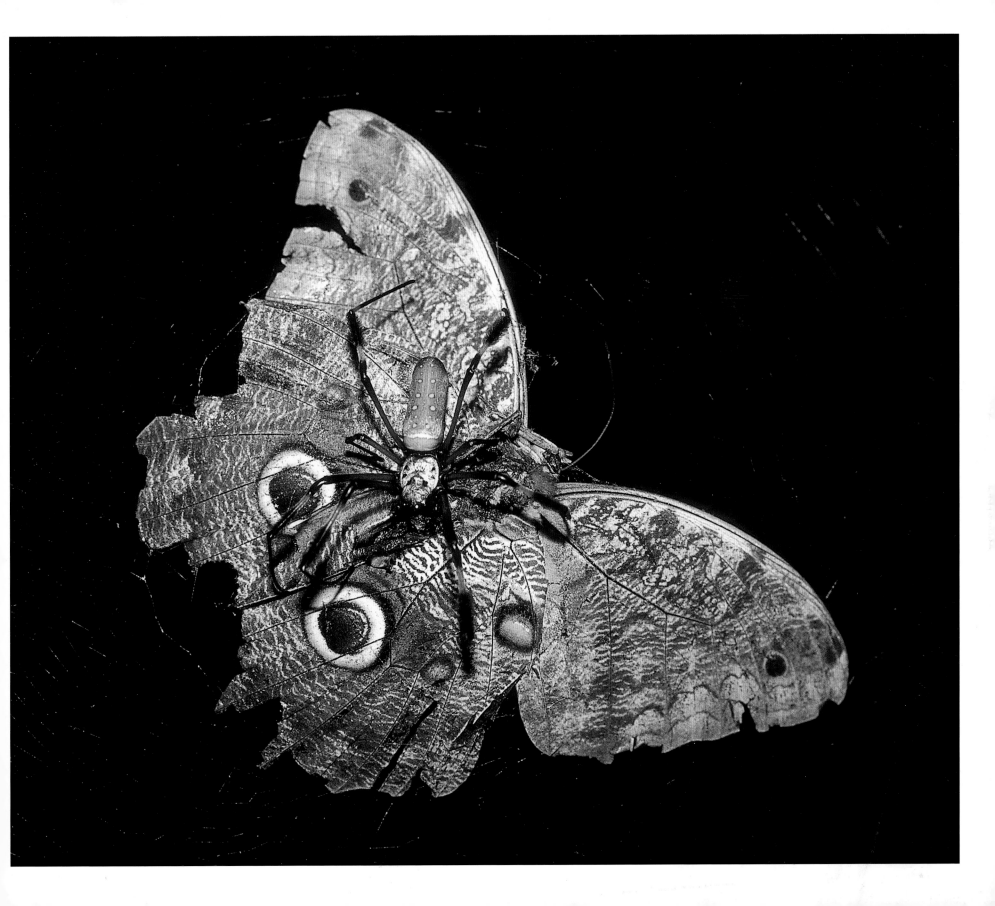

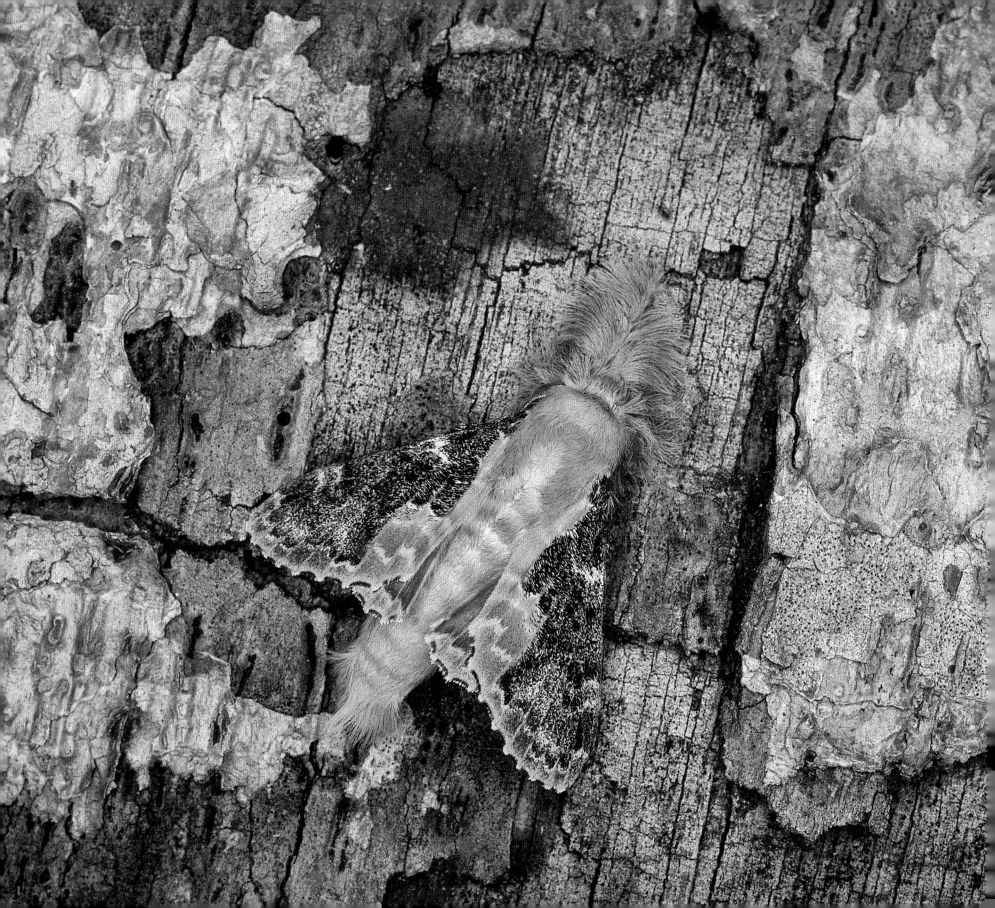

are the only animals whose eyes face directly forward, allowing binocular vision; prey species have eyes on either side, which allows them to see around them. At best, when faced by the moth's eyespots, an attacker will feel threatened and withdraw. At the very least, the surprise causes it to hesitate, and the prey takes advantage of this to make its escape. A moment can save a life.

Suddenness also counts. The surprise factor does not work if the markings are revealed gradually. Some moths possess a further refinement, such as the West African species that, not content with suddenly exposing its red abdomen, simultaneously covers itself with a foul-smelling yellow froth.

Artful Dodgers

Butterflies and moths are nature's magicians and have developed different strategies to deal with attack. Apart from intimidation, as described above, there is a second ploy: to divert a predator's attention. In these cases, the insect does not avoid attack but deflects it. Ocelli on the edges of the wings attract predators' attention to less essential parts of the body, distracting them from the vulnerable head and thorax. Some butterflies and moths possess false heads complete with imitation antennae. In older specimens it is not uncommon to see several bite marks in the area of the false head, demonstrating the attention it attracts from predators, and its value to the prey, which owes its life to this ploy. The hindwings of Hairstreak butterflies (the subfamily Theclinae in the family Lycaenidae) have long tails that resemble antennae and brightly colored markings that look like a head; black and white lines converge on this false head, attracting the observer to that spot. When feeding, the Hairstreak slowly moves its hindwings up and down to distract attention from its actual head. It is a virtuoso of trickery!

Notodontidae family of moths
Suriname

Some moths and butterflies that are completely camouflaged at rest reveal brilliant colors on their rear wings when they take flight. This stratagem confuses the predator, whose eye is drawn by the moving insect but perceives nothing once it has settled. The resulting confusion is enough to ensure the fugitive's safety.

Following pages:
Details of butterfly and moth wings.

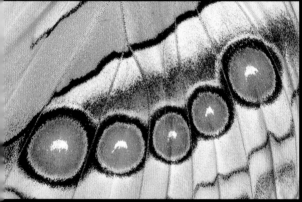

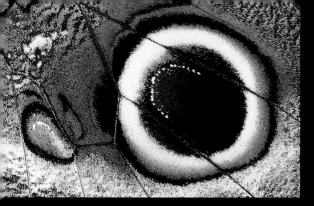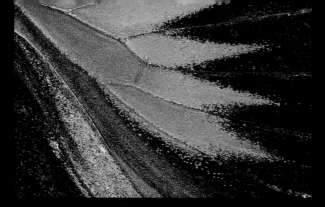
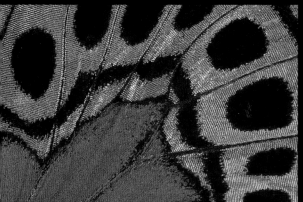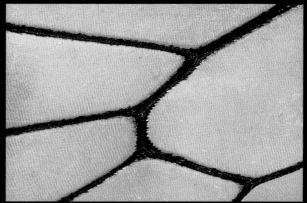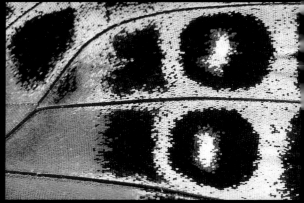
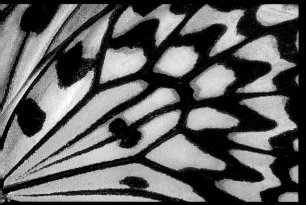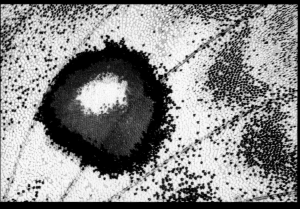
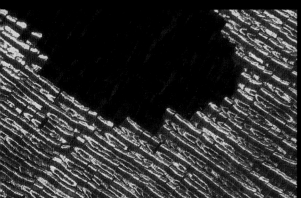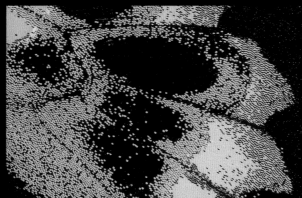

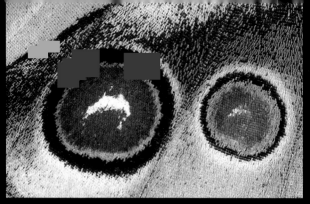

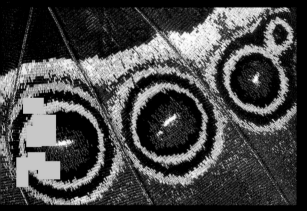

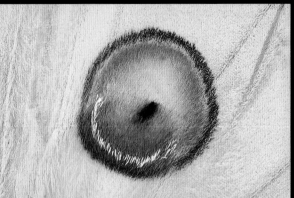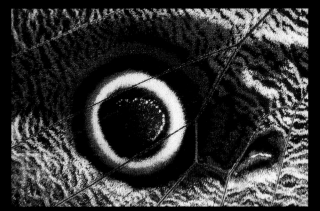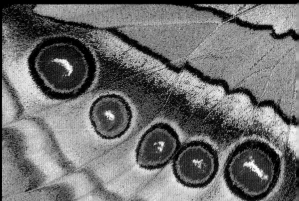
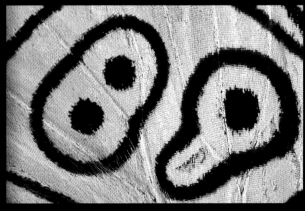

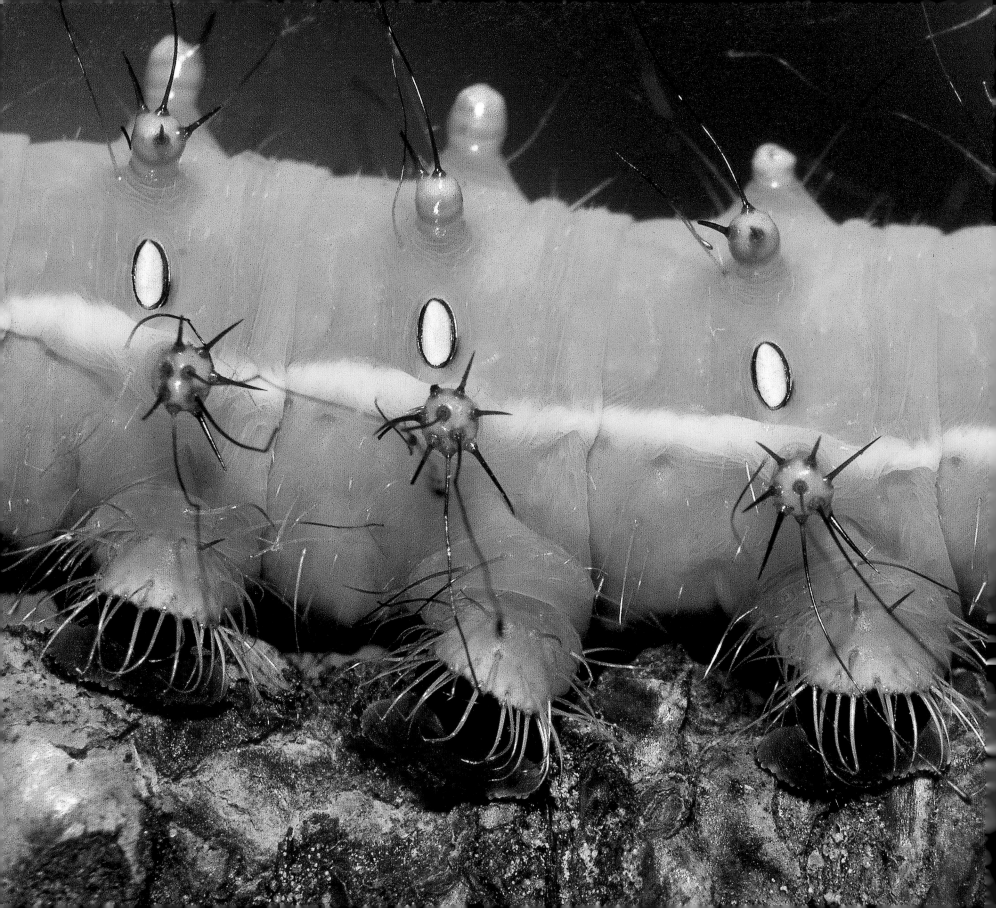

The World of Caterpillars

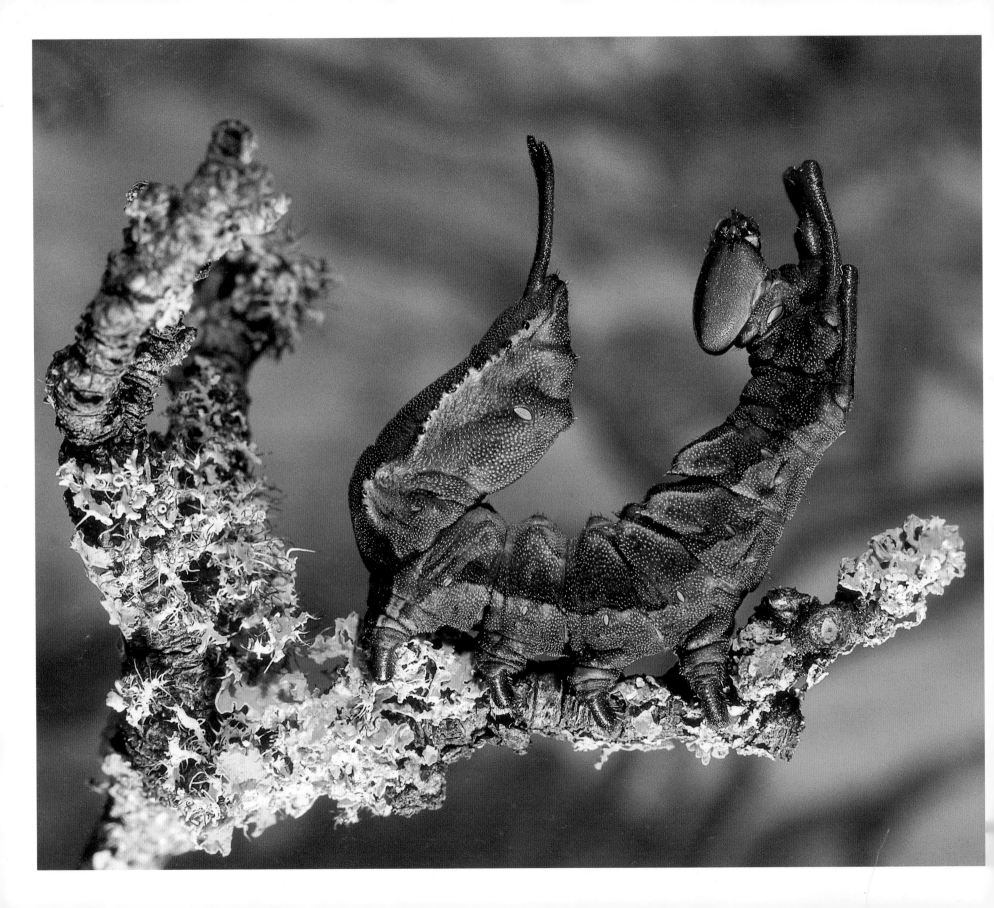

The World of Caterpillars

The caterpillar is the larval stage of butterflies and moths and the primary feeding time in the insect's life span. Caterpillars eat almost without interruption. Their powerful jaws are fearsomely effective tools for grinding food. Some species can feed on a wide variety of plants, which enables them to colonize many different habitats. Others, by contrast, depend strictly on a single plant species and starve to death if it is not sufficiently plentiful. The relationship is complex because caterpillars are capable of ravaging plants, yet they are dependent on the plants' survival for their own.

Stuffing itself with food, the caterpillar grows at an extraordinary speed. In the two weeks after it is born, it increases its weight a thousandfold. This forces it to molt: The caterpillar sheds its exoskeleton, and while its skin is still soft it inhales air to expand its body; when the cuticle hardens, the caterpillar lets out the air and has room to grow. A caterpillar molts several times before it pupates—the final change from which it will be reborn as a butterfly.

This insatiable eater also fulfills a role that generally goes unnoticed. The thousands of caterpillars that cover the trees in a given area produce hundreds of pounds of droppings for every acre of land. This is highly appreciated by plants, which find in them the organic compounds essential for growth. This quid pro quo works well, as long as humans do not interfere by introducing their unwelcome ideas.

Stauropus fagi
Lobster moth
France

This moth's caterpillar is certainly the strangest in Europe. Adopting its typical defensive position, it raises its head and the rear third of its body. Some caterpillars in this family squirt an irritating fluid, while others inflict extremely painful bites on their attackers.

Previous pages:
Saturnia pyri
Great Peacock moth
France

The adult Great Peacock is the largest of Europe's moths and butterflies. With its brightly colored, club-shaped protuberances, the Great Peacock's caterpillar warns hungry predators that they eat it at their own peril. Colors spell danger.

Insatiable Appetites

Saturnia pyri
Great Peacock moth
France

A caterpillar's first meal is its own egg, which contains essential nutrients. As soon as it is hatched, the caterpillar sets off in search of food. This voracious behavior causes it to grow rapidly, and it undergoes several molts.

When they hatch, caterpillars are tiny and look completely harmless. But they are equipped with mandibles designed for chewing food, and they spend their time ingesting everything that can provide them with nourishment. Indeed, a caterpillar's life could be summed up in two activities: ingesting food and digesting it. Dissecting a caterpillar reveals that its digestive organs occupy almost the entire volume of its body. This compulsive eating produces a phenomenal growth rate in the larva; some species multiply their birth weight 72,000 times.

A Caterpillar's First Meal: Its Own Egg

Before hatching, the young larva secretes an acid that causes its egg to break open, allowing it to wriggle out. As soon as the caterpillar is free it devours the chorion, the egg's nutritious membrane, which contains important compounds that promote growth.

The problem posed by caterpillars is not so much their insatiable appetite as their large numbers. The combination of these two factors is formidable. A single oak tree, under normal conditions, may be home to as many as 50,000 caterpillars. They devour whole leaves, albeit in different ways. Some caterpillars destroy leaves completely, while others, known as leaf miners, burrow into leaves, making tunnels without destroying their outer surfaces. The larvae of

Tortricid moths (Tortricidae family) are leaf rollers, using leaves for both shelter and food. All plants, even the most toxic, can be eaten by these permanently hungry creatures, and there is no plant that does not have its associated caterpillar. There is even a family of Lepidoptera that feasts on aquatic plants and does considerable damage to waterlilies.

Gluttons—But Very Choosy Ones

Studies of the Carolina Sphinx moth (also called the Tobacco Hornworm, *Manduca sexta*) have shown that individuals that have tasted the nectar of solanaceous plants (a family, Solanaceae, that includes tomatoes, potatoes, and eggplants) will no longer feed on anything else; they will die of starvation rather than eat anything else. Researchers discovered that the nectar of solanaceous plants is rich in indioside D, a molecule that is made up of glucose and lipids, which strongly stimulate the four taste receptors that caterpillars have around their mouths. These receptors, called *sensilla styloconica*, function like small external tongues, which taste and touch leaves to detect their chemical composition and determine whether they are edible. They are especially sensitive to indioside D, and once they have been stimulated by this molecule they can no longer recognize other nutritious substances.

Caterpillars have a very wide variety of diets. Some species have jaws powerful enough to

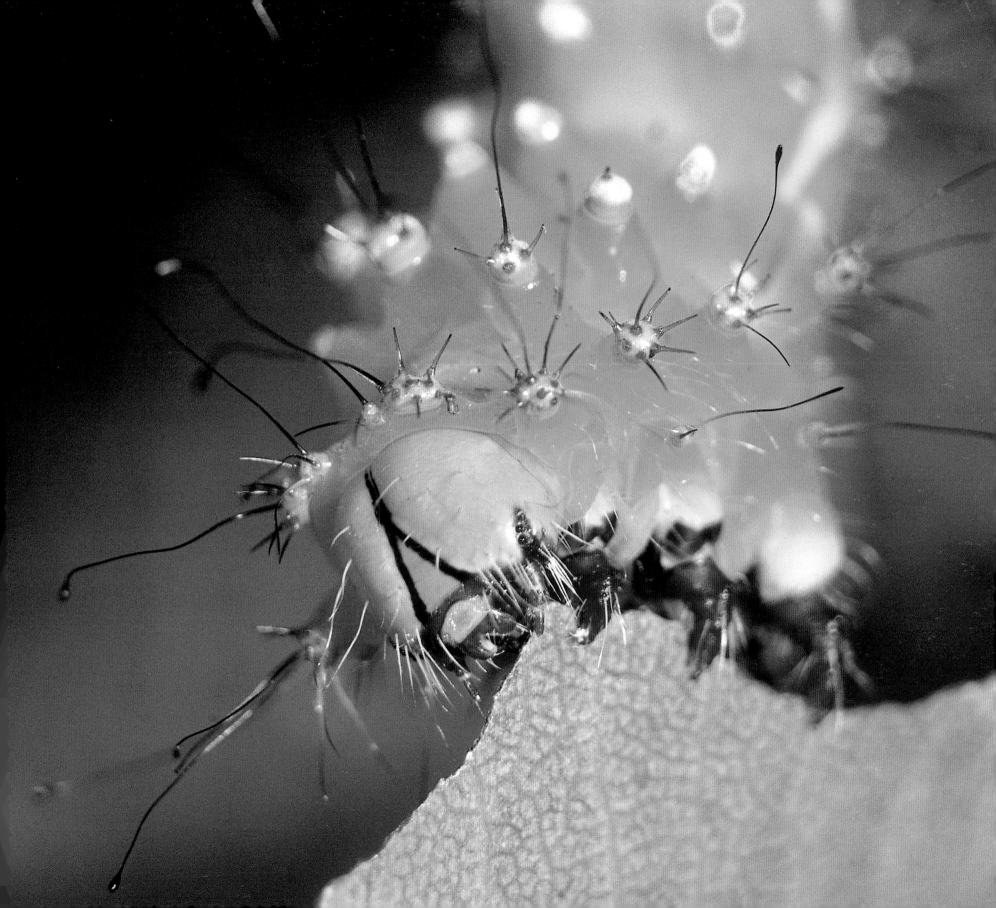

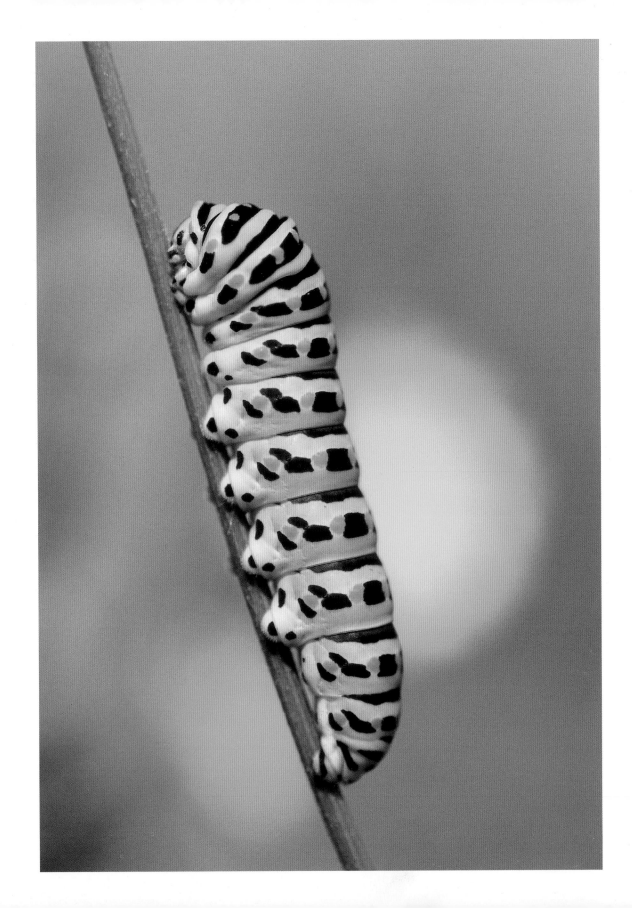

Papilio machaon
Old World Swallowtail butterfly
France

This handsome caterpillar feeds on all types of garden and wild umbelliferous plants, such as fennel, carrots, dill, and cumin.

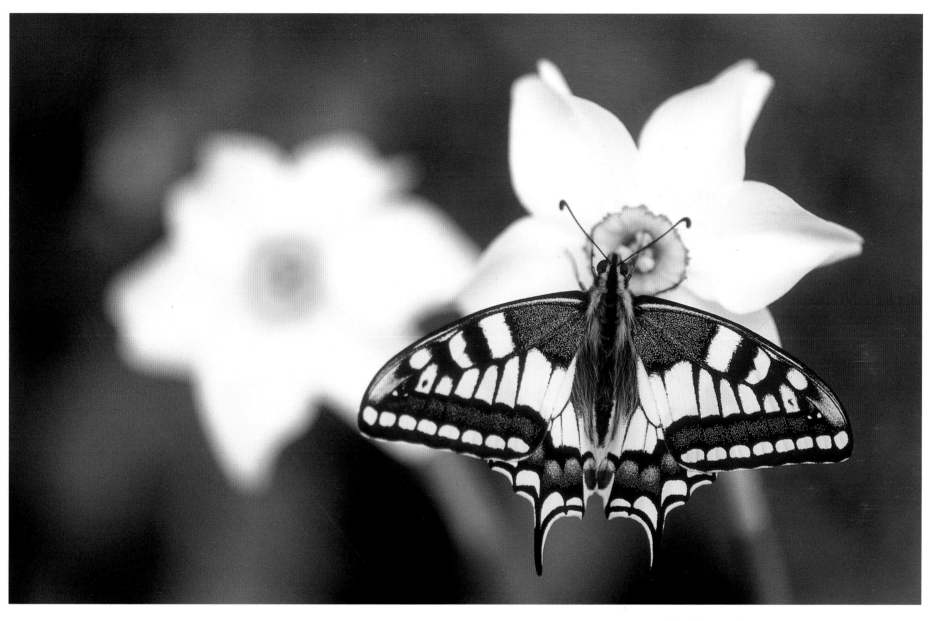

Papilio machaon
Old World Swallowtail butterfly
France

This large, highly active butterfly, one of the most spectacular in Europe, is now more often seen in books than in the wild, for it has fallen victim to modern agricultural methods as well as to parasites in the caterpillar stage. Powerful fliers, the adults have a strong migratory tendency.

perforate wood—for example, Cossids (Cossidae family) dig tunnels into the trunks of trees; for this reason, many species in the family are sometimes Carpenter moths. Some large caterpillars in this family give off a strong odor resembling that of a goat; thus, they are sometimes referred to as Goat moths. Because their food is so tough and is digested slowly, these caterpillars have a very long larval stage, taking three years to develop. Experiments have shown that if the same larvae are fed on beetroot (which they will willingly consume), they reach their full size in just one year.

Unobtrusive but Dreaded—Those Who Feed on Hairs

Although the great majority of Lepidoptera larvae devour vegetable matter, some have a clear preference for animal organs, as in the case of the small moths of the Tineid family (Tineidae), some of which attack the skin. Their mention is enough to strike terror into the hearts of furriers, and anyone who owns woolen garments, such is the damage their caterpillars have wrought over the many centuries during which they have cohabited with humans. Unobtrusively, clothes moths and other tineids that attack leather worm their way into the smallest opening, hiding under the slightest fold, and gnaw at far more fibers than they can actually eat. Fine new wool or a soft rabbit fur can bring these larvae to maturity in just four months. If these are soiled with body fluids such as sweat or blood they favor the insects' development even more. More highly processed fabrics are less nutritious, and larvae living among these take four years to reach the chrysalis stage. Their adult life is rarely longer than two weeks. Before humans offered these small moths board and lodging, they lived in abandoned birds' nests and among the remains of dead mammals. These insects also offer two perfect examples of symbiosis: There is a moth that lives exclusively among the hairs of animals, and the horns and antlers of certain ruminants are also eaten by some caterpillars while the animals are still alive.

The Incredible Harmony of Symbiosis

Even more surprising is the association between a small Tineid moth and the yucca plant, of which the moth is the sole, essential pollinating agent. As in the case of the moth that lives among animal hairs, each species of yucca has its own species of Tineid moth. The larvae feed on the plant's ripe seeds. At nightfall, after mating, the female moth goes in search of yucca flowers. Her proboscis—which is otherwise useless, because this adult moth does not feed—is modified to act as a pollen-collecting device. The pollen is collected directly from the plant's male sexual organs and rolled into a large ball. On arriving at another flower, the insect places the pollen on a female

Hyles euphorbiae
Leafy Spurge Hawk moth
France

Caterpillars are fearsome eating machines, ravagers that nothing seems able to stop. However, they can also be extremely fussy: If they do not have access to their favorite plant, the caterpillars of some species will starve to death.

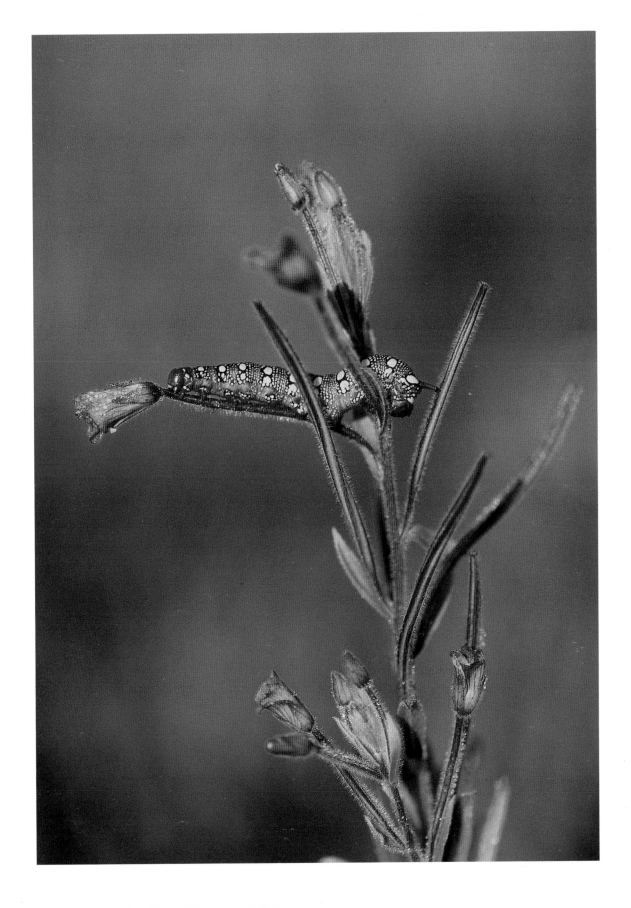

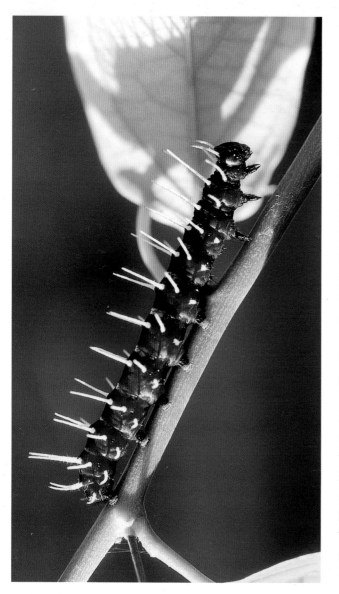

Heliconius wallacei
Wallace's Longwing butterfly
Suriname

sexual organ, while laying an egg or two in it. The fertilized flower then produces seeds, on which the larvae feed. More seeds are produced than are needed for the larvae to eat, and thus some of these reach maturity and produce new plants. Both moth and plant gain from this perfectly functioning symbiosis. These Tineids are not the only butterflies or moths whose larvae grow in symbiosis with another organism, but they are perhaps the most highly developed examples.

Cannibals and Carnivores as Sweet as Honey

Members of the family Lycaenidae also form symbiotic relationships. These pretty blue butterflies, which are numerous throughout the Northern Hemisphere from Alaska to Siberia, normally lay their eggs one by one, placing each on its own host plant or slipping it directly into a flower. This individual attention is an important precaution because the caterpillars are often cannibalistic and are not above eating their siblings if the opportunity arises. In most of these species the caterpillar has a gland on its back that secretes a sweet substance of which ants are extremely fond. In return the ants are generous in looking after the caterpillar, keeping it safe from parasitic insects of the Diptera and Hymenoptera orders—sometimes even to the point of neglecting their own offspring.

The relationship between the Large Blue butterfly (*Maculinea arion*) and *Myrmica sabuleti* ants presents a good example—although some relationships, while mutually advantageous, remain optional: for the Large Blue it is indispensable for the larvae's survival. After hatching on a thyme flower at the end of June, the young caterpillar starts to feed on its host plant. Three molts later, in September, having reached the size of a grain of rice, it drops off its flower and goes in search of an ant. If it does not find one within two days, the caterpillar starves to death. Luckily, the type of ant in question generally lives among the roots of the thyme plant, which maximizes the chances of such an encounter. In other species of the Lycaenidae family, which are less dependent on ants as hosts, the caterpillar

Opposite:
***Arctidae* sp.**
Brazil

Caterpillars are equipped with extremely powerful jaws for grinding and can devour leaves right down to the midrib, the tough vein at the center of the leaf. This huge appetite allows them to build up enough reserves to metamorphose into moths and, in some species, to ensure that an adult incapable of feeding itself survives long enough to produce the next generation.

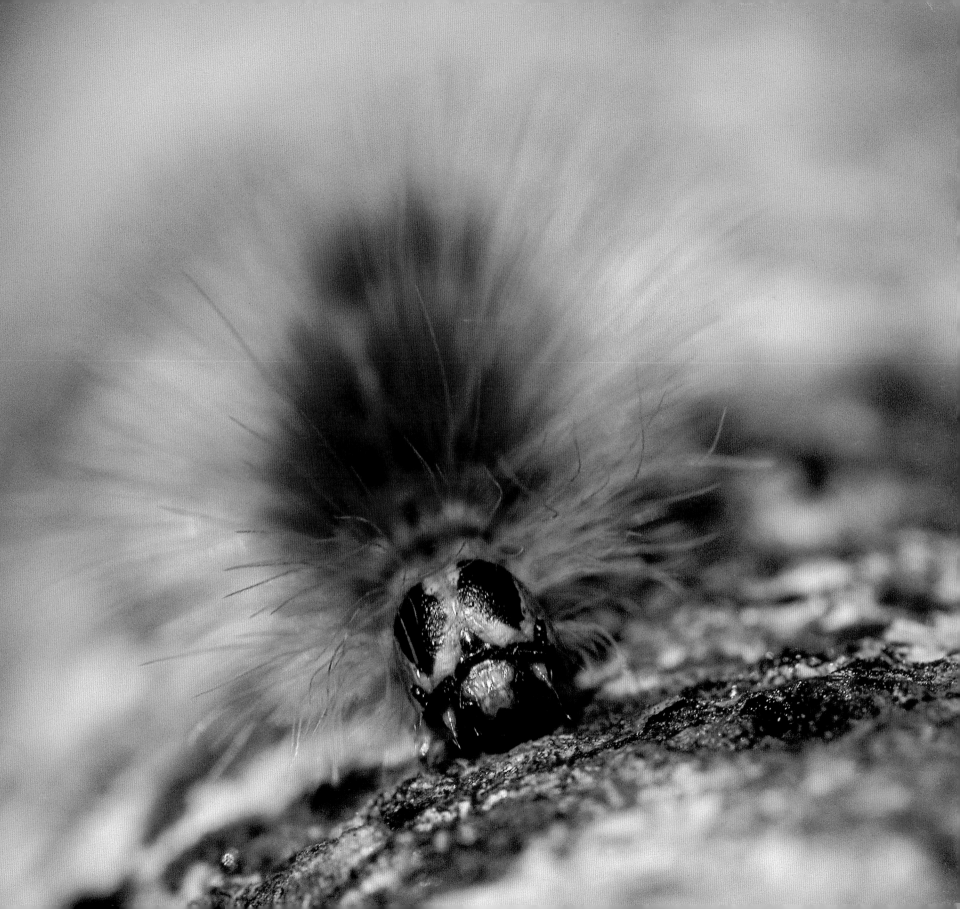

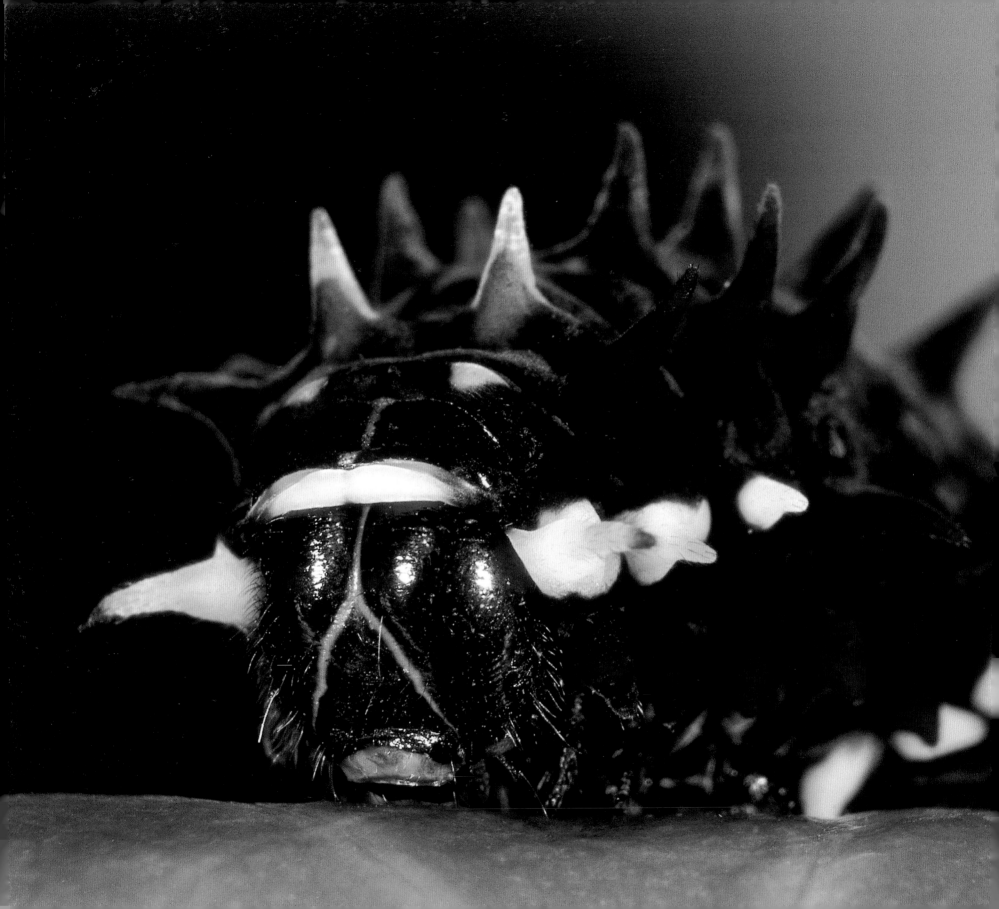

becomes carnivorous at this stage, devouring the insects it encounters while it awaits an ant to come and take charge of it. The ant strokes the caterpillar with its antennae, until the gland has been stimulated enough to produce the sweet secretion. The ant feeds on it until the caterpillar draws itself up to the full height of its well-fed little body. This is the signal. The ant takes hold of the larva—the front of whose body has been rendered swollen by the act of suddenly secreting the sweet substance—and carries it off to its nest. There, protected from predators and from the weather, the caterpillar grows until the following spring, eating ant larvae and, in return, secreting its succulent liquid for the adult ants to feed on. It will become a chrysalis in May, and in June or July it emerges as an adult. The ants escort the butterfly to the surface, surrounding it to make sure it is protected, until its handsome blue wings have dried and it can take flight.

The caterpillar appears to gain far more from this arrangement than the ants. Thus, in addition to satisfying the colony's appetite with its secretions, the Large Blue possesses other means of luring these normally ferocious defenders from their nest: smell and sound. The sense of smell is fundamentally important to ants, and the caterpillars' sweet liquid has the same odor as the ants themselves. This completely disorients the needy

Parides sp.
Costa Rica

Studies conducted on wild radish have recently shown that attack by caterpillars early in the season is beneficial to the plants' health later in the season. This early damage to the plant reduces by half the damage done by later arrivals of caterpillars. Moreover, plants thus sensitized produce 60 percent more seeds.

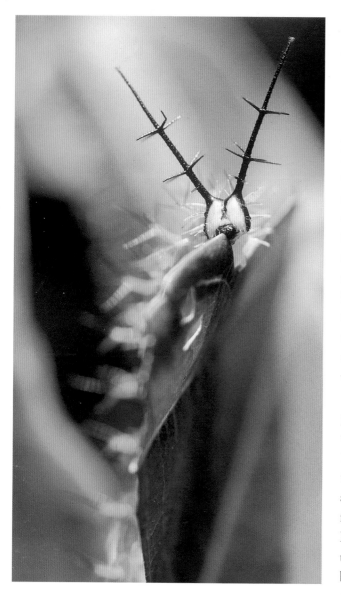

Catonephele acontius
Acontius Catone butterfly
Suriname

Caterpillars produce hundreds of pounds of droppings for every acre of forest. This organic matter enriches the soil with nutrients essential to plants. This beneficial role of caterpillars is often forgotten.

little ants, who mistake the caterpillar for its own larva. Once the caterpillar becomes a chrysalis, it continues to entice its hosts by singing their own song: It rubs its abdomen against the outer shell of the chrysalis, producing a creaking sound that is identical to the sound made by ants when they rub their heads against their bodies. Confused ants sometimes introduce so many caterpillars into their nest that all the eggs and larvae are devoured, and the colony is wiped out. However, this result is obviously not in the interests of the caterpillar either, which will die of starvation without the ant larvae for nourishment.

Even more astonishing are the very few caterpillars that have evolved into formidable predators. Representing less than one percent of the 175,000 or so species of butterflies and moths, they are armed to kill. They hunt by ambush, armed with shields, claws, and perfect camouflage, with a vigor that produces many victims. Equipped with sensory hairs and dorsal nerves that can detect the slightest contact with a foreign body, these killers have lightning reflexes, spinning around in a split second to stab their prey before they devour it. The twenty known species of these rare killer caterpillars, belonging to the Geometridae family, are found in Hawaii.

An Arsenal of Chemical Weapons for Self-Defense

The vast majority of caterpillars feed on plants, which face a difficult job—sometimes in vain—in trying to get rid of them. To protect themselves against these insatiable gluttons, plants have developed various strategies, notably an arsenal of naturally occurring chemicals. Corn, for example, which is severely attacked by the European Corn Borer (*Ostrinia nubilalis*), secretes a poison to protect itself from this parasite. However, this compound is chiefly concentrated in the leaves and especially in their outer covering. The caterpillars, therefore, have developed a strong preference for the flowers, which contain a high amount of sugar—which is the exact antidote for the poison that the corn secretes. This is a true cat-and-mouse game between the plant and its pest, each adapting to the tricks of the other.

Some plants are more effective in their strategies for defeating caterpillars. The passionflower vines of tropical America are a particularly sophisticated example. Their chemical arsenal allows them to repel most of the insects that could cause them harm. Unfortunately, however, its poison is ineffective against the Heliconius butterfly, which

Actias selene
Indian Moon moth
India

The small plump bodies of these voracious caterpillars are considered perfectly edible, even a delicacy, by many peoples all over the world. Hairless caterpillars are always preferred to hairy ones.

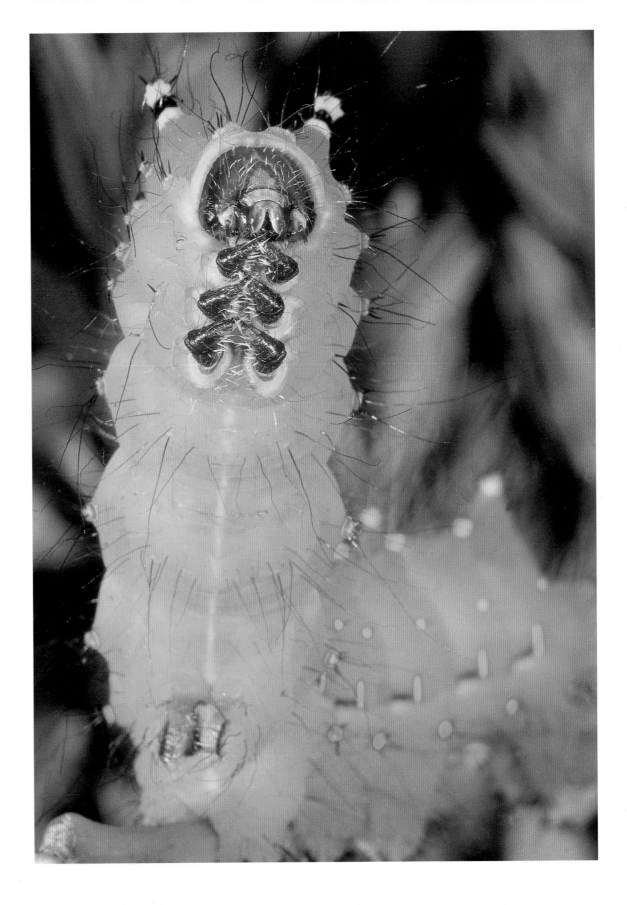

Acherontia atropos

Death's Head Hawk moth
France

Contrary to appearances, the "head" of this caterpillar is in fact a tail. At the other end of its body the real head, armed with powerful jaws as sharp as razors, is busily clipping the leaves of the potato plant, its host, making a loud chewing sound. This gastronomic uproar is thought to frighten off potential predators.

can still safely lay its eggs on the plants. Through the genius of evolution, however, some species of passionflower have developed an adornment at the base of their leaves: two small yellow balls that are perfect imitations of the eggs of the hated butterfly. No female of the *Heliconius* genus would dare to lay eggs on a leaf already visited by another female, because her young would risk being devoured by older caterpillars, so she flies on to another plant. However, if despite this deceit the butterfly still lays her eggs on one of these passionflowers, the plant has a backup plan: the imitation eggs are in fact nectaries that attract ants and wasps—who will also devour the caterpillar larvae. Ants are not always the allies of caterpillars; they provide their powers to those who offer the best exchange of services.

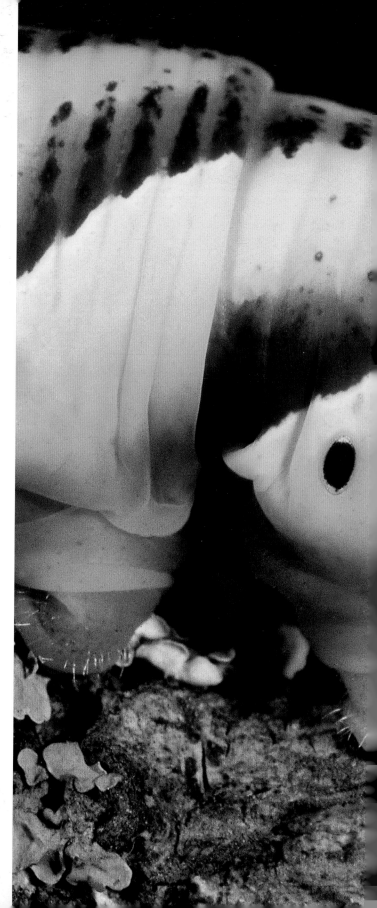

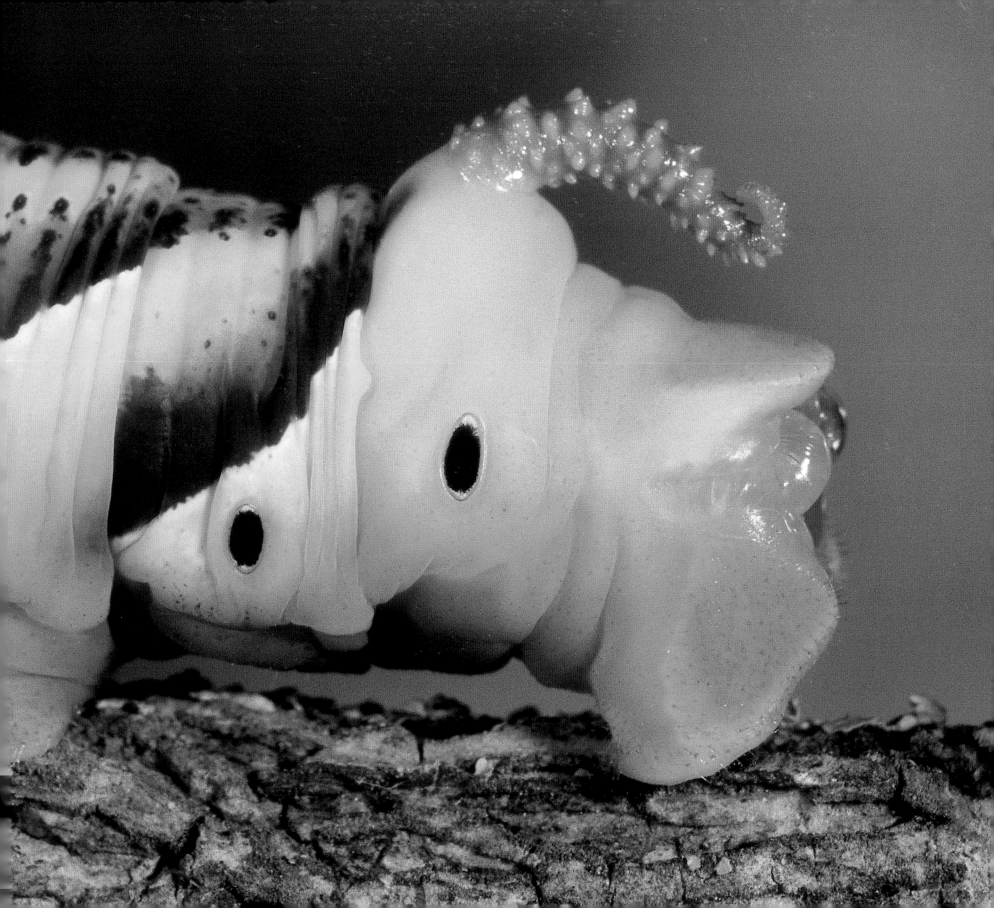

Too Beautiful to Touch

Morpho peleides
Common Morpho butterfly
Costa Rica

The hairs of Morpho caterpillars produce intense irritation. These caterpillars are peculiar in that they are cannibalistic, leading entomologists to suggest that this is an adaptation stemming from a lack of predators, enabling Morphos to keep their population under control.

A caterpillar is not simply a fat, soft worm that inspires more revulsion than desire. Whether glabrous or hairy, they use the whole palette of colors that nature offers to adorn their body, which is divided into thirteen segments. They may be completely camouflaged or brightly colored and bear spines, bristles, or hairs. Some are even sought after because of their beauty, their dazzling colors heightened by tufts of hair or other appendages that may be showy or contrasting.

True Legs Are Used for Eating, and False Ones for Walking

The first three segments of a caterpillar's body constitute the thorax, which is barely separate from the abdomen. Each thoracic segment bears a pair of legs that foreshadow those of the butterfly to be. These true legs, which are simple in structure, play little part in movement: They are primarily used to firmly grip leaves while the caterpillar's formidable mandibles tear them to shreds. The ten remaining segments form the abdomen and bear five pairs of short, fleshy, false legs, called prolegs; the last pair, at the end of the caterpillar's abdomen, are called anal prolegs. The prolegs are equipped with rows of tiny hooks and move in telescopic fashion as muscles extend and retract them; they give the caterpillar excellent grip as it moves along and climbs vertically.

The plump body of a caterpillar is certainly a tempting invitation for predators whose appetites are as sharp as their beaks. For this reason, many caterpillars choose to conceal themselves. Rendered unobtrusive by their dull colors, they do everything possible to pass unnoticed. Some are almost indistinguishable from bird droppings. Those that feed on wormwood flowers resemble them both in pattern and in color. Others mask their vulnerability under a shelter of silk, with which they make their dwelling. Having woven the shelter, they then add various bits of debris collected from their immediate surroundings, which help to camouflage it.

Perfect Imitations

Caterpillars also know how to make themselves invisible through posture and movement. The masters in this field are the Geometridae. When at rest they stand on their anal legs and stick out at an angle; they look exactly like twigs. These caterpillars are also known as measuring worms (Geometridae means "earth measurers") or inchworms because of their looping movement (they are also known as loopers), supposedly measuring an inch each time they progress. This movement occurs because they have only one or two pairs of prolegs: They bring their rear legs all the way up to their front legs, forming an arch, then straighten

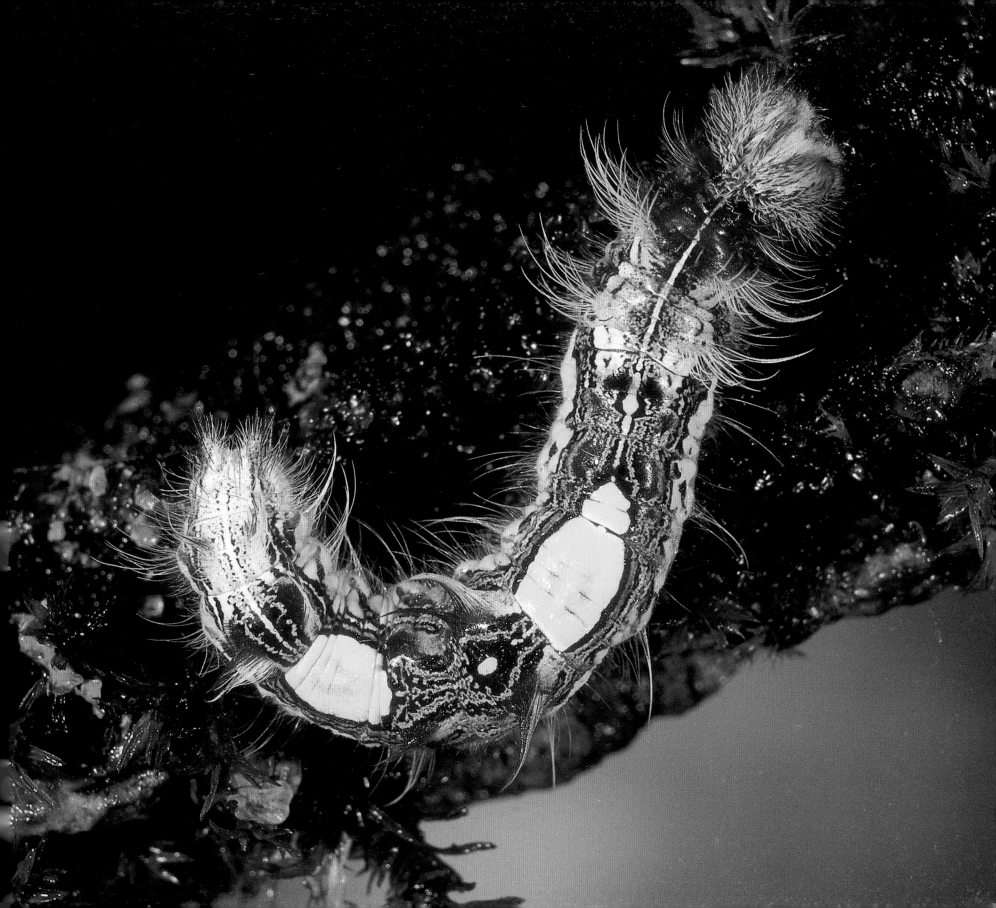

by extending their front legs as far forward as possible. Others do not try to hide but simply disappear the moment they are disturbed: The tiny caterpillars of the *Lymantria* genus are equipped with long hairs that allow them to catch the wind and be carried tens of miles away. By contrast, other species ostentatiously display bright or showy colors. The flashy garb informs predators that the caterpillars are poisonous to eat. These bright colors and contrasting patterns are called aposematic, from the Greek words *apo*, meaning "away," and *sema*, meaning "sign." The brighter the colors, the more memorable they are; the more visible the caterpillar, the more dangerous it is.

Panoplies That Intimidate

The most sophisticated version of this system, true for many caterpillars, involves appearing invisible from a distance but extremely striking at close quarters. They blend into the vegetation, but if an intruder disturbs them they reveal—from inside folds in their skin—filaments, warts, and other swellings that they move vigorously under their attacker's nose, striking menacing poses. The caterpillar of the Death's Head Hawk moth makes a loud noise with its mandibles when it eats, to intimidate potential attackers. If, despite this, it still feels threatened, it contracts its body

suddenly, expelling air and producing a high squeaking sound identical to that of a mouse. A caterpillar that can cry out—that is enough to disconcert the boldest predator. The caterpillar of one Hairstreak species rises up like a little serpent, revealing two large ocelli on the back of its head, which makes a strong impression on an ill-intentioned individual. This technique is at its most highly developed among Swallowtails (Papilionidae family). Its caterpillars have a forked, eversible organ at the back of the head, known as an osmeterium, which secretes a foul-smelling compound to deter antagonists. The larva of the Spicebush Swallowtail (*Papilio troilus*) defends itself with the help of two enormous eyespots. These adornments, besides being vividly colored, often give off a sickening smell, which enhances their repellent effect. If intimidation does not have the desired effect, some caterpillars squirt out a corrosive liquid; others, like miniature porcupines, possess spines that sting and embed themselves in the skin of an attacker, causing a burning sensation like that of nettles.

One for All and All for One

Some species have opted for a communal defense strategy, such as various Processionary moths. So astonishing is their caterpillars' behavior that, unusually, the species takes its name from the

Actias selene
Indian Moon moth
India

Here is the abdominal part of the caterpillar's body, showing the fleshy prolegs. The true legs, which are hard and chitinous and will be retained in the insect's adult form, are attached to the thorax and always number three pairs.

Following page:
Orgyia antiqua
Rusty Tussock or Vapourer moth
France

This caterpillar, which is very common in Europe, is to be avoided at all costs. Its venom glands secrete through its hairs a poison that is intended to deter the curious.

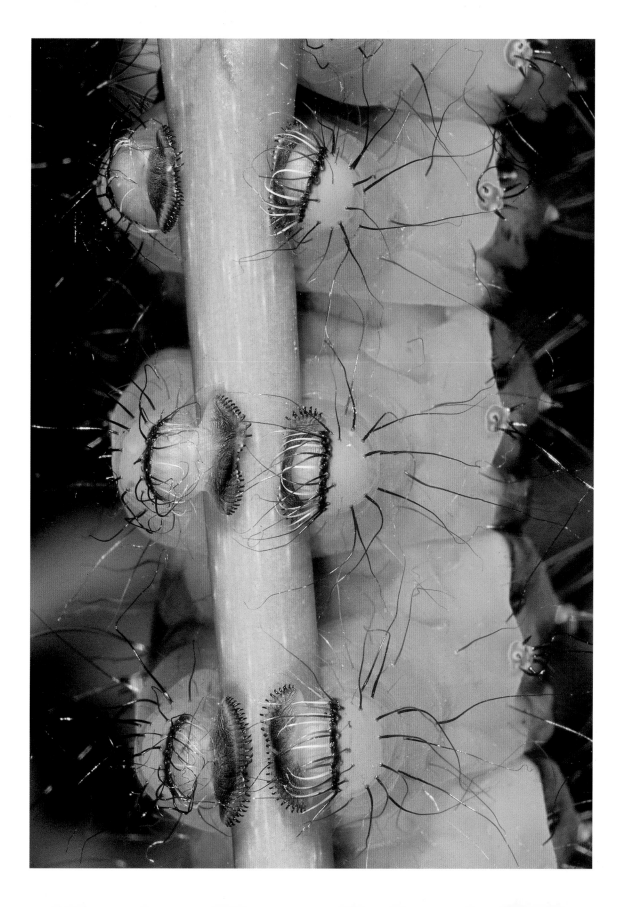

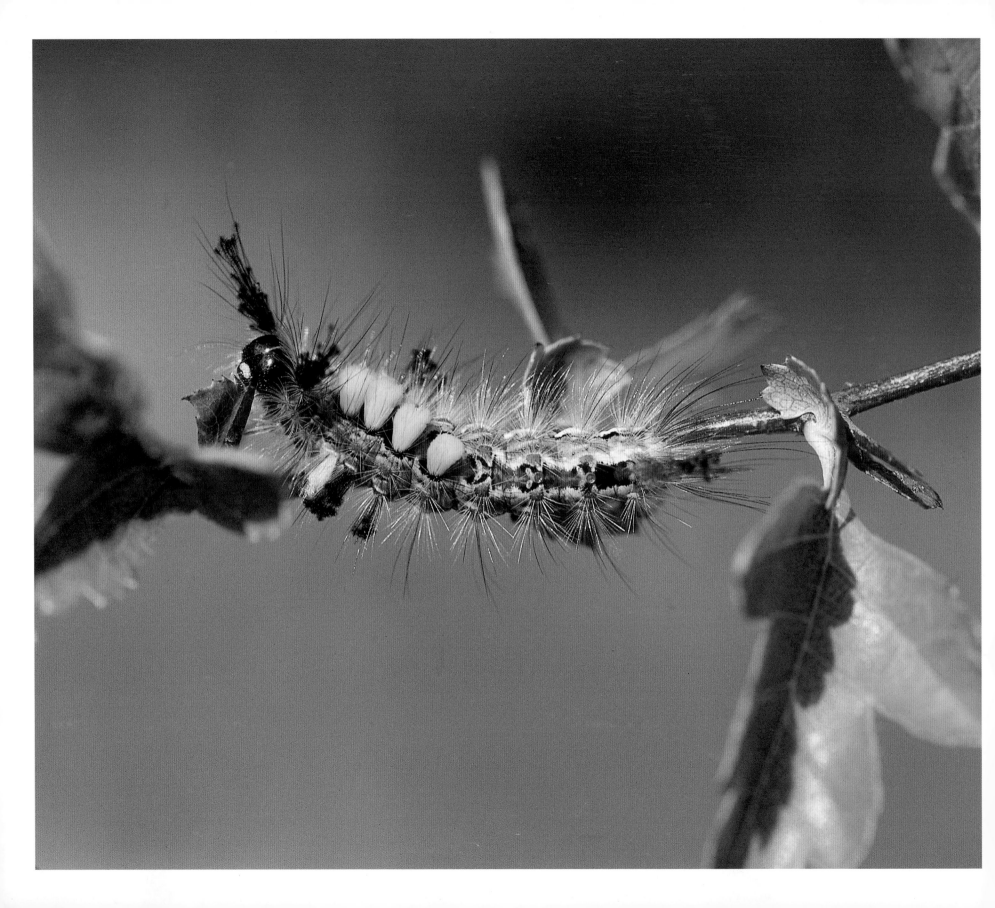

larva rather than from the adult insect. All Processionary caterpillars are moth larvae, and they specialize in living on a particular species of plant—there is a Pine Processionary moth (*Thaumetopoea pityocampa*), an Oak Processionary moth (*Thaumetopoea processionea*), and a species that lives on cherry trees—but all have in common a tribal lifestyle and a peculiar way of moving about. The eggs, laid on the trunks of host trees, produce small, hairy caterpillars. Each possesses a pair of silk glands—actually highly modified salivary glands—and active spinnerets that produce a great quantity of silk, with which the caterpillars weave a sturdy, protective communal shelter. The young caterpillars start by eating their egg coverings, but then they must face the hostile outside world to find sustenance. In the evening, the caterpillars emerge together from their comfortable lair to seek out feeding areas, which they are capable of completely stripping of foliage. The type of procession they form differs from species to species—some move in single file, others have a leader who is followed by two caterpillars alongside each other, then three caterpillars, up to a maximum of eight, in closely packed ranks. They are blind and have no sense of smell, and thus each caterpillar must follow its predecessor

by remaining in immediate contact. If one is removed from the line, the whole line comes to a halt until the missing caterpillar returns. Jean Henri Fabre, a famous entomologist, used a very simple experiment to illustrate the curious behavior of these processions. He made the leader of a procession move along the rim of a tank with a circumference of 4½ feet (1.35 m), until the procession had completely covered the tank's rim, producing an unbroken circle of caterpillars. These went round and round for a week without stopping until, when some caterpillars fell to the ground exhausted, the line was broken and this strange perpetual motion was brought to a halt. When they are not the plaything of curious researchers, these caterpillars take turns leading the procession. They find their way back home to their communal shelter with the help of silk threads that they spin with every step they take—like the thread of Ariadne, which led Theseus out of the labyrinth, the caterpillars' silk stretches from their nest to the feeding site.

This extraordinary behavior might seem like an irresistible magnet for predators, who could eat their fill if they came upon such a procession. However, the caterpillars have more than one trick hidden under their silky cloaks. The hairs on the caterpillars' backs are

Geometridae family of moths
France

Thanks to its perfect camouflage, this slim, brownish caterpillar passes unnoticed. With just two pairs of prolegs, these caterpillars have a particular way of moving that has earned them the name "measuring worms" or "inchworms." Their resemblance to a young twig of their host tree and stillness at the first hint of danger are their best defenses.

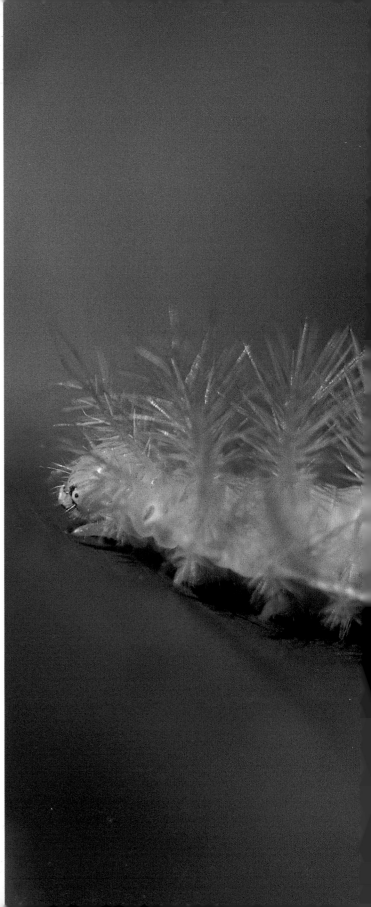

Automeris sp.
Brazil

One should not be deceived by the handsome, delicate green of this shaggy moth caterpillar: Each bristle is an offensive weapon, filled with poison.

sensitive, and when touched the folds of the larvae's skin open to reveal warts covered in stinging hairs, with barbed ends like harpoons, which are connected to poison glands. Each wart is surrounded by long-branched hairs which, when touched, eject the poisonous silk hairs. These tiny darts, laced with cyanidelike compounds, enter the skin and produce intense burning and tissue necrosis that can lead to coma or even death in an animal as large as a dog. These harmful insects have even been blamed for the deaths of young children who were attracted by their silky beauty. In short, it is important to beware of these strange creatures. Thanks to their formidable defenses, the caterpillars have become increasingly invasive and are a veritable scourge in forests. They can even sense when a storm is coming and troop back to their protective shelter.

Beware of Those Smaller Than You

All these caterpillars seem well defended against attacks by predators. However, the biggest threat they face does not come from creatures larger than themselves. The most deadly fate that can befall them comes from tiny wasps, whose larvae grow within the caterpillars' very bodies—predation is less

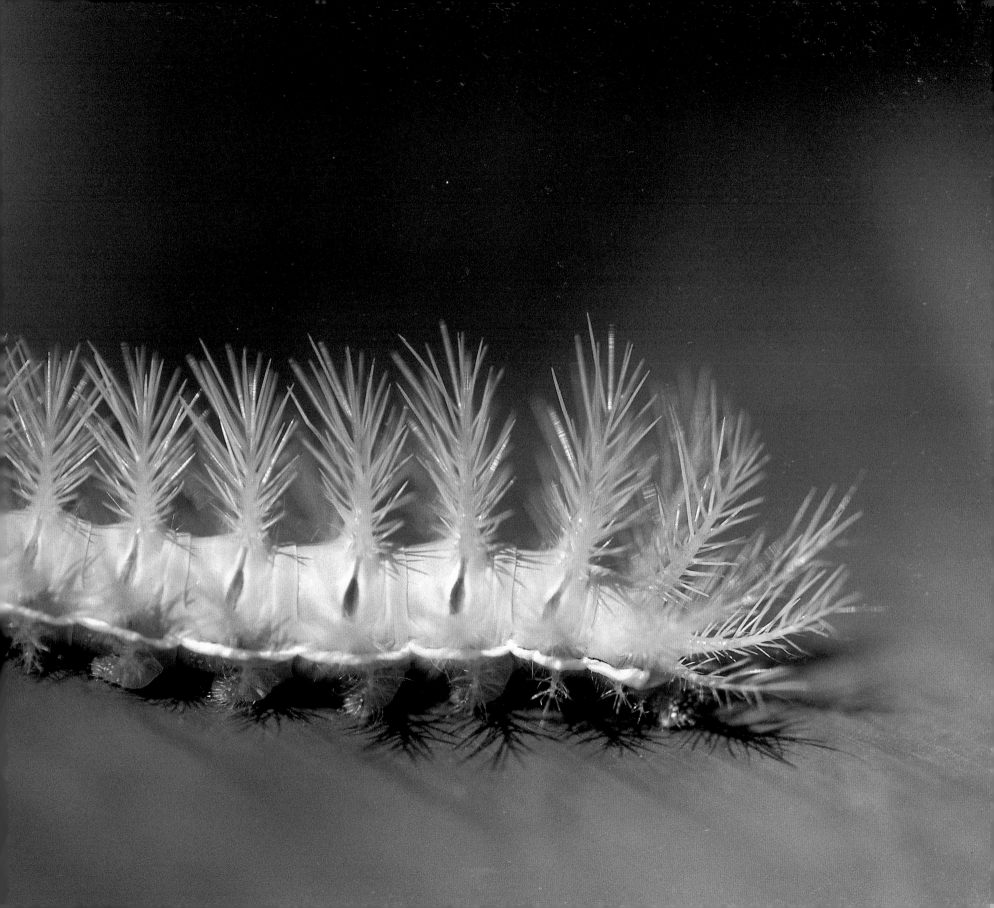

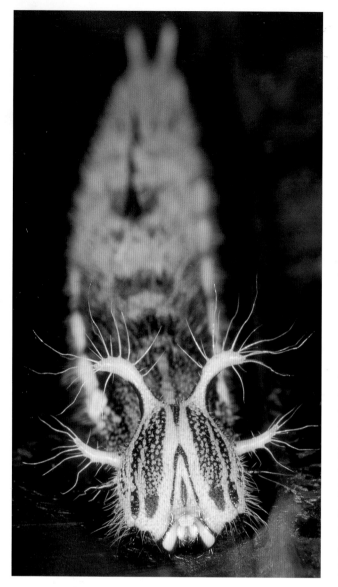

Caligo sp.
South America

This caterpillar, with its highly ornamented head, will change into one of the most unobtrusive of all adult butterflies.

of a threat than parasitism. Attracted by the caterpillar's smell, the wasp pierces the caterpillar's protective cuticle and lays several eggs. Its larvae grow by devouring the caterpillar from within. Once fully grown, they leave the hapless insect's body and metamorphose into adults, remaining attached to its back until they finally take flight. A caterpillar thus stricken dies before reaching adulthood. The young parasitoid larvae start by eating the host caterpillar's fat reserves and muscle, taking care to leave its vital organs untouched. The caterpillar enters a sort of lethargic state but continues to feed. When the parasite larvae are almost fully grown, they attack the vital organs, killing the caterpillar once they no longer need it. The strangest and most fascinating part of this odd form of parasitism is that the wasp, to succeed in its mission, needs the help of a completely unexpected partner. If it simply injected its eggs into the caterpillar's body, the latter's immune system would soon destroy them, and the wasp's efforts would be in vain. For this reason it injects, at the same time as its precious eggs, a large quantity of a virus that destroys the caterpillar's immune defenses, leaving it completely powerless in the face of the parasites' invasion. The virus produces a phenomenon identical to the effects of HIV in humans: Infected lymphocytes first clump together and then destroy themselves. What is

most astonishing is that the wasp and virus share DNA sequences: The proteins coded by genes in the virus' DNA are found notably in the wasp's venom, indicating close coevolution. The wasp is first attracted to its host by the plant on which the caterpillar feeds: As it is devoured by the caterpillar, the plant sends out an olfactory distress signal, which the wasp perceives. Nature still has plenty more to teach us.

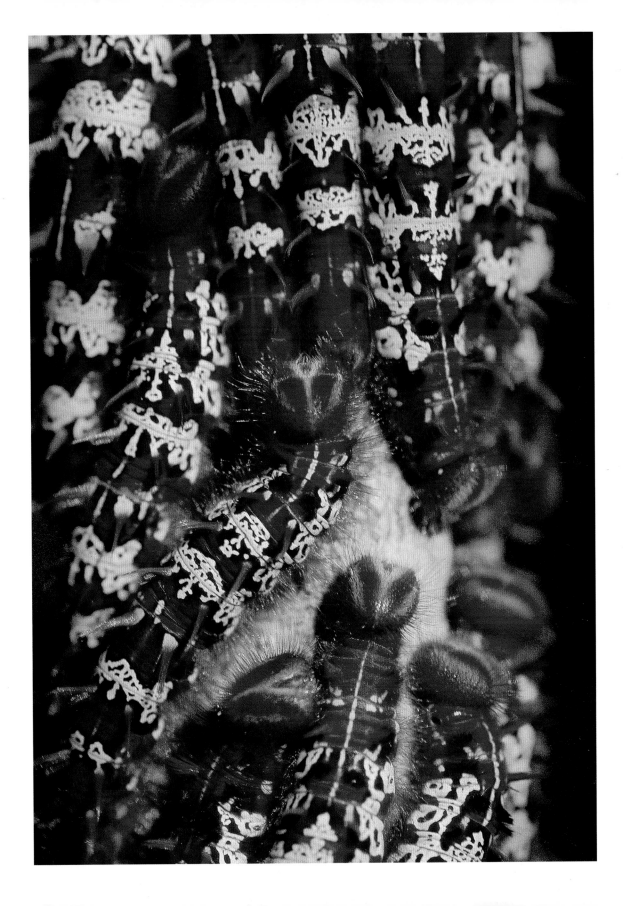

Morpho telemachus metellus
Amazon rain forest, Brazil

These butterfly caterpillars gather into
swarms when they rest. Their stripes and
pattern of grouping make them resemble
an orchid. Touching them, however, is out
of the question.

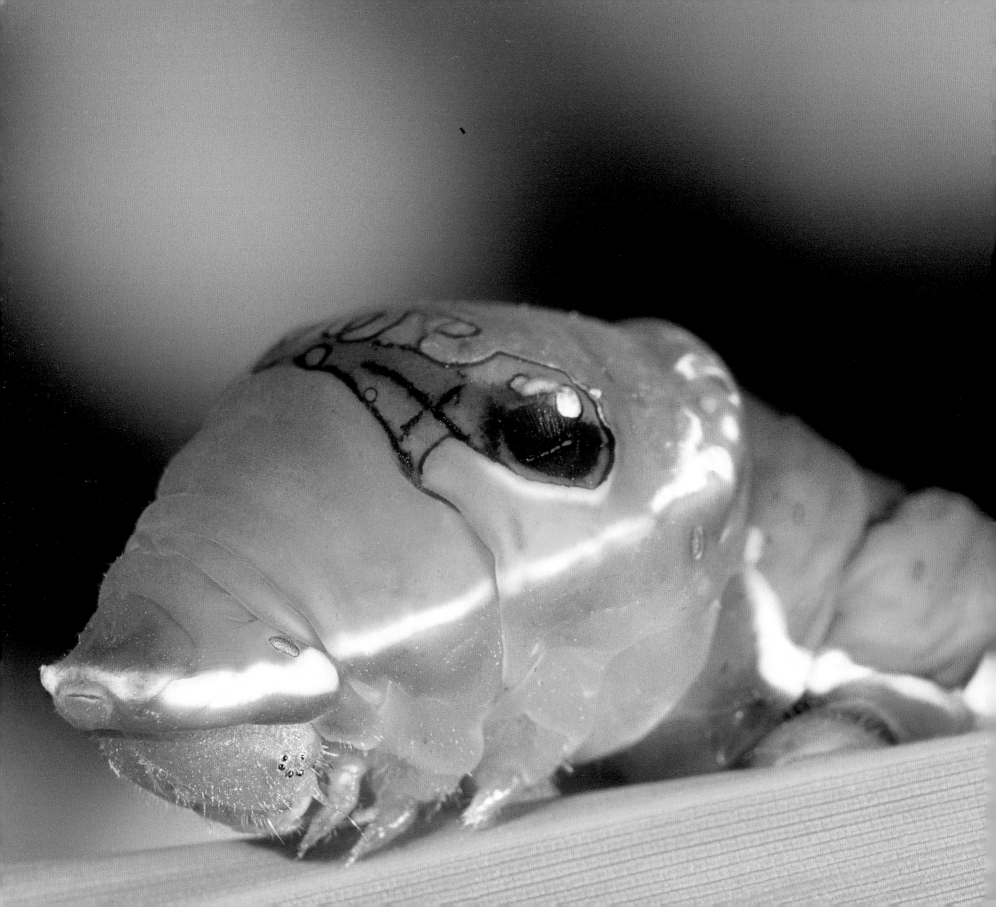

Papilio sp.
South America

When they feel threatened, caterpillars belonging to the Papilionidae family, the Swallowtail butterflies, unsheathe a soft, orange-colored, forked organ, which gives off a strong smell to deter predators. Called an osmeterium, it is situated just behind the head.

From Caterpillar to Butterfly

Limenitis reducta
Southern White Admiral butterfly
France

Suspended from the empty casing of its pupa, this handsome butterfly is slowly drying its new wings.

The butterfly or moth is only the final of four different forms that the insect takes during its development—this adult is called the imago. Before attaining this perfection, which is often short-lived, the butterfly must pass through the successive stages that often make up most of its life span.

Everything begins with an egg—or rather, with the laying of a number of eggs. Depending on the species, these may be laid separately or in a mass, on one specific plant species or at random, in which case the caterpillar will feed on a vast range of plants. From these eggs attached to plants little caterpillars are born. The incubation time varies, depending on the ambient temperature and humidity.

The process thus described is widespread in the animal world—it is after hatching that all the magic of the insect world is revealed.

Changes of Skin for Fat Babies

An insect's juvenile form is completely different from the adult, both in its appearance and in its lifestyle. Between the larva, which is known as a caterpillar in the Lepidoptera, and the adult insect comes an intermediate stage: the pupa.

When it hatches, the little caterpillar emerges, gnawing at the covering of its egg after having partly dissolved it with an acid substance, and then bursts it by means of muscular contractions. In some cases, its task is made easier by a cuticle with toothlike protrusions. The caterpillar then sets about growing; but, being endowed, like all insects, with an external skeleton, it cannot do so continuously because it soon finds itself constrained by its protective outer covering. It needs to molt. Each time this happens the inner layers of its exoskeleton dissolve and a new, larger outer covering is formed underneath the previous one. The insect then swells up by contracting its muscles, or by absorbing air or water, and bursts its old skin. It remains in its swollen state until the new skin has hardened. Only then can it expel the air or water, and resume growing in the increased space available to it. These molts are the only times in the caterpillar's life when it stops eating. Each, however, is followed by a renewal of its appetite.

This life cycle in stages may seem limiting, but it endows insects with remarkable powers of adaptation, which have allowed them to become astonishingly widespread and conquer the entire world. Butterflies and moths are part of a class of

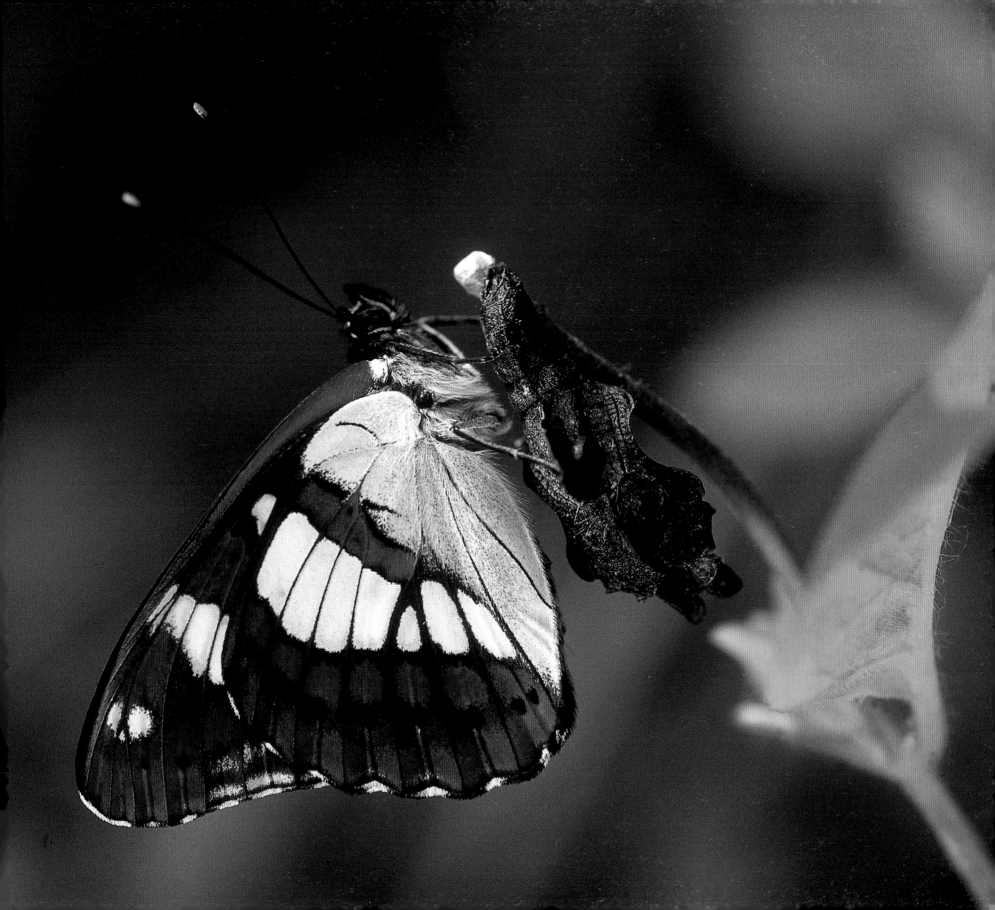

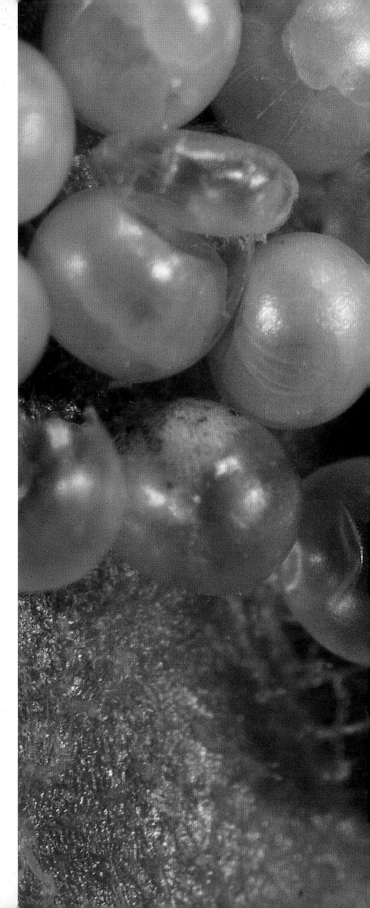

Manduca sexta
Carolina Sphinx moth
or Tobacco Hornworm
South America

This minute caterpillar has just hatched
and has not yet had time to devour its
own egg covering. It will grow rapidly in
stages, regularly molting and leaving
behind its old skin. Each time this happens,
the caterpillar is particularly vulnerable.

highly developed insects known as
holometabolous insects, which undergo
a complete transformation between their
juvenile and their adult states. The inclusion
of a pupal stage allows the larva and the adult
to specialize in very different areas. Typically,
in butterflies and moths the caterpillar devours
vegetable matter (and sometimes animal matter,
as in the case of Tineids, as discussed above).
The adult, on the other hand, feeds on nectar,
a substance that is totally inaccessible to the
larva. However, although the adult has access
to resources that are out of the reach of the
larva, the latter is more resistant to unfavorable
conditions and can burrow to seek shelter and
await the return of fine weather.

Feverish Metabolic Activity in a Motionless Body

The last larval stage, following the last molt,
is transformed into a chrysalis. During this
stage the insect is immobilized and cannot
feed or move about, but great upheavals are
taking place within. During this stage the
organism undergoes a complete structural

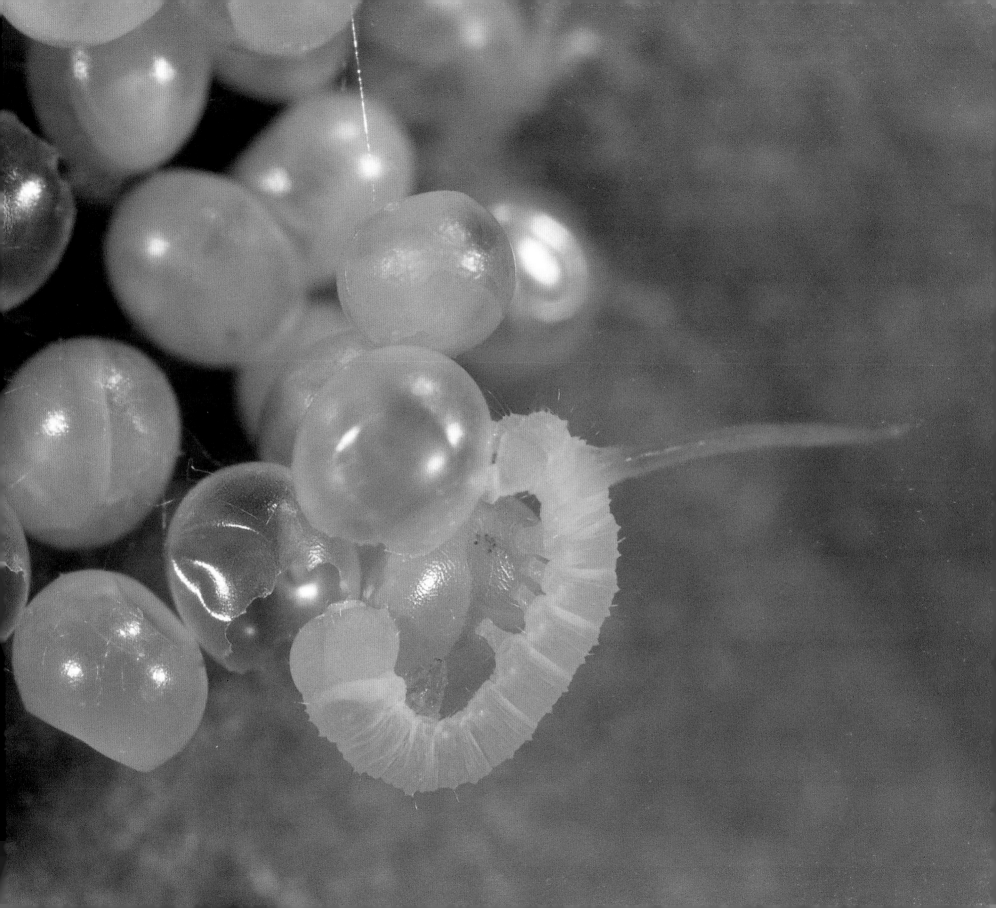

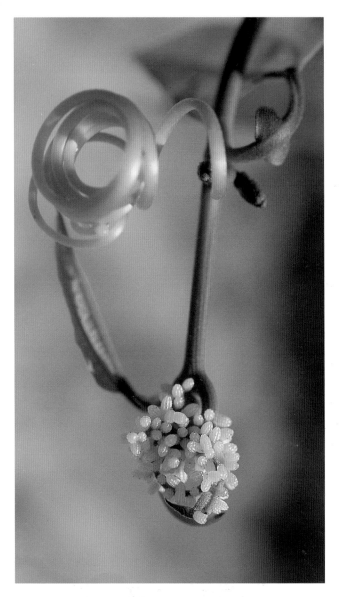

Heliconius sara

Sara Longwing or Small Blue Grecian butterfly
Suriname

The eggs of Lepidoptera can take many forms. Viewed under the microscope, these small golden pearls reveal very delicate marks on their surface, which make them look like veritable jewels of nature.

reorganization of its external and internal organs, in its whole appearance as well as in its physiology. The creature that will emerge will be the perfect adult insect; it will neither grow nor undergo any more significant changes for the rest of its life.

This transformation involves two stages: first, the destruction of the larval tissue, and then reconstruction of adult tissue from the mass of embryonic cells called imaginal discs. These changes are genetically predetermined and must follow an exact sequence, coordinated with clockworklike precision. Following the principle that "nothing is created, nothing is lost, and everything is transformed," it is clear that the cells found in the successive stages of a butterfly or moth's life cycle contain the same genetic information. There is therefore a sort of biological clock that activates, in the correct order, the various groups of genes responsible for these changes. This process is regulated by hormonal mechanisms, which are in turn triggered by outside factors such as length of daylight, temperature, and the maturity of the plants consumed.

Hormones—The High Priests of Metamorphosis

The entire process of transformation from caterpillar to butterfly is controlled by hormones. The caterpillar grows and undergoes regular molts, which are controlled by the molting hormone. These are secreted by glands in its thorax, which are themselves activated by neurosecretory cells in the caterpillar's brain. The other very important hormone, which controls general development, is the juvenile hormone. This is made in a region just behind the brain and is the substance that causes the caterpillar to grow. Its action ensures that the larval structures are retained. Its concentration is progressively reduced with successive molts, so that its effects are gradually lessened. At the end, when its concentration is very low, the molting hormone becomes dominant, and with the following molt the caterpillar becomes a chrysalis.

Tithorea harmonia
Suriname

The adult butterfly's organs can be dimly discerned through the chrysalis' translucent skin. A phenomenal upheaval is happening within this tiny world, which is closed and protected but continues the exchange of gases with the exterior that is necessary for respiration.

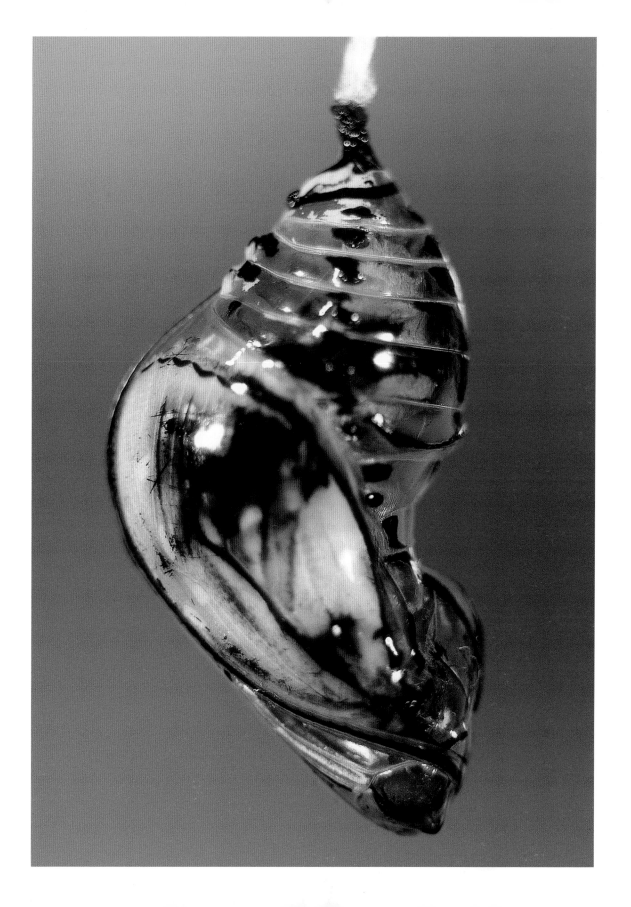

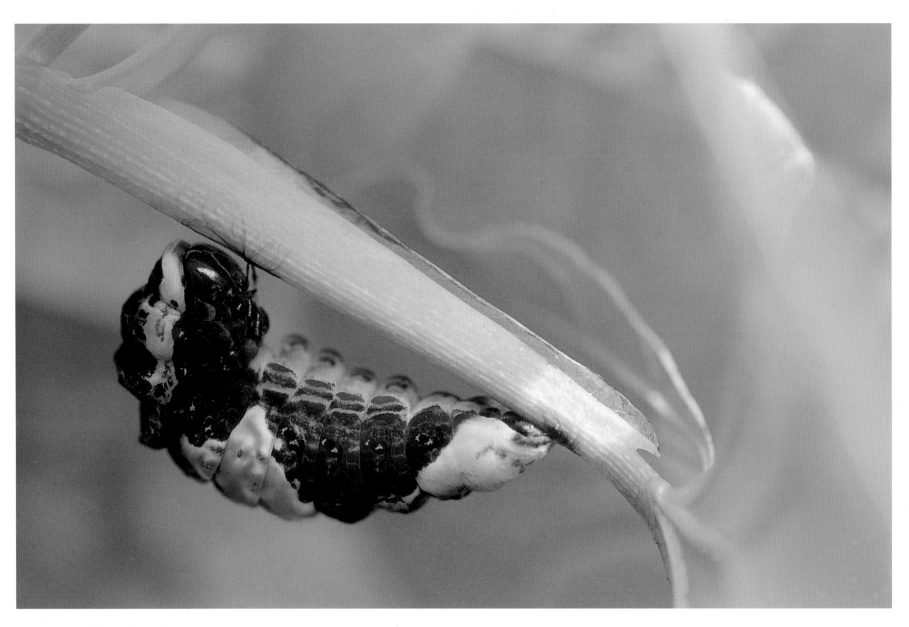

Heraclides thoas
Thoas Swallowtail butterfly
Suriname

When the caterpillar is ready to pupate, it
stops feeding and seeks a suitable place
to undergo its metamorphosis. This must
be chosen carefully, for it is also where
the adult will emerge and spend its first
few, most vulnerable hours, drying itself
before taking flight.

Archaeoprepona demophon
One-Spotted Prepona butterfly
or One-Spotted Leafwing
Suriname

Although seemingly inert, the pupa is an
extremely important stage in the butterfly's
development. Within the chrysalis, a total
transformation and reorganization of the
butterfly's organs is taking place, which
will turn a plump caterpillar into an elegant
butterfly.

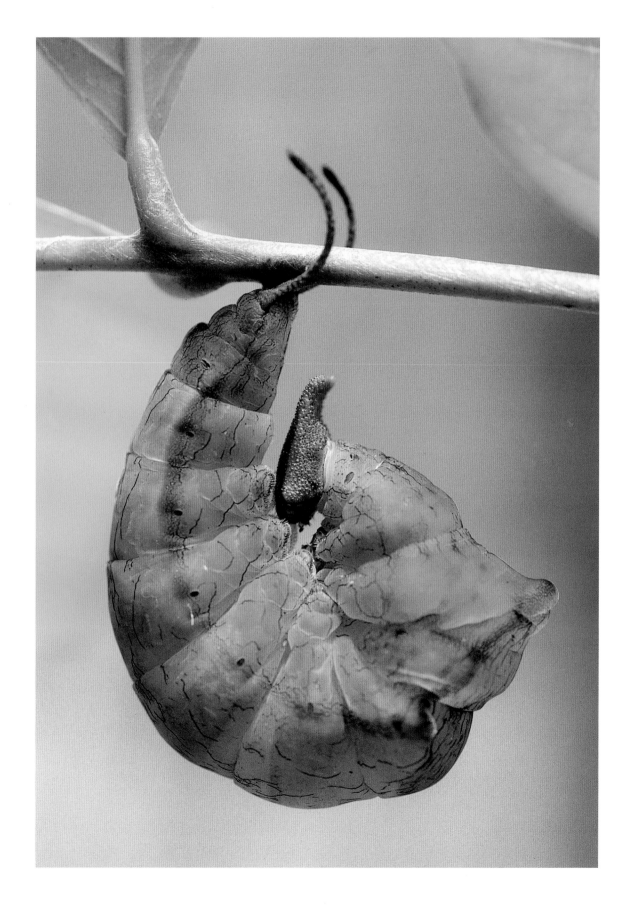

Papilio machaon

Old World Swallowtail butterfly
France

The insect on the chrysalis (a member of the large Hymenoptera family, which includes wasps, bees, and ants) is a parasite of butterflies and moths. The adult female searches among flowers and plants for a suitable prey—preferably a chrysalis—into which she lays her eggs. When they hatch, the larvae will feed on their host, eating nonvital organs first in order to let it stay alive as long as possible, so that they can develop fully. When they are almost adult, they will devour the butterfly's vital organs, killing it.

Life in Slow Motion, Awaiting the Return of Fine Weather

This complex mechanism is, in fact, even more sophisticated than it might at first appear. The life cycle of some butterflies and moths also includes a period of rest, called a diapause, during which they become dormant and nothing happens. During this sleeplike period, which can last up to eight months, the insect's heart continues to beat, it consumes oxygen and produces carbon dioxide, but all its metabolic processes are reduced almost to zero. At this point, the larva's metabolic rate is about one 2000th of that of the adult insect. The diapause may be caused by unfavorable environmental conditions, or it may be an integral part of the insect's life cycle. In either case, its purpose is to hold off on reproduction until conditions are more favorable to hatching larvae. Some species produce only one generation per year, such as the Silkworm moth, whose larvae all hatch in the spring. Other species produce several generations per year. Eggs laid in summer produce adults that do not undergo a diapause, whereas those laid before the winter produce adults that spend the cold season in diapause before laying their eggs, which hatch the following spring.

Whether a female lays eggs that go into diapause or not depends on the conditions in which she developed as a very young larva, or even when still in the egg. Thus, females that began their development when the days were short, in the fall, lay eggs that develop immediately. Those females that hatched in the spring, when the days are long, lay eggs that will not develop until the following spring, after undergoing a diapause. The stimulus that directly causes different types of egg to be produced is controlled by a neuro-hormone in the female, which acts upon the eggs before they are laid. It appears that a hormone produced by the cells in the intestinal wall of these insects is at the root of these phenomena of photoperiodism and diapause. This hormone is believed to influence the neurosecretory systems in the brain.

In some butterflies, such as the Map butterfly (*Araschnia levana*), the adults that come from generations that underwent a diapause—that is, hatched in spring— are so physically different from those that did not (those hatched in summer) that for a long time they were considered to be different species.

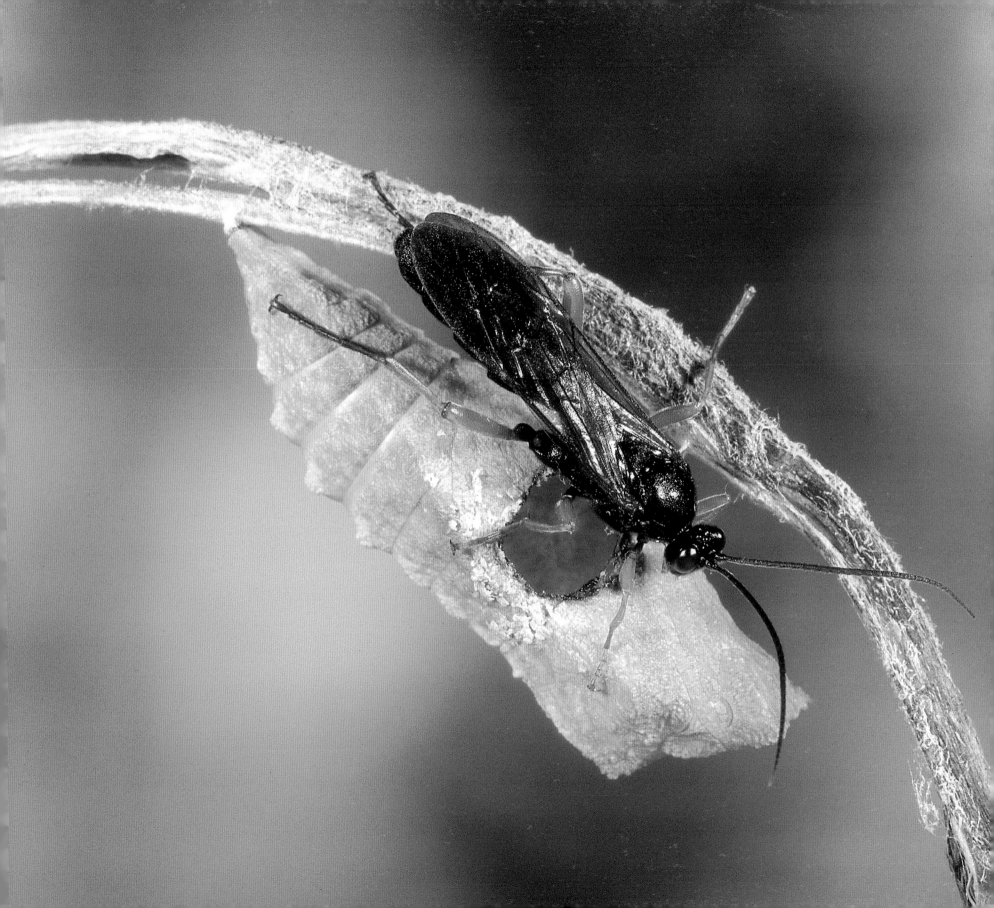

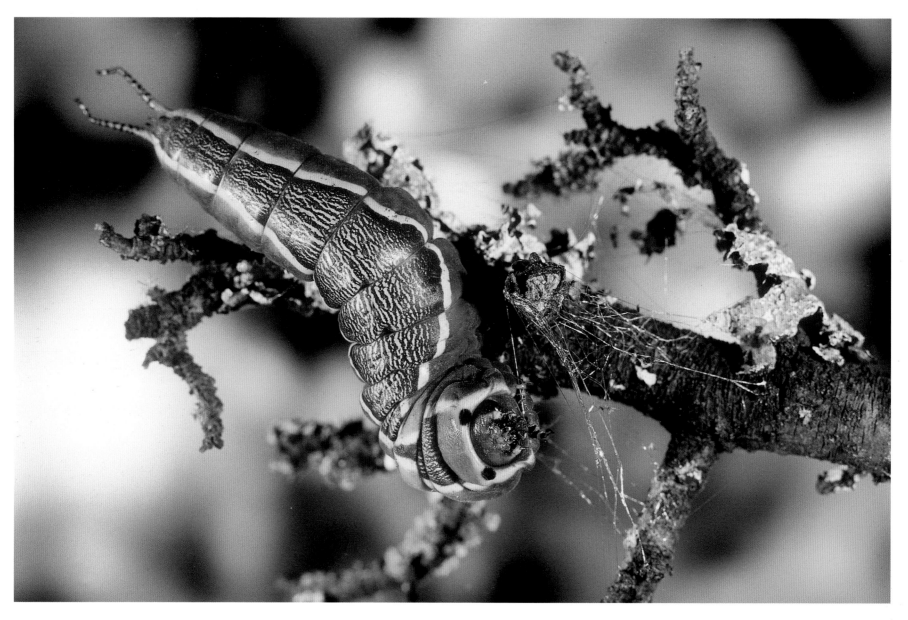

Cerura vinula

Puss moth
France

Upon reaching maturity the caterpillar stops feeding and seeks a suitable place for it to pupate. It then empties its stomach, attaches itself to its support by means of robust silk threads, and takes on an unobtrusive coloring, which allows it to escape the notice of curious eyes. Some species spin silk cocoons.

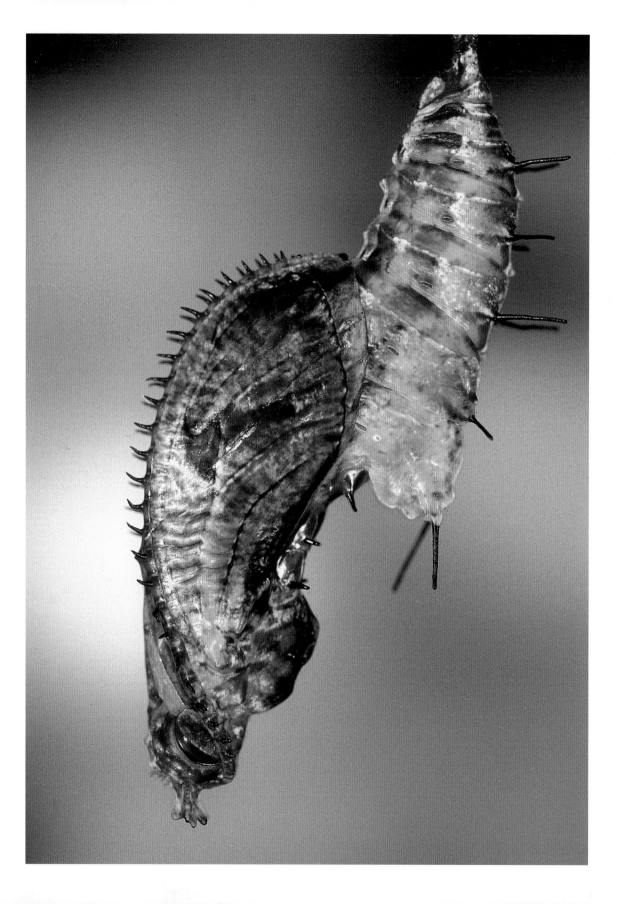

Heliconius melpomene
Postman butterfly
South America

Butterflies and moths are holometabolous—
they undergo a complete metamorphosis,
and the larva bears no resemblance to the
adult. Between the larval and adult stages,
the pupal stage allows a total reorganiza-
tion of the insect's anatomy. Among
hemimetabolous insects, such as
grasshoppers or cockroaches, the larva
resembles the adult, and its metamorpho-
sis is gradual.

Each Gene Has its Say

The way metamorphosis takes place in insects suggests that different groups of genes are being activated at different times in an individual's life. Thus larval, pupal, and imaginal stages differ, according to which of these gene groups is being activated or inhibited. Three hormones are involved in the growth and metamorphosis of these insects. A neurosecretion in the brain, called brain hormone (BH), triggers the secretion of molting hormone (MH). The latter favors growth and the development into an adult. Juvenile hormone (JH) causes larval characteristics to be retained. Growth and transformation from larva to adult insect are the result of the interplay between these two hormones. Scientists have dissected butterflies of all kinds to try to solve this mystery. In the process, they have identified the glands that produce these different hormones and have been able to vary their proportions. They have also succeeded in preparing purified extracts of juvenile hormone using dried insects taken from museums, for this hormone is extremely stable. Through many experiments, they have established that it is possible to produce small pupae and dwarf adults by suppressing juvenile hormone from the early stages of a caterpillar's life. Conversely, it is also possible to produce giant caterpillars, pupae, and adults by prolonged exposure to juvenile hormone. Normally, the level of juvenile hormone in the blood falls with each molt, gradually allowing the molting hormone to take effect. The glands that produce juvenile hormone come from surface cells located by the mouthparts. They clump together and then migrate toward the rear of the body. These glands undergo rapid autolysis when metamorphoses are over and are thus not found in the adult insect.

Inside the chrysalis, the fat reserves accumulated by the caterpillar are used for the development of adult characteristics. The characteristics typical of the adult, such as wings, mouthparts, reproductive organs, and jointed legs, are already present in the larva as imaginal buds, awaiting the right conditions to develop fully.

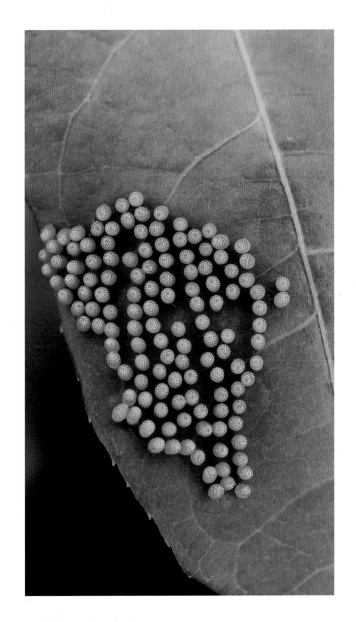

Heliconius doris
Doris Longwing or Doris butterfly
Suriname

Butterfly and moth eggs have numerous predators and parasites. The parasites include the smallest known insects, notably the Mymaridae, a family of tiny wasps with downy wings and a span of less than 2 millimeters.

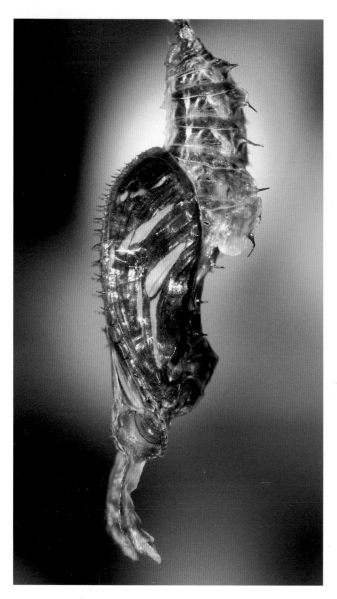

Heliconius charitonia
Zebra Longwing or Zebra butterfly
South America

This outwardly static stage in the butterfly's life conceals a total upheaval in the larva's organs, which is triggered by juvenile hormone and by external stimuli such as temperature and length of daylight.

Rebirth Produces a Perfect Insect

When it breaks out of the skin of the chrysalis, the butterfly experiences a second hatching. The epidermis splits along precise lines of fracture, and the insect immediately ingests air, which partly fills its digestive tract. It emerges, head down, first freeing its legs and antennae, before carefully pulling clear the rest of its body. When the butterfly first emerges, its wings are soft and crumpled. As a caterpillar, it most likely chose to pupate in a spot favorable to taking flight as an adult. When it emerges, it will often remain motionless for a while, suspended from the skin of the chrysalis. Now it must unfold its crumpled wings. The pressure of blood flowing along the hollow nerves causes the wing membranes to gradually lose their creases, and the wings spread fully. The butterfly takes care to spread them widely, so that they dry fully and harden in the air—the insect must wait for its wings to dry before it can take flight and begin its adult life. As it waits, the butterfly expels its meconium, which presents a very odd spectacle for the unprepared observer. This red or sometimes orange liquid is thin and opaque; it looks like blood, but it is actually waste material.

This second hatching leaves the butterfly or moth extremely vulnerable. However, the emergence from the chrysalis always takes place under the most favorable conditions. Moths come out at twilight, whereas butterflies usually emerge in the morning, so that they can make their maiden flight in optimum conditions. Cold, rain, and strong wind often delay the final birth of these beautiful insects.

Dryas julia

Julia Heliconian or Julia butterfly
Suriname

This lovely tropical butterfly is finishing
drying its long, elliptical wings in the sun.

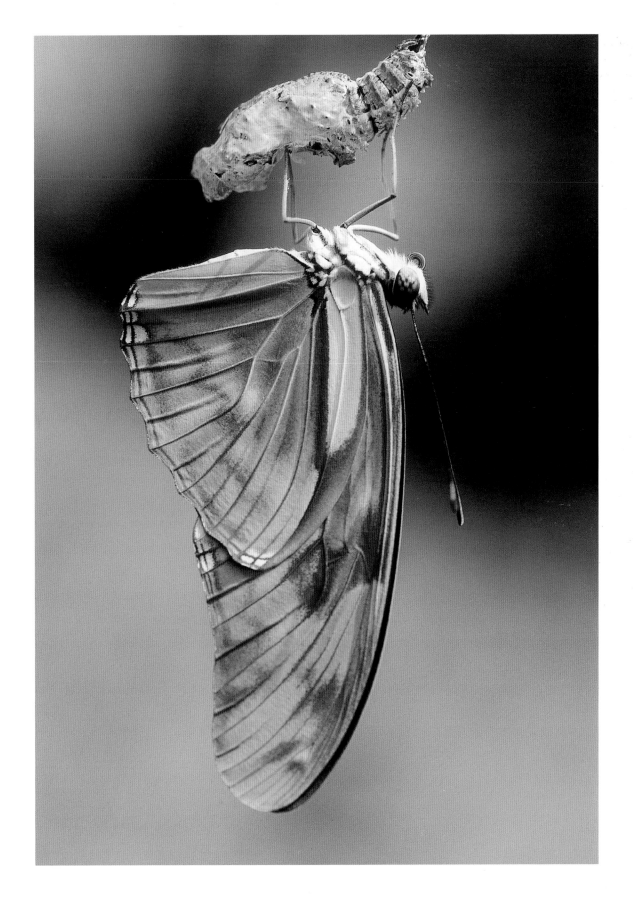

Charaxes jasius
Two-tailed Pasha butterfly
France

The adult, also known as an imago, swells
its body by taking in air, in order to split
open the pupa's outer covering. It can
then extract itself cautiously. Its wings are
damp, soft, and fragile, and it must remain
suspended vertically beneath its chrysalis
for some hours before they dry and take
on their final shape. Only when this ritual
is over can the adult take flight and
embark on its short life of courtship.

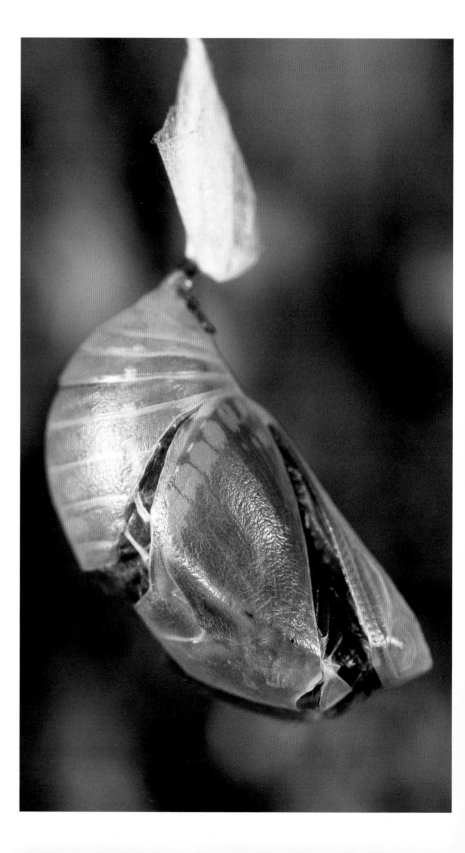

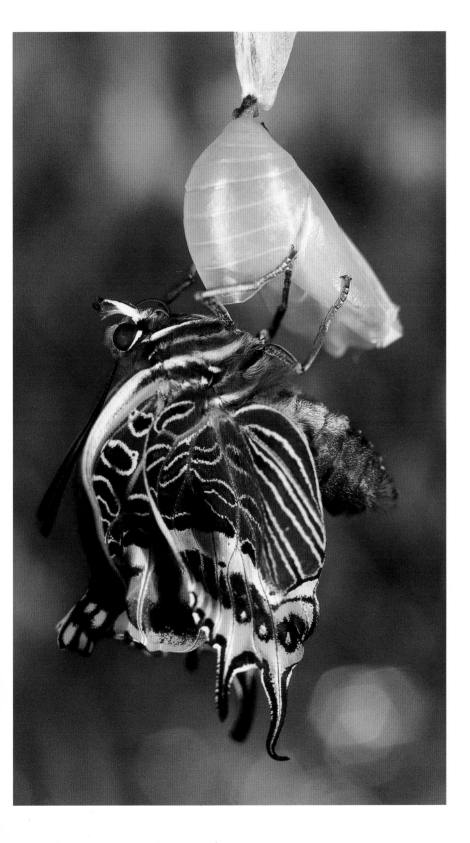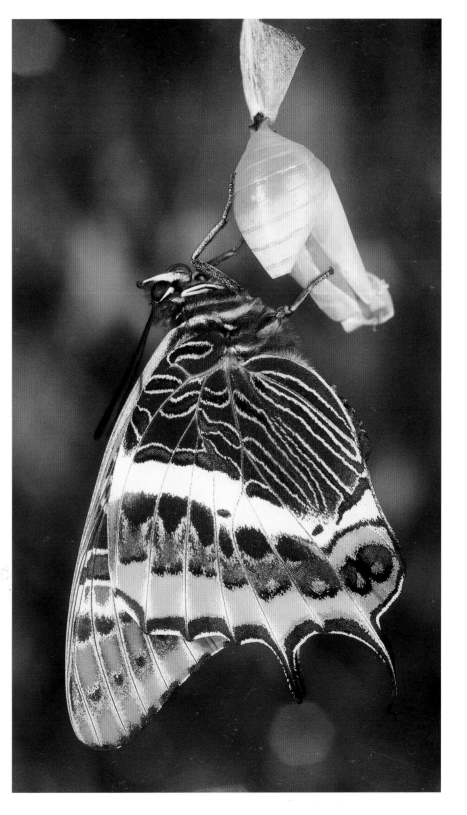

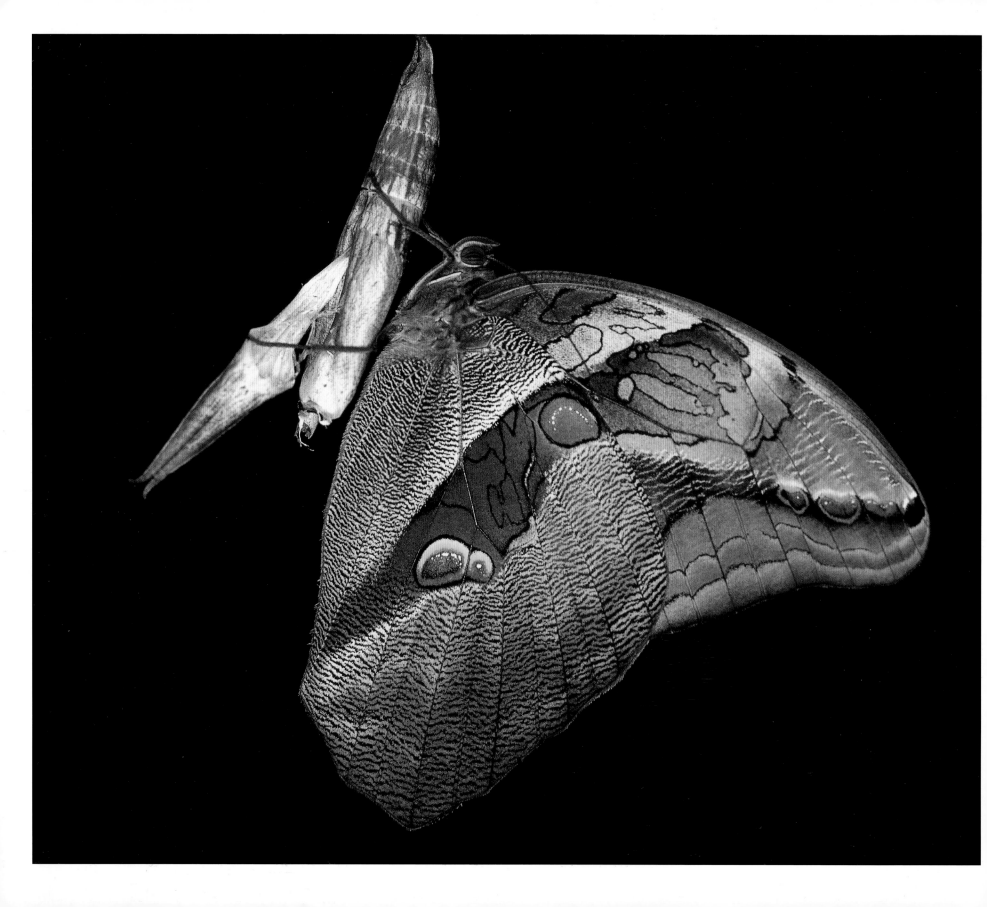

Opposite:

Eryphanis polyxena
Purple Mort Blue butterfly
French Guyana

The butterfly's four wings are covered with
a network of rigid nerves, which brace the
membranes covered with colored scales.
At the very start of the adult's life, these
nerves allow the circulation of both air
and blood. However, the tips of the wings
harden rapidly, preventing all circulation
and allowing the insect to fly.

Argema mittrei
Madagascar Moon moth
or Giant Comet moth
Madagascar

When it emerges from the pupa's outer
covering, or shortly before it takes flight,
the moth ejects meconium from its anus.
This liquid, which is often red, gives the
impression that the insect is bleeding.

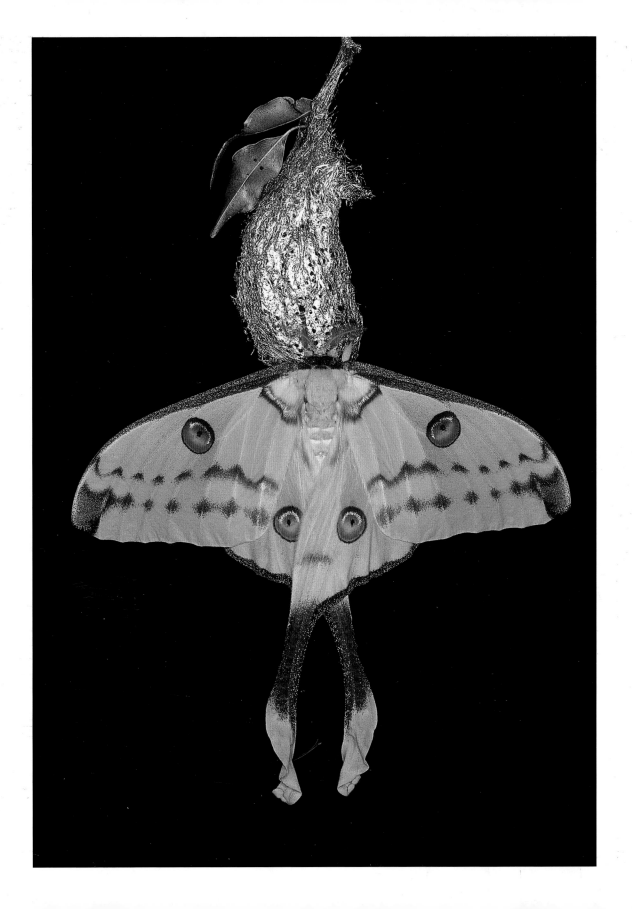

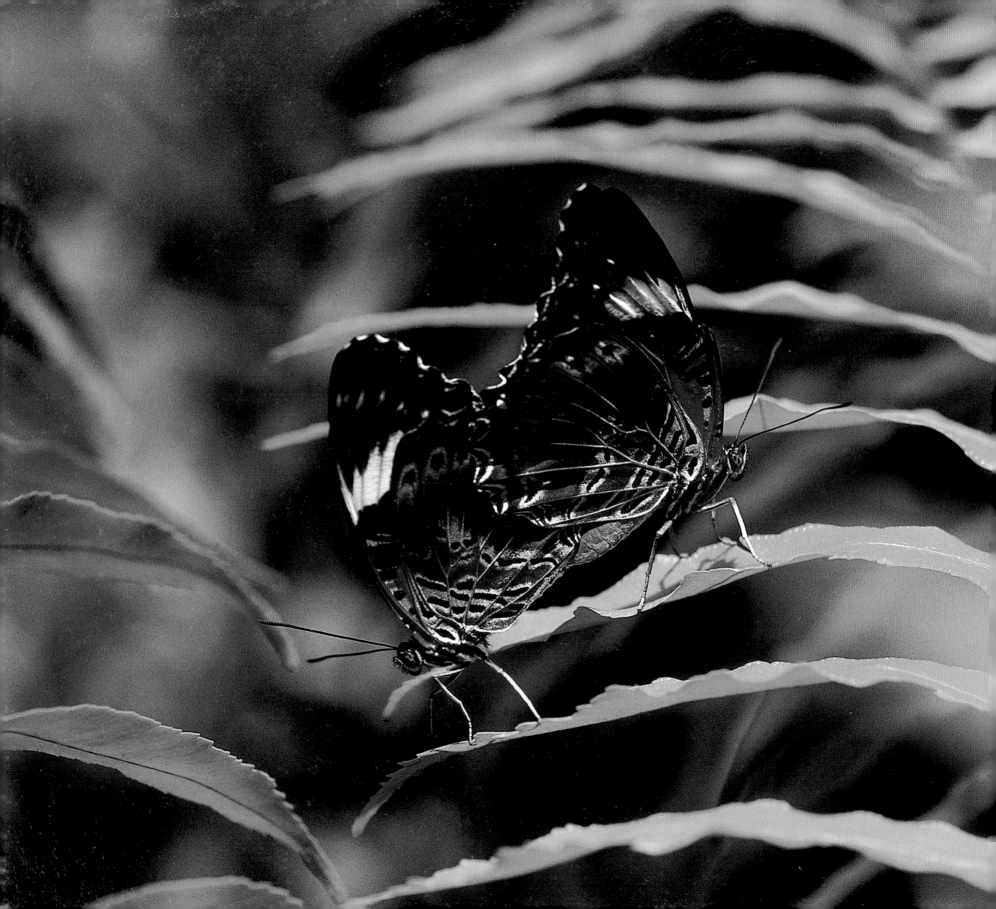

The World of Butterflies and Moths

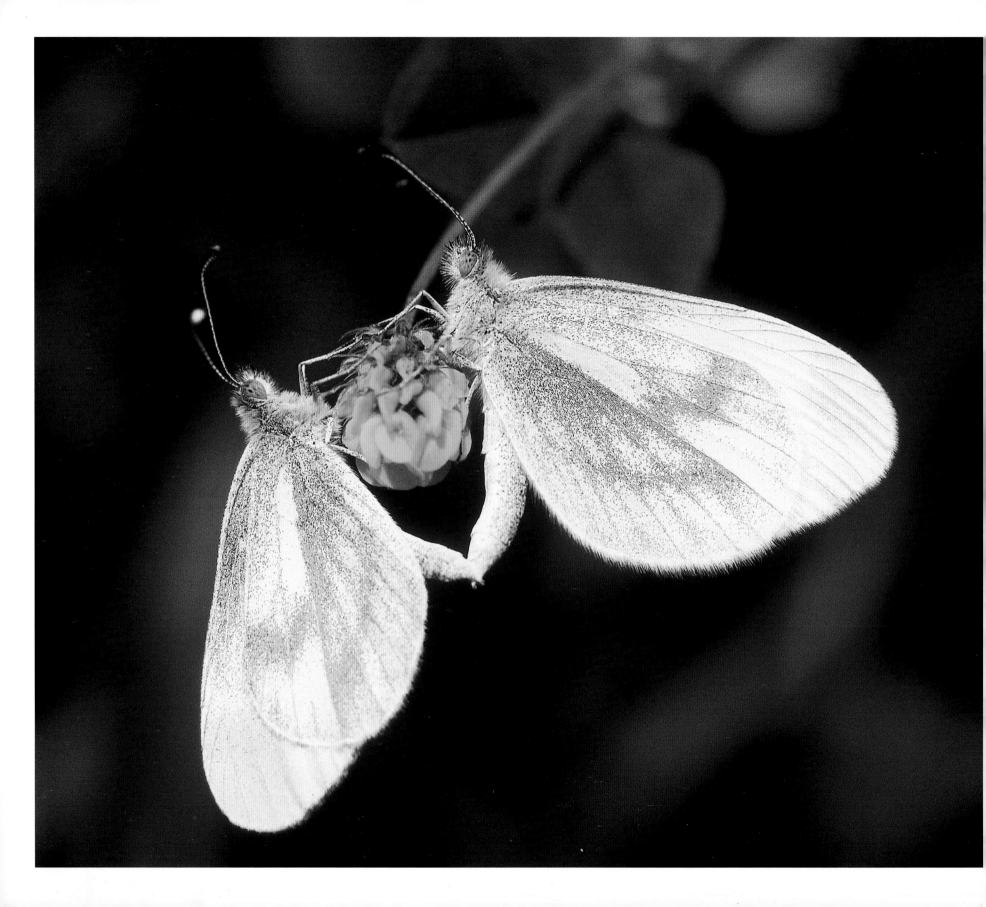

The World of Butterflies and Moths

These unique creatures have fascinated humans since the dawn of time. A butterfly's fluttering flight is as much part of the warm days of summer as a bird's song is part of a spring morning. Delicate and luminous, graceful and mercurial, the butterfly possesses innumerable facets, and it is a living jewel that tempts human greed. Its fragile beauty has inspired poets, painters, and photographers. Its remarkable complexity has defied engineers and researchers, mocked military genius, and excited the curious.

This elusive creature, which takes on different bodily forms for different functions, is endowed with an adult body entirely devoted to mating. To seduce its mate, the butterfly has developed an armory that would make Casanova turn pale. A master in the subtle art of chemistry, it concocts perfumes that send out a sexual message, which it disseminates by means of wingbeats or can detect at a distance of many miles with its feathery antennae. It is helped in this by senses more acute than any found in mammals.

Some butterflies and moths rival birds in their ability to migrate over several thousand miles. However, although there are innumerable species, as a whole these resemble each other in both appearance and habits. Their formidable diversity masks an incredible uniformity.

Leptidea sinapis
Wood White butterfly
France

Facing each other, the ends of their abdomens joined together, these delicate white butterflies are a symbol of nuptial love.

Previous pages:
Cethosia sp.
Papua New Guinea

The Nymphalidae is the largest butterfly family. All its members flaunt contrasting patterns. In some species the sexes are so similar that they can only be told apart by the structure of their forelegs—and it takes a careful, expert observer to do so.

Bodies Built for Love

Parnassius apollo
Apollo butterfly
France

Mating is just the final climax of a long courtship ritual, which each partner must perform scrupulously.

In its adult form, the butterfly or moth is entirely devoted to mating. Some species are so bent on finding a mate that they do not feed; indeed, they have lost their mouthparts. The insect's abdomen contains complex reproductive organs, which occupy its entire rear section. The male's two testicles are connected to the ejaculatory canal, which extends into an organ of copulation, flanked by two genital valves that hold the female during mating. The female's ovaries contain eggs at various stages of maturity. She can store the male's sperm and fertilizes the eggs when they reach maturity. The fertilized eggs then leave the reproductive chamber and are covered with an adhesive substance before being laid, generally on the leaf of a host plant.

A Ghostly Dance

The Ghost moth (*Hepialus humuli*, also known as the Ghost Swift) is famous for the male's mating dance, for which the species is named. In May and June males seeking a mate gather by the hundreds at twilight above the waving grass. Seemingly suspended by an invisible thread, the pure white moths flicker in the pale evening light like little ghosts, appearing and disappearing among the plant stems. Their uniform white color, pearly wings, and vast numbers transform this simple movement into a spectacular ballet, which the females find irresistible. Their cousin does the same but enhances its dance with a pleasant scent, secreted by glands on its rear legs and diffused by its dancing movements. Among the other species of the Hepialidae family, by contrast, especially those in which the female has no wings and therefore cannot move about, the males are guided solely by their prospective mates' scent. In general, though, both males and females seeking a mate perform mating dances. The male pursues the female, who pretends to flee. So intent is the couple on performing these preliminaries to mating that the dance can last for hours. It allows each partner to ensure that the other belongs to the same species, as both repeatedly behave in specific ways. This is a safety mechanism, which prevents the production of hybrids, which would be sterile. However, even among butterflies love does not always listen to reason, and sharp-eyed butterfly watchers have sometimes observed hybrids of species that should not have anything to do with each other, such as the Southern and Eastern Festoons (*Zerynthia polyxena* and *Zerynthia cerisyi*), as amusingly described by Dany Lartigue in his *Mémoires d'un chasseur de papillons* (Recollections of a Butterfly Hunter).

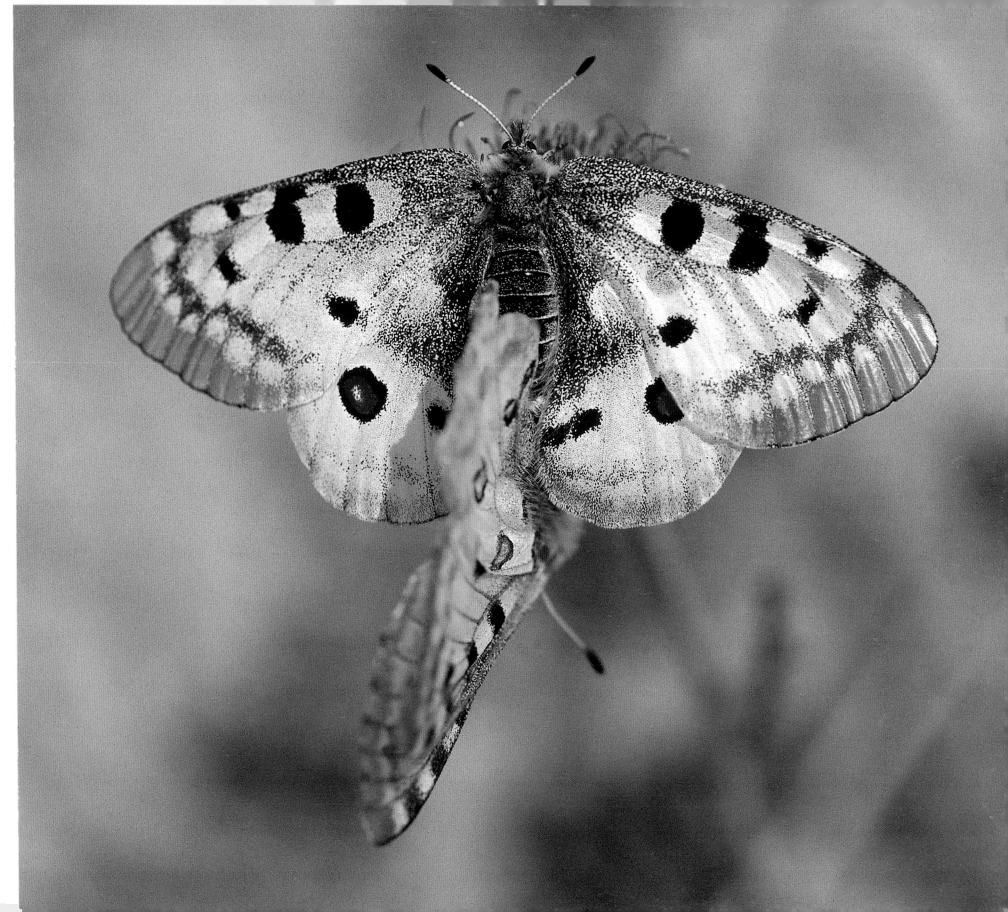

Perfume of Love, Scent of War

When several males desire the same female, they do battle using scent as their weapon. Each male diffuses his own scent, in the hope that it will seduce the female. If she replies to the invitation and dances with a particular male, this means that she has agreed to mate with him. A female that is not available, either because she has already been fertilized or because she is not yet ready, does not join in the dance and signals her lack of interest by raising her abdomen by almost 90 degrees. However, the males of certain species have other means of quietly having their way. They emit a pheromone that has an aphrodisiac effect on the female, making her receptive to mating. This "weapon" works only at close quarters and can be emitted only once in a male's short life. During their mating dances, the Danaidae family transform alkaloids contained in crotalaria (a mimosaceous plant) into an aphrodisiac substance. The male spreads out the tufts of hair at the end of his abdomen directly in front of his chosen female. Each hair contains 400 filaments covered with a sticky, scented powder that stimulates the female. Then, during the nuptial flight, he brushes her head and antennae with this powder several times, in order to coat them and render her sexually available. It may take as long as four or five hours before the female consents to mating. When she does, she places her abdomen close to the male's; when contact is established, the two butterflies position themselves back to back, and the male can then discharge his seminal fluid into the female's body. This operation is lengthy, taking between thirty minutes and three hours and requires peace and quiet. If the couple is disturbed, they can fly away without separating, settling somewhere quieter. Although the female may mate with several males, it appears that only the sperm of the last mate fertilizes the eggs, which explains why males continue to try to drive away their rivals even after mating has taken place.

Senses at the Limits of Perception

The degree to which butterflies and moths are sensitive to mating scents is unimaginable to humans, who have poor senses. For example,

Melitaea phoebe
Knapweed Fritillary butterfly
France

The position adopted by two mating partners may sometimes appear acrobatic, but is in fact governed by the rules applying to each species, which allow their genital organs to come together in an optimal manner.

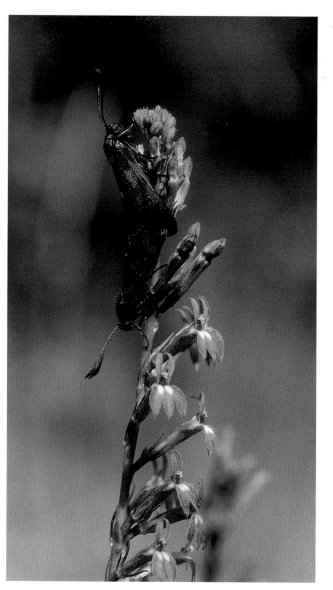

Zygaena filipendulae
Six-spot Burnet moth
France

Back to back on a flower, these two moths abandon themselves to the joys of love without a care in the world. Their disgusting taste, clearly advertised by their contrasting colors, makes them highly unappetizing to birds.

the female Silkworm moth (*Bombyx mori*, in the family Bombycidae), which has been studied far more than other species because of the silk its caterpillars produce, makes an odoriferous molecule in glands located on her abdomen. This molecule, called bombykol, is a pheromone that is dissipated in the air, helped by the lovelorn female's beating wings, which act as a ventilator and diffuser. This substance is dispersed in infinitesimally small quantities, until the molecules reach the huge branched antennae of a male, as far as 6 miles (10 km) away. At once the male sets off in search of his future partner. With every foot that he draws closer to the female the scent becomes stronger, spurring him on further. Laboratory studies using synthetic bombykol showed researchers that the moth's receptors can perceive a single molecule of this pheromone among a billion other scents in the environment— an astonishing degree of sensitivity.

Deluded Lovers Meet a Terrible Fate

The powerful attraction of sexual pheromones is cleverly exploited by a group of spiders that feast on moths. Rather than spin a web, this hunter uses a method that is as sophisticated as it is

effective. The female spider is able to mimic the pheromones of certain female moths, thus attracting male prey. Rather than spin a large web, she weaves a long thread with a sticky ball at the end like the bolas that South American gauchos use to catch livestock—hence it is known as the Bolas spider. The spider dangles its scented weapon, spinning the bolas in a circle to disperse the sexual chemical. As the male moths approach, the spider swings the ball at them. They are inextricably caught in the trap of the cruel predator, which quickly hauls up its prey and devours it. The trap is infallible, and the thread unbreakable by even the biggest moths. Engineers have been unable to reproduce the thread's physical properties: It is twice as elastic as rubber, yet stronger than nylon. And its victims, drunk on the perfume of promised love, throw themselves at it with delight.

Locked Together in Copulation

The two or three rearmost segments of the insects' abdomens contain organs involved in copulation. They are highly complex, both in the male and in the female, and ensure that the ends of the two partners' abdomens are held in tight contact throughout the duration of mating. The

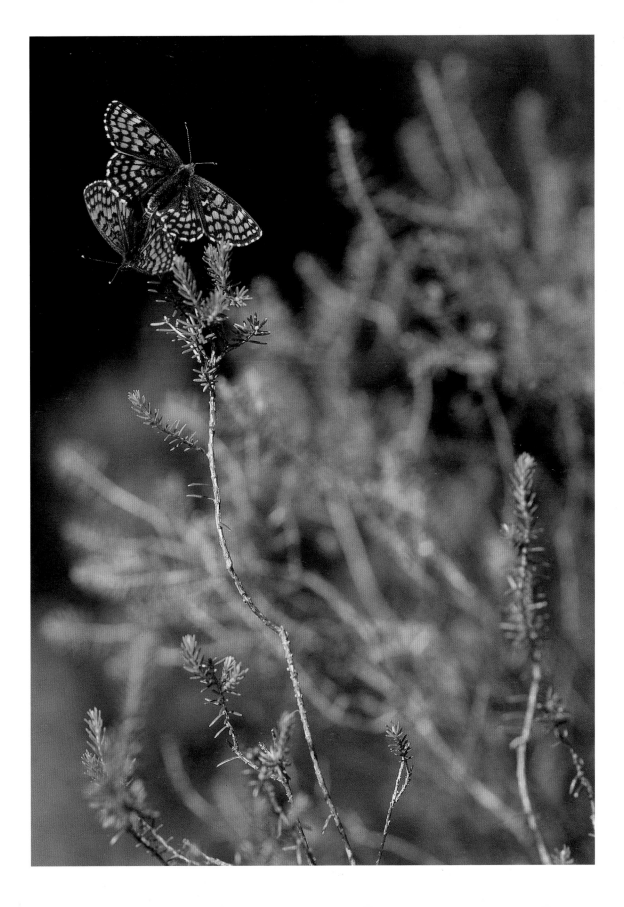

Melitaea phoebe
Knapweed Fritillary butterfly
France

Mating back to back requires that the
insects remain motionless on a flower.
However, the two butterflies can take
flight, remaining coupled, in search of
a quieter spot.

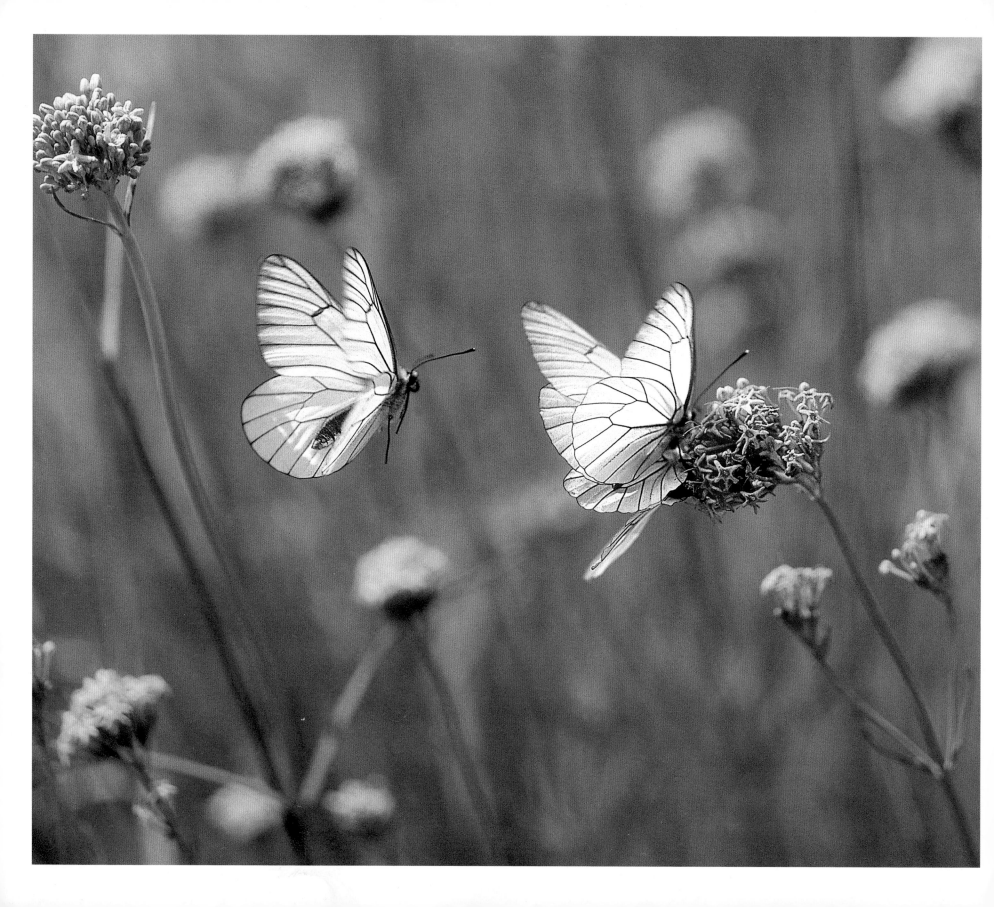

male's is equipped with a pair of valves that attach themselves to the female during fertilization. In the female the final abdominal segments are fused, forming a precisely controllable egg-laying tube called an ovipositor. This enables the female to lay, in a carefully selected spot, the desired number of eggs. The internal reproductive organs occupy the greater part of the female's abdomen. They consist chiefly of two tubular ovaries, in which the eggs are formed and grow before entering the oviduct. The two oviducts converge in a chamber, which also receives the male's spermatozoa. This is where fertilization takes place. Before being laid, each fertilized egg is surrounded by a viscous substance that will ensure that it sticks to the chosen laying site.

The male's genital organs consist of two testicles, which produce sperm. This travels down two sperm ducts to a single ejaculatory canal, which leads to the organ of copulation, or penis. Copulation can last several hours without interruption, ensuring that fertilization is optimized. Moths, in particular, remain joined together throughout the day after beginning to mate the night before, and they separate only with the arrival of twilight.

Sophisticated Scent Diffusers

Male butterflies and moths bear specialized scales, called androconia, that help in the production of mating scents. They are connected to glands situated within the wing membrane, which secrete odoriferous substances. The scales, which have many pores, allow the scents to be diffused. These scales may be arranged in clumps at the rear end of the abdomen or may be distributed over the wings' entire surface, along their edges, sometimes in visible groups called androconial patches. Hairs on the androconia also help to diffuse the scent, as do the beating of wings. Sometimes a male will not be content to seduce a female only by means of scent, but will optimize the process by adding a visual element. An example is the Hepialidae family where very marked sexual dimorphism (the female is pale brown, the male completely white) is emphasized by the partners' nocturnal dance. Other species besides these little flying ghosts also use colors to help them in their quest for a mate.

Aporia crataegi
Black-veined White butterfly
France

Males sometimes compete to win the favors of a female. Each suitor uses his scent to persuade the female to choose him.

Polyommatus bellargus
Adonis Blue butterfly
France

The sole mission of the adult butterfly or moth is to perpetuate the species. The Adonis Blue butterfly does not breed exclusively with its own species, and sometimes it produces hybrids with the Chalkhill Blue (*Polyommatus coridon*), with which it shares the peculiarity of confiding its larvae to the tender care of ants, which play the role of nanny. The Large Blue butterfly (*Maculinea arion*) does this as well.

Love in Ultraviolet

The Clouded Yellow butterfly (*Colias crocea*, Pieridae family) looks very different in the visible spectrum from how it looks under ultraviolet light. In the visible spectrum, males and females have yellow wings with black borders. Under ultraviolet light, however, the female appears completely black, while the male's hind wings are adorned with handsome iridescent blue patches. Butterflies and moths can perceive light far into the ultraviolet end of the spectrum, further even than birds; thus it is not surprising that they make use of this capacity, which their predators do not possess. They become recognizable only to each other, which confers an undoubted advantage. The trick becomes even more effective when it involves species that mimic other species. Mimicry is an important method of evading predators, but the butterfly needs to be able to recognize its own species in order to reproduce. The use of colors at the far end of the ultraviolet spectrum allows the insects to fool predators but recognize each other.

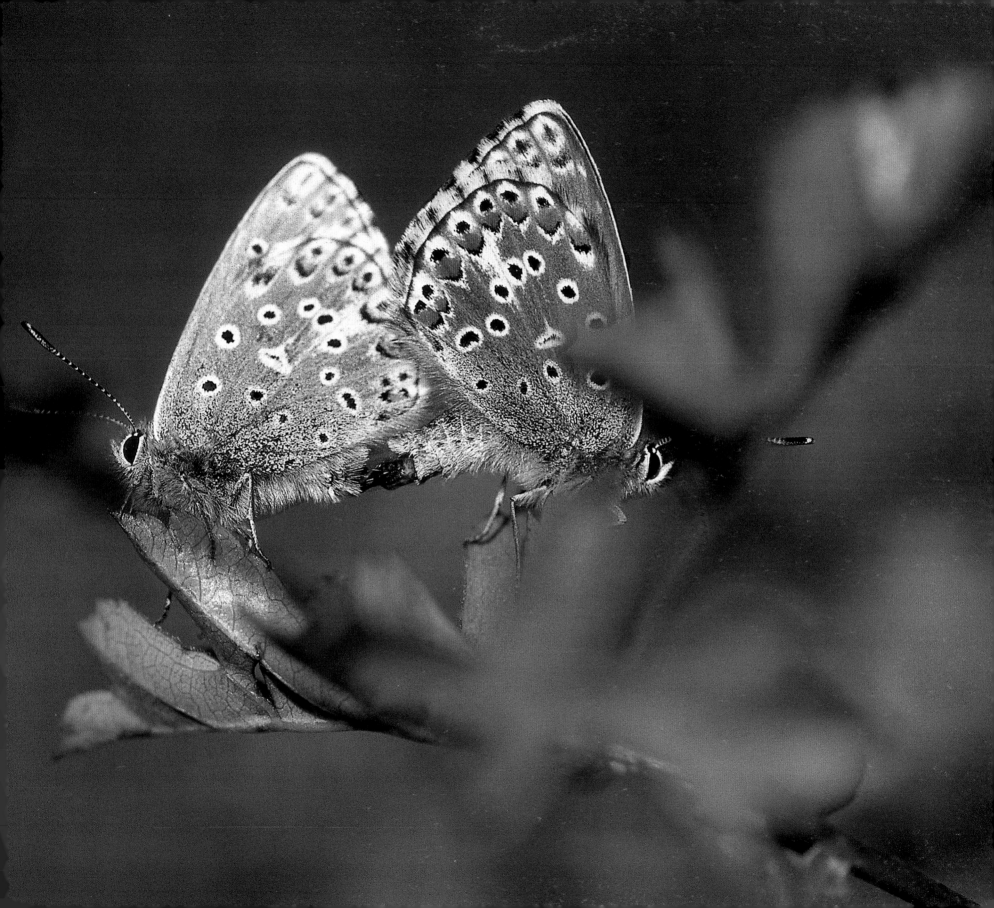

Astonishingly Keen Senses

The job of a butterfly's long, erectile proboscis is only to ingest food; the privilege of tasting it is reserved for the insect's legs. The butterfly has three pairs of legs, as do all adult insects. The first pair has extremely sensitive taste receptors at the ends. They are capable of detecting traces of sugar at concentrations 200 times lower than what humans can detect. The insect is then stimulated by the information, pumping up its proboscis with blood. The unfurled proboscis stretches out toward the sweet food to suck up its juice.

Antennae for Touching and Feeling

The antennae play several essential roles. They are involved in the sense of touch, and in some species such as the Monarch, they contain an organ (Johnston's organ) that enables the butterfly to orient itself in flight. However, their most highly developed function is the central role they play in finding a mate, through their powerful detection of scents. Smell receptors are distributed over the entire surface of the antennae. Although some butterfly antennae are threadlike, the majority are club-shaped. Male moths, however, possess extremely sophisticated antennae, whose serrated surface may be described as pectinate (comb-shaped), bipectinate, or even pinnate (featherlike), depending on the complexity of their structure. These antennae are specialized in detecting a number of scents specific to the given species. The male Atlas moth (*Attacus atlas*, in the Saturniidae family) has approximately 10,000 chemoreceptors on its antennae.

One of the female sexual pheromones is called bombykol. This molecule, made by glands located on the moth's abdomen, is produced only by females that have not yet mated. Laboratory experiments on silkworm moths have shown that males possess 17,000 scent receptors on their antennae; only 300 of these need to be stimulated for a male moth to perceive a scent. The same experiment, carried out with a molecule very similar to bombykol but with one atom changed, showed that the male moth was about 1,000 times less sensitive to it; thus, this extreme sensitivity to the female pheromone is not replicated with other substances. The male, pro- grammed to respond to a given molecule, is not able to sense much else.

The females' responsibilities are quite differ- ent. If they choose the wrong type of plant when they lay their eggs, they condemn their offspring to death by starvation. It is crucial, therefore, that they be able to recognize the plants on

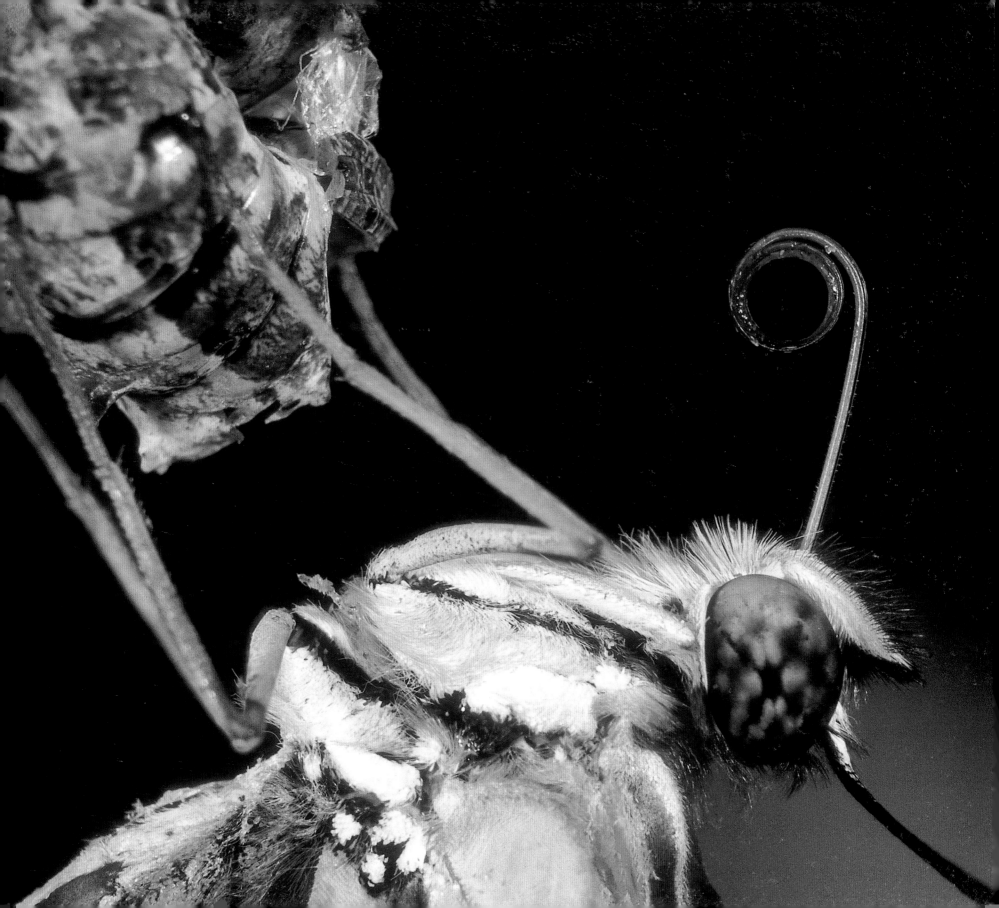

which they settle. Their antennae guide them in making this identification. However, their sensory capacities go well beyond this. Like their legs, the antennae can also analyze scents, thanks to minute hairs called sensilla. An electron microscope reveals that these hairs have a spongy structure; odors penetrate their pores and are picked up by the nerves within. Sensilla are also distributed over the rest of the insect's body. Some are specialized in detecting the species' sexual pheromone, while others subtly distinguish many different smells, allowing the insect to recognize the host plant. The antennae also contain extremely sensitive receptors that analyze air currents and other vibrations.

Lungs That Improve Vision

Butterflies and moths breathe by means of tracheae, tubes that branch throughout the body to carry oxygen directly to the cells. The tracheae also act as air pockets to absorb the shocks of wingbeats, and they insulate the flight muscles from cold. In moths, the tracheae reflect light, considerably improving the insect's vision after nightfall.

Butterflies and moths have multifaceted eyes that can see in all directions simultaneously. Consisting of thousands of simple eyes called ommatidia, each of which is connected to the brain by a nerve, they occupy a large volume on the surface of the head. Their sense of sight is fundamentally different from ours, producing a vision of the world similar to a mosaic, each part of which corresponds to what is perceived by one ommatidium. Compound eyes contain between 12,000 and 17,000 ommatidia, resembling a honeycomb when viewed under a microscope. It is difficult to imagine what such a fragmented field of vision must look like.

This system works efficiently in analyzing light, shade, and movement at close quarters. The power of perception decreases as distance increases. The eyes also perceive colors, but within a different range from human eyes, with special sensitivity to ultraviolet, which flowers use widely in guiding their invaluable collaborators toward their nectar. Flowers are not alone in using ultraviolet. The wings of the males of the Pieridae family differ from those of the females in that some of their scales reflect ultraviolet light; this

Euplagia quadripunctaria
Jersey Tiger moth
France

Butterflies and moths taste flowers simply by landing on them and using their feet, which are equipped with sensory receptors. However, some adult butterflies and moths do not feed—the caterpillar's digestive system was converted during the pupal stage into an air-filled sac that makes the body lighter, aiding flight.

Zygaena filipendulae
Six-spot Burnet moth
France

Perception of time is important to butter-
flies and moths, enabling them to ensure
that their breeding coincides with the most
favorable period. Internal biological clocks,
coupled with complex hormonal mecha-
nisms, control their behavior in keeping
with daily and seasonal cycles.

Opposite:
Hesperidae family of butterflies
France

Although they are equipped with very sim-
ple hearing systems, butterflies and moths
can nonetheless locate and interpret the
sounds around them, and some can even
sense the sounds made by predatory bats.

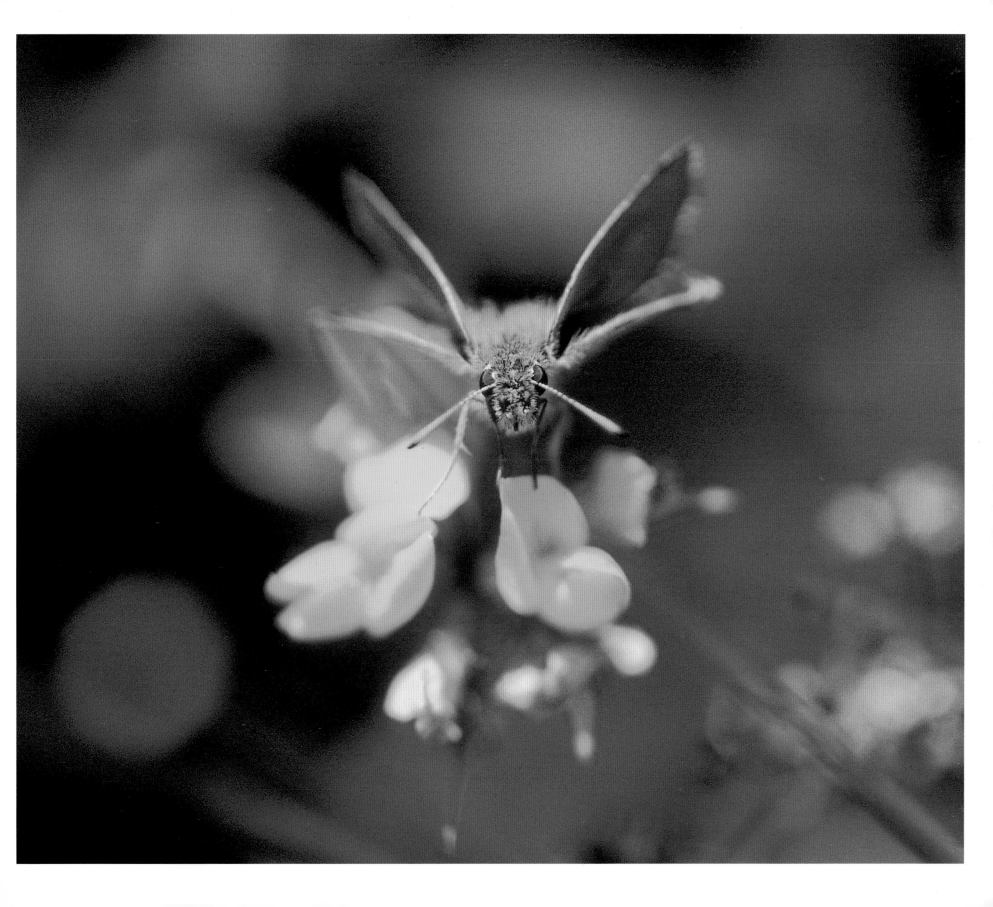

Heliconius charitonia
Zebra Longwing or Zebra butterfly
South America

Perception of a food smell usually triggers the uncoiling of the proboscis. Taste organs on the feet detect traces of food, then the sensilla at the end of the proboscis take over. These must be sufficiently stimulated before they will trigger suction.

provides another means, in addition to scent, whereby potential sexual partners can identify them.

The enormous, protruding eyes are arranged laterally on the butterfly's head, giving it panoramic vision. As stated above, this is typical of prey species because it enables them to see a predator more easily. As well as their compound eyes, many butterflies also possess two simple eyes known as ocelli. The ocelli are situated on the top of the head between the antennae and the compound eyes. They are usually covered with hairy scales and are invisible under a magnifying glass unless the area is cleared of scales. Their function remains unclear, but three theories have been put forward: They might allow a silhouetted view of close objects; they may function in the same way as a photographer's exposure meter; or they may work in conjunction with the compound eyes, acting as a range finder.

Moths' eyes are highly specialized for detecting light and are especially sensitive to lower-frequency ultraviolet rays. This sensitivity is widely exploited by collectors, who easily catch large quantities of insects by using mercury vapor lamps at night.

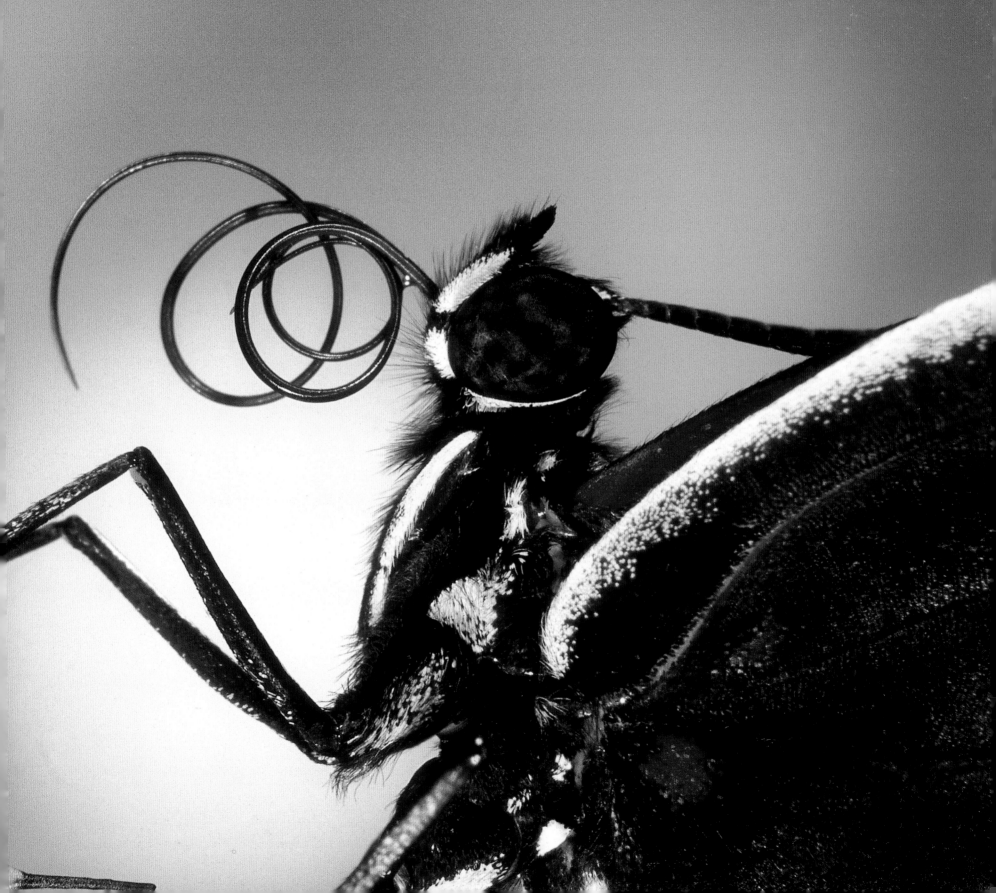

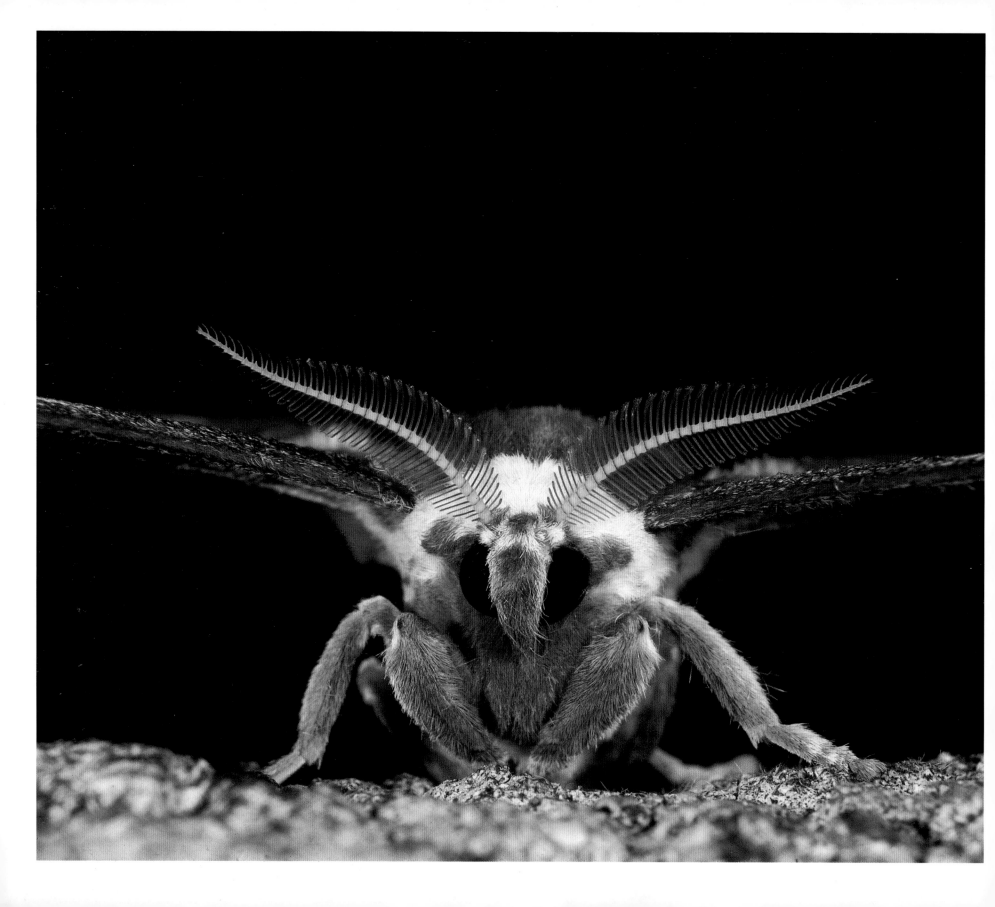

Opposite:
***Rothschildia* sp.**
South America

The antennae of this male moth are highly
developed, all the better to detect the
molecules of pheromone given off by
females. One molecule is enough to
stimulate each of the tens of thousands
of receptors on the antennae.

Neococytius cluentius
Cluentius Sphinx moth
French Guyana

In some moths, ommatidia are grouped
together to give a brighter overall image
by making each of the perceived images
overlap. Movable pigments act as a screen
by day and draw back at dusk, to optimize
night vision.

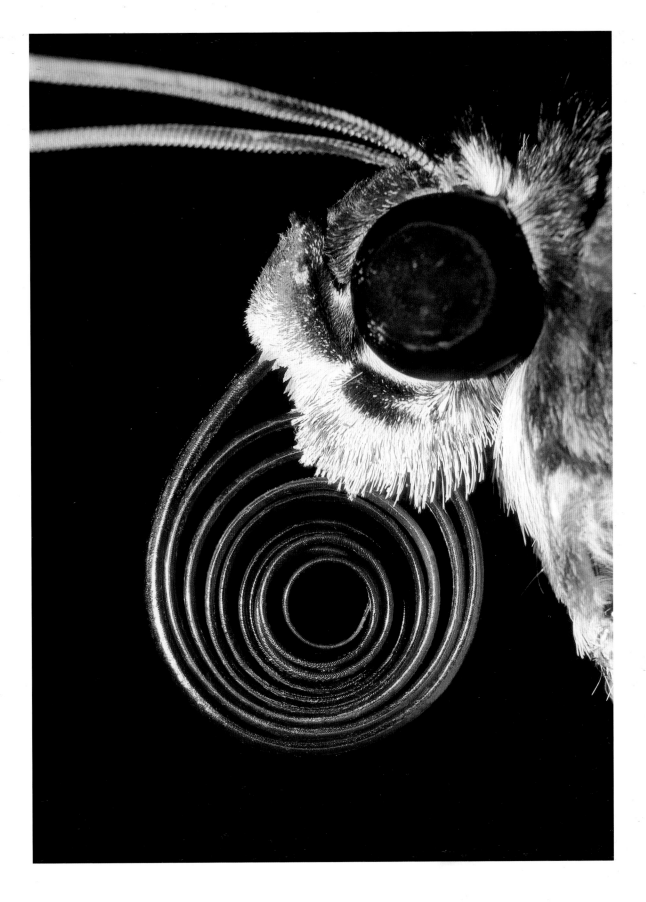

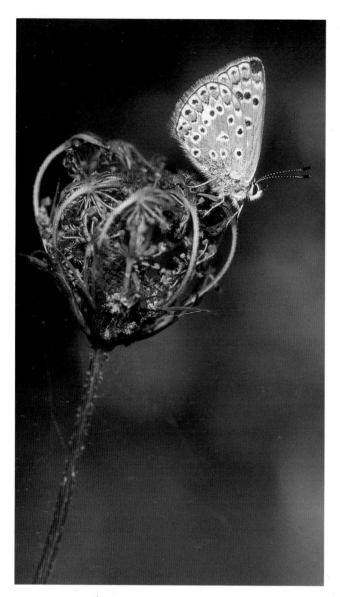

Polyommatus icarus
Common Blue butterfly
France

The female uses her antennae to locate
a suitable place to lay her eggs, essential
for the survival of the species. The sense
of touch resides in the sensilla, which are
simple receptors distributed over different
parts of the insect's body.

Feet for Tasting, and a Thorax That Can Hear

Despite their clawed ends, which allow them to
hold onto almost any surface, the legs of butter-
flies and moths are used for locomotion only to
a limited extent. However, the legs incorporate
a number of sensory organs, which allow the
insect to taste the food on which it settles.
The tarsus of the forelegs is a powerful olfactory
organ that can smell the scent of nectar or of a
sexual partner. However, it is rather difficult to
distinguish the sense of smell from that of taste
in this case, for both respond to the same chemi-
cal stimulus. The usual distinction drawn
between smell and taste is that the former acts
at a distance, whereas the latter requires contact;
for this reason, in the case of a butterfly's or
moth's legs it is not possible to say for certain
which is involved.

Hearing, on the other hand, resides in the
thorax. This central part of the body, between
the head and the abdomen, is extremely robust
because it is where the three pairs of legs and the
two pairs of wings are attached to the body, which
require powerful muscles to function. Like their
vision, the hearing of butterflies and moths
extends across a broad range. Noctuid moths
possess highly developed tympanal organs that
are especially sensitive to frequencies from of about
200 kHz, the frequency used by predatory echolo-
cating bats. When threatened by an approaching
bat, noctuids can execute swerves and loops that
would be the envy of the most skilled fighter
pilot. When the situation becomes critical, they
close their wings and let themselves fall to the
ground to escape these voracious winged mammals.

Models for Science

Butterflies and moths not only inspire poets and
astonish biologists, they also fascinate the armed
forces, which see in their prodigious capacity for
flight an inexhaustible source of ideas for micro-
drones—tiny unpiloted spy planes. Butterflies
and moths are capable of sudden maneuvers—
hovering, sideslips, sudden stops, and even back-
ward flight. To perform these and still remain in
the air, they employ several aerodynamic mecha-
nisms. Two inspired researchers at Oxford
University meticulously studied the flight of Red
Admirals (*Vanessa atalanta*, Nymphalidae family)
under laboratory conditions. In order to under-
stand the secrets of their lift, the force that coun-
teracts weight and allows it to be balanced, the
scientists placed the butterflies inside a glass tube

Fabriciana adippe
High Brown Fritillary butterfly
France

The respiratory organs of butterflies, like
those of birds, consist of tracheae and air
sacs that lighten the insect and make
flight easier. The tracheae are even found
in the wings, where they provide rigidity.

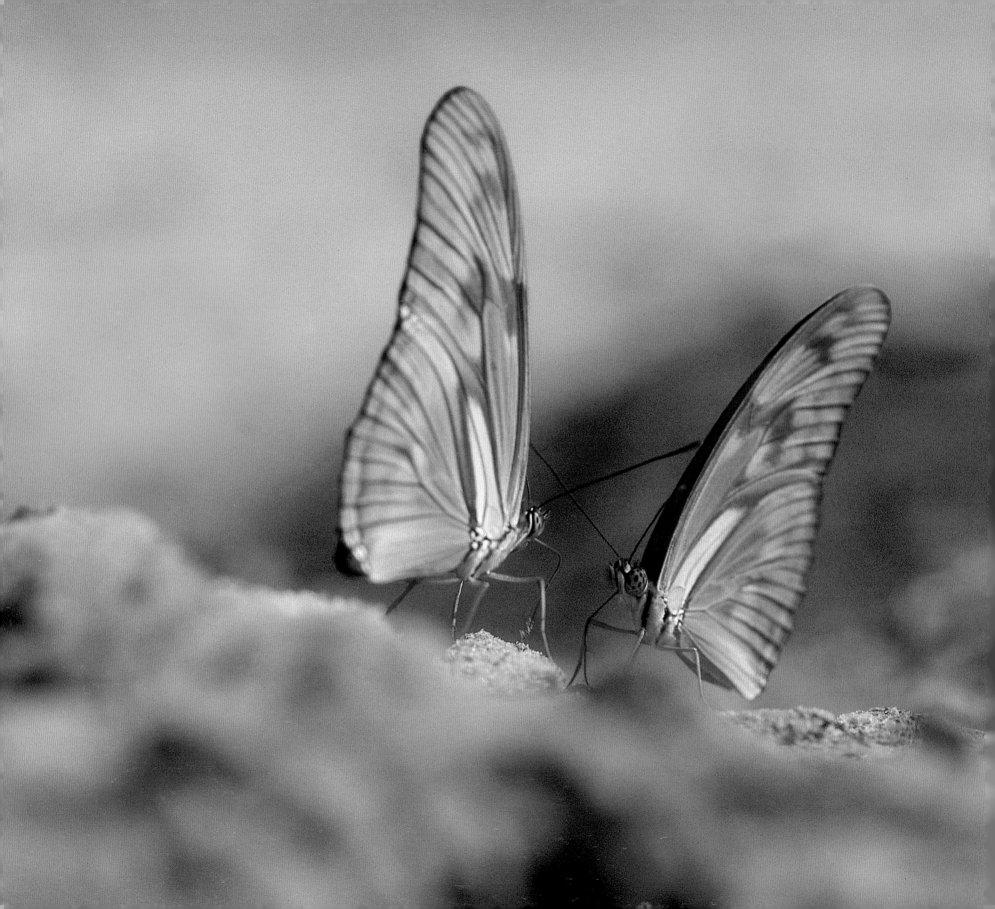

through which a light air current flowed. White, nontoxic smoke was added to reveal the way the air swirled. The experiment revealed three distinct phenomena: First, rapid wingbeats rendered impossible the dreaded phenomenon of stalling, which is so dangerous in aviation. This is the phenomenon known as delayed stalling. Second, rotation of the butterflies' wings produced lift, similar to the lift of a tennis ball. Finally, each wingbeat caught the slipstream of the preceding wingbeat, so that the butterfly gained extra lift by pressing down on moving air.

Now all that remains for engineers is to reproduce these results artificially—which for the moment lies beyond the reach of human technology. Tomorrow, perhaps, the armed forces will possess pretty insectlike robots that can spy anywhere. After the armed forces will come the police, and then industry. When that happens, butterflies will cease to inspire poets and will only provoke alarm and suspicion. Little do these innocent creatures suspect. . . .

Dryas julia
Julia Heliconian or Julia butterfly
Brazil

Tension receptors enable the insect to perceive vibrations as well as movements in the air. This sense is involved in balance, which is indispensable to flight.

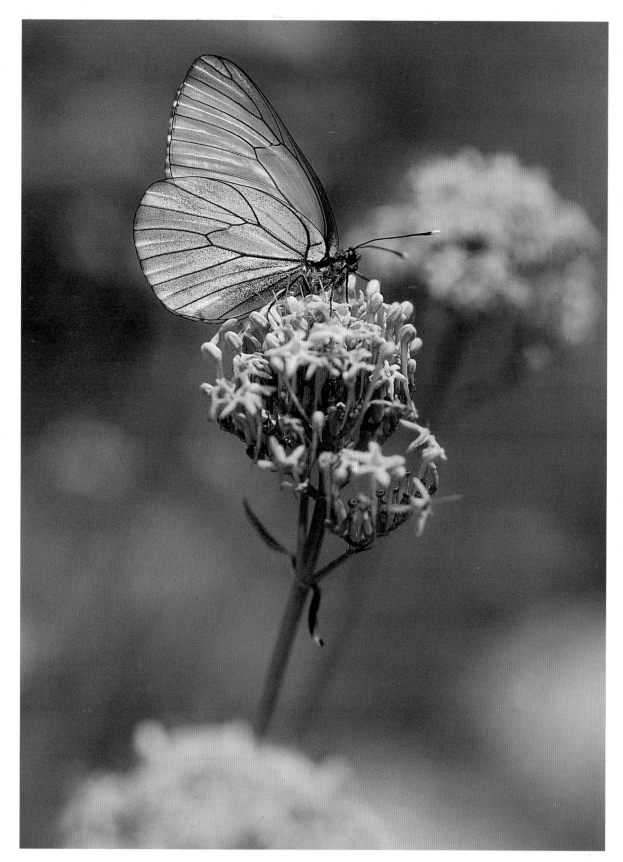

Aporia crataegi
Black-veined White butterfly
France

The wings of butterflies and moths are not only used for flying. They are also devices for catching and absorbing light energy from the sun, which raises the insect's body temperature high enough to allow flight and for it to stay alive. In short—technological perfection!

Opposite:
Zygaena sp.
France

The sides of moths' bodies, soft and membranous, are pierced by six to eight respiratory spiracles. The insects also perceive sounds through the sides of their bodies.

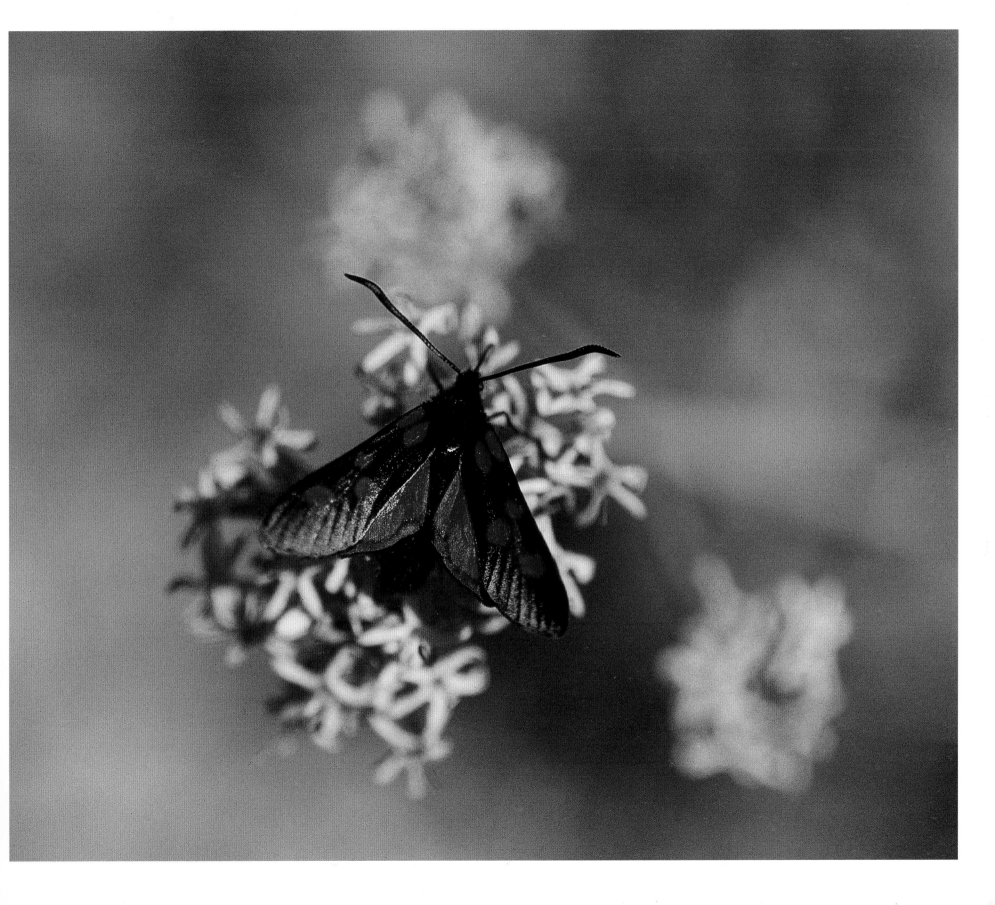

Hordes on Migration

Danaus plexippus
Monarch butterfly
Mexico

The Monarch is the only North American butterfly that migrates over long distances. Taking the same route generation after generation, it crosses the continent every year, from Canada to Mexico.

Although the migration of birds is well understood, that of butterflies is much less so. It is difficult to imagine that these delicate creatures, with such vulnerable bodies, can withstand the rigors of a migratory flight. And yet some are great migrators. Unquestionably, the most famous of these is the magnificent Monarch (*Danaus plexippus*), the pride of the United States and Mexico. This butterfly is aptly named, for it is the king of the skies.

A Pendulum Swinging to the Rhythm of the Seasons

Migration is the annual movement back and forth between two regions inhabited by the same animal species in different seasons. This is a different phenomenon from the invasions caused by emigration, because there is no return to the original region. Emigration occurs as a result of overpopulation, when limited space and food force a substantial proportion of the population to leave. This emigration has no precise direction or destination. An example is the Great Southern White butterfly (*Ascia monuste*, Pieridae family), which breeds on the islands off Florida year round. The caterpillar feeds on a common plant in salt marshes. At regular intervals, the adults emerge from their chrysalises and fly in flocks numbering several thousand, so concentrated that they look like snowstorms. The flocks fly along the coastline, sometimes more than 50 miles (85 km),

and found colonies when they settle. The same phenomenon of invasion can be seen in another butterfly of the same family, the Large White (*Pieris brassicae*) of Europe and Asia.

True migration is completely different. It is not caused by overpopulation but by unfavorable environmental conditions. An adverse temperature is one of the main reasons for migration. The Bogong moth (*Agrostis infusa*, Noctuidae family) lays its eggs in the spring in the plains of southeastern Australia. Spring is a favorable time for plant growth and thus for caterpillars to develop. However, the region's summer heat is deadly for the adults, which are forced to migrate to the Australian Alps, where the altitude promises cooler air. The adults spend the hottest months there, in the shelter of rocky clefts, before returning to the plain in the autumn.

Europe is home to migratory species that travel to and from the north of the continent and Africa. The best known are the Red Admiral (*Vanessa atalanta*) and Painted Lady (*Vanessa cardui*), which belong to the same genus, and various species of Sphinx moth, which can travel more than 2,000 miles (3,300 km). With their long, narrow wings and sturdy bodies, the Sphinxes have all the physical features a long-distance traveler needs. North–south migration across Europe is virtually identical in birds and in butterflies and moths, broadly following two main routes: a westerly, coastal route from the Atlantic Ocean to the North Sea, and a route

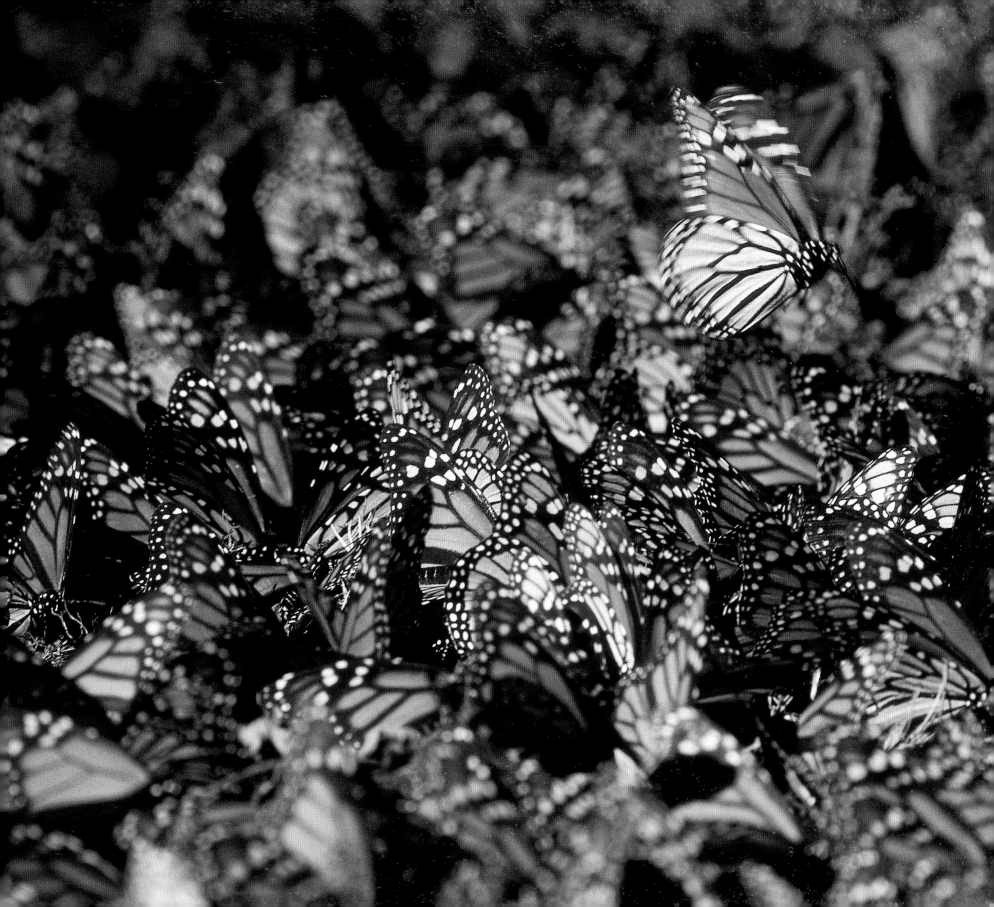

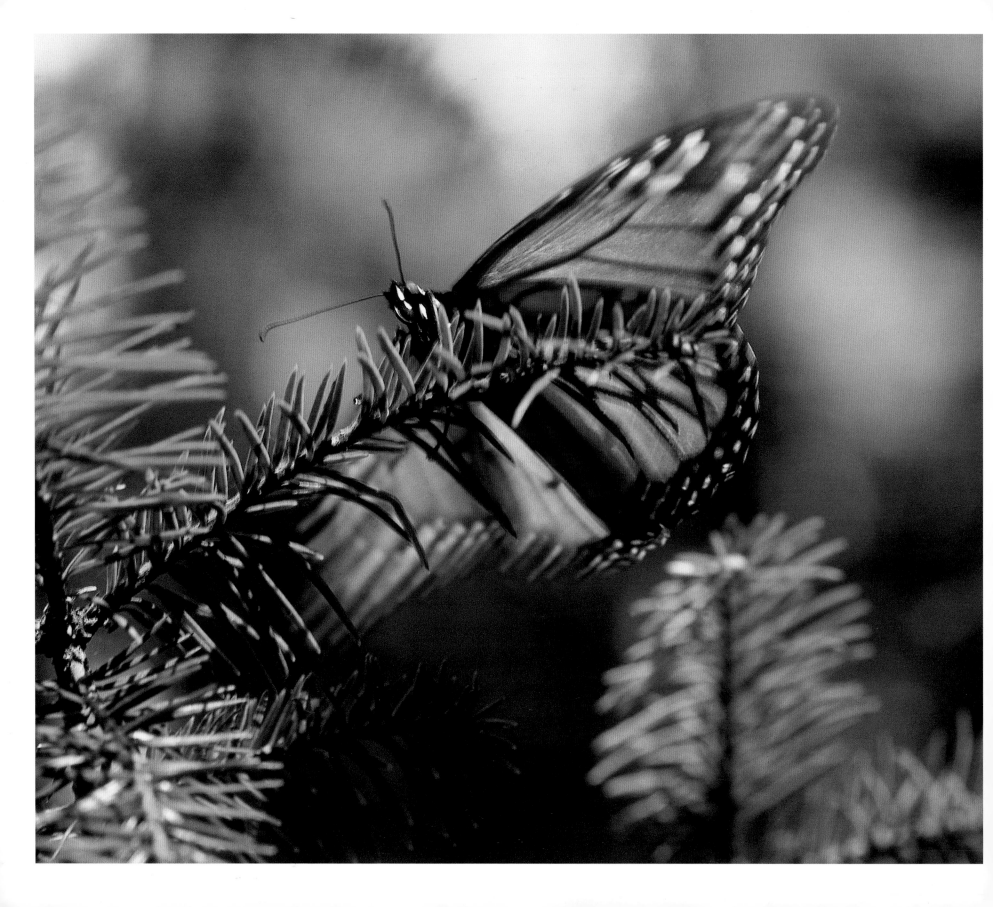

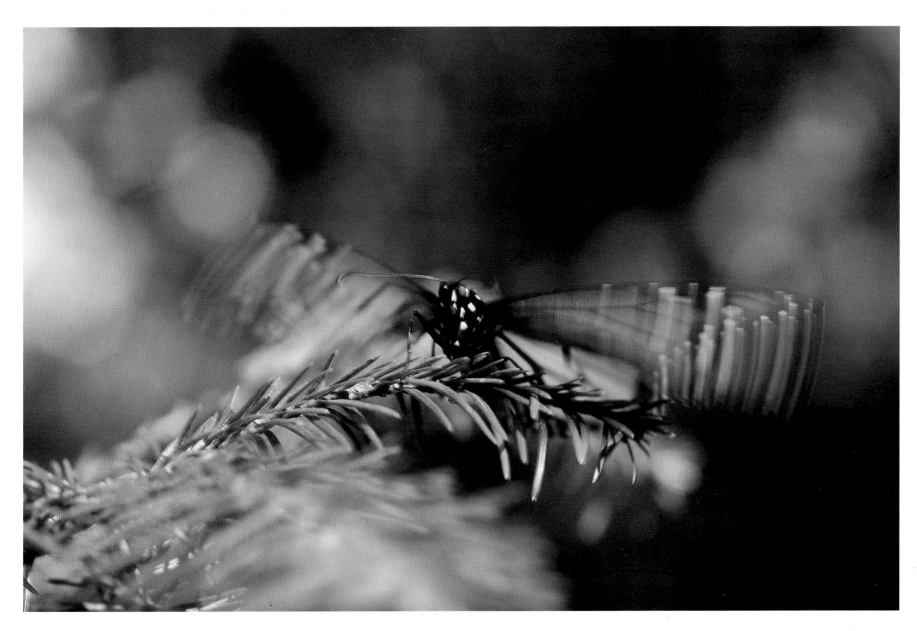

Danaus plexippus
Monarch
Mexico

Every spring this tropical butterfly heads north in search of its host plant: the poisonous milkweed. This not only provides the insect with food and lodging but also with immunity, making both caterpillar and adult highly poisonous—a fact to which they alert all potential predators by flaunting magnificent contrasting colors. It is thanks to the northward extension of the range of the milkweed that we witness the spectacular migration of the butterfly that depends on it for survival.

through eastern France, which follows the valleys of the Rhône and Saône rivers. No obstacle is insurmountable for these small bodies driven by the desire to migrate. Mountain passes and straits of the sea are favored routes.

King of the Skies

The best known of these migratory species is the Monarch, which each year leaves Canada and the northern United States to winter in Florida and Mexico, where it breeds. Two different populations exist, on either side of the Rocky Mountains.

Everything about the Monarch is impressive: the splendor of its orange finery, its powerful flight. This great migrant can fly 80 miles (130 km) without stopping, and some individuals can cover 1,200 miles (2,000 km) in less than a week—a formidable achievement for an insect with a wingspan of just 4 inches (10 cm). During their migratory flights, Monarch butterflies conserve energy by taking advantage of columns of rising warm air, which saves them having to beat their wings and allows them to rise to great altitudes, where a lucky few glider pilots have observed them, more than 3,200 feet (1 km) above the ground.

The gathering of thousands of butterflies on a tree, which disappears completely under the brightly colored living cluster, is an extraordinary sight, both for its scale and its majesty. Sometimes the concentration of butterflies is such that the

ground crawls with them to a depth of 4 inches (10 cm). This is how they hibernate, huddled together in a mass. The butterflies reach their winter quarters between November and the end of December, and they remain there until March or April. When fine weather returns they emerge from their lethargy to make short, preparatory flights before returning north, where there are the plants rich in latex from which they obtain all their immunity. The lengthening days and warmer temperatures awake them from their torpor. Their sexual organs—whose development had been suspended during migration—become fully formed, and they are able to mate.

Toxic and Tough, Yet Fragile

Monarchs, each of which weighs one one-hundredth of an ounce (.5 g), live together in such large flocks that their weight can make large trees bend. Their wintering areas are special ecosystems at high altitude, sheltered from strong winds, where temperature and humidity are such that they allow minimum energy expenditure. The Monarch shuns rain and wind—a single storm can kill 2,500,000 butterflies—as well as low temperatures; it becomes paralyzed at temperatures below 40° F (4° C). The Monarch also needs plentiful water or high humidity that creates morning dew, which explains why it winters at high altitude. In these regions the danger comes from cold nights, which transfix these

Danaus plexippus
Monarch
Mexico

Flying exclusively by day, migratory
Monarchs gather in the evening in vast
hordes on a few host trees—always the
same ones—at intervals along the route
of their odyssey. As they travel, their
numbers are swelled by new individuals
encountered along the way, until they
number in the thousands.

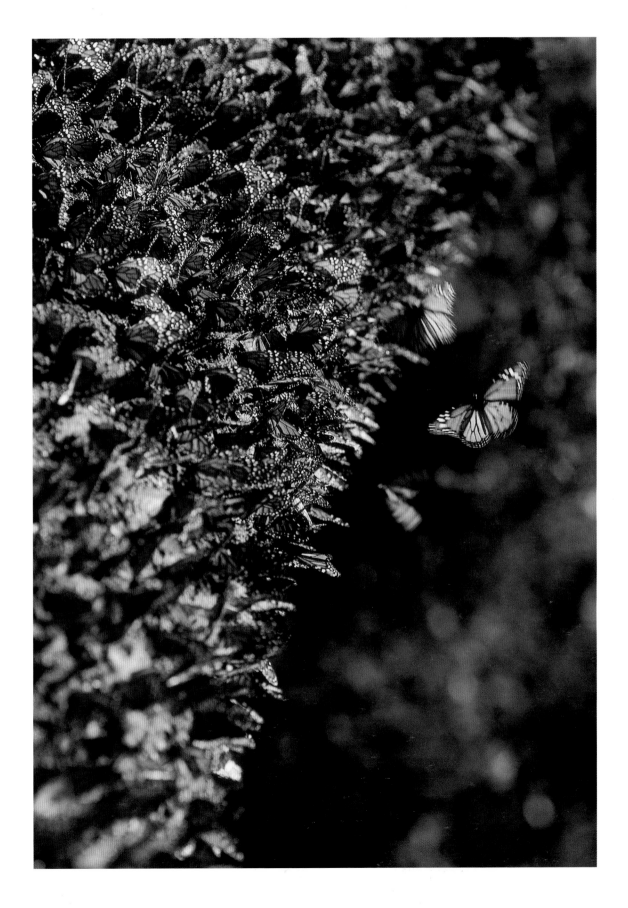

Danaus plexippus
Monarch
Mexico

Scientists estimate that between 100 and 200 million Monarchs set off on their long voyage every September. The most spectacular gatherings take place on the border between Canada and the United States. In 1975 North American researchers discovered where Monarchs winter in Mexico: in the evergreen forests on the summits of volcanic mountains.

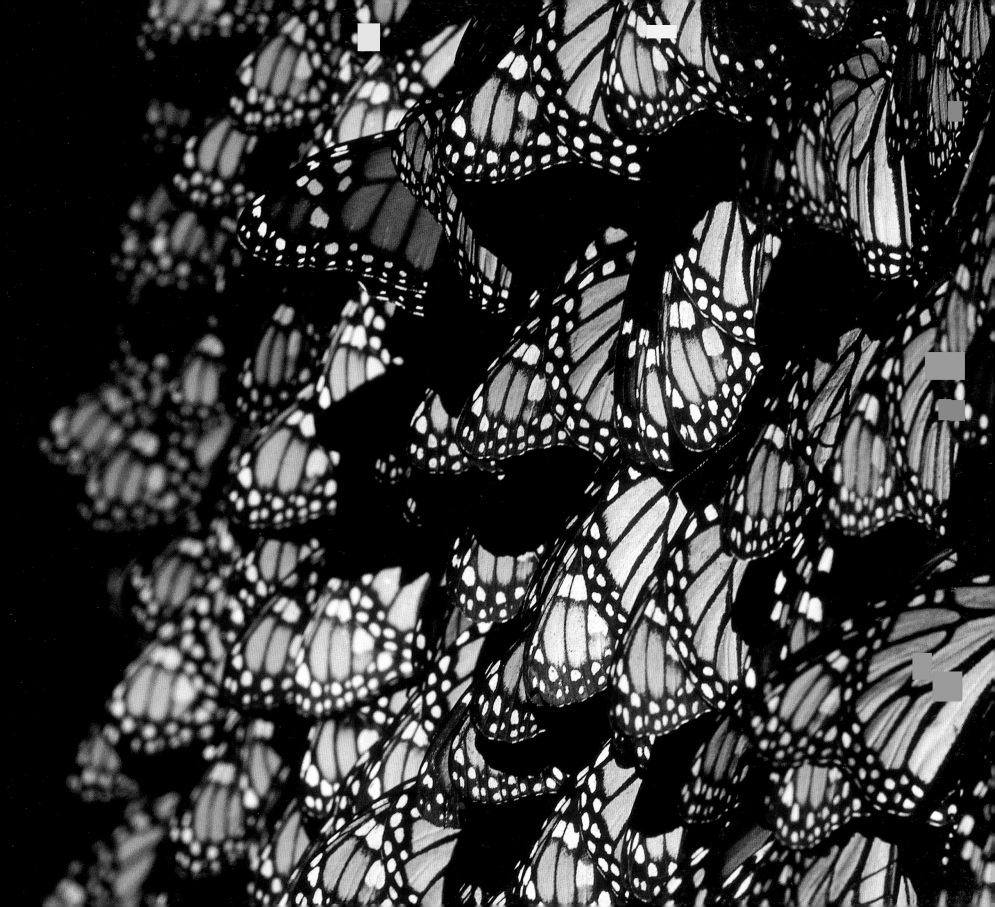

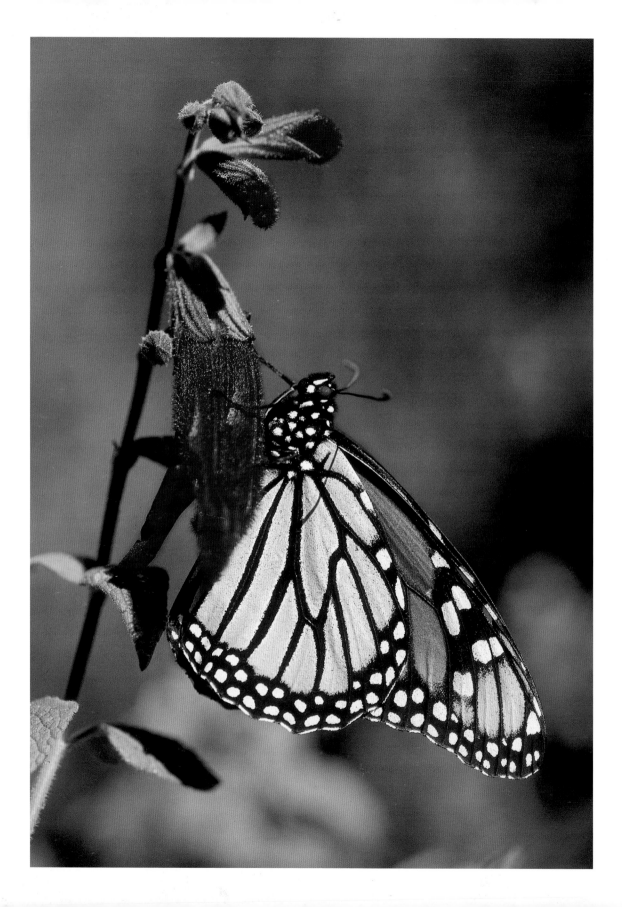

Danaus plexippus
Monarch
Mexico

Although the caterpillar is strictly dependent on milkweed, the adult feeds on the nectar of different flower species. This extremely rich food supplies the energy it needs for its long flight. The sugar in nectar, converted into fat, is its fuel.

beautiful butterflies, causing whole clusters of them to fall to the ground. This is manna from heaven for a species of small rodent, the black-eared mouse (*Peromyscus melanotis*), which is not affected by the insect's poison. So plentiful and easily caught are they that the mouse also migrates to feed exclusively on Monarchs during the winter. The only precaution it takes is to eat only the interior tissues, which contain less of the deadly poison than the skin.

A Long Journey, Punctuated by Egg-Laying

The return journey involves chiefly female insects, for the males usually die after mating. The females lay their eggs to coincide with the flowering of poisonous milkweeds. Development from egg to adult takes between twenty and forty-five days, with an average of thirty days, depending on the temperature and the availability of food, the caterpillars' host plants. Each new generation resumes the northward journey from its birthplace, and migration ends in June, when the milkweed dies in southern regions. Indeed, it is the plant's life cycle that governs the butterflies' journey, for although the adult feeds on a vast range of plants, the caterpillar depends solely on milkweed. Thus, four or five generations succeed each other until the butterflies reach

Quebec, the northern limit of the Monarchs that live on the eastern seaboard. The last Monarchs left in Mexico, however, reach Ontario in one almost continuous journey, covering about 1,800 miles (3,000 km).

A Migration Accomplished by Several Generations

Birds make several migratory journeys during their lives (unless they are killed early by a predator). Butterflies, however, do not live that long. Thus, several successive generations begin, continue, and end the same migration. The great-grandchildren often complete the journey begun by their ancestors.

The last generation, born toward the end of the summer in northern North America, is the only one that makes the great return journey southward. Falling temperatures and diminishing daylight are the signals that it is time to begin this great voyage. The adults gather in increasing numbers and fly exclusively by day, sleeping at night on trees, where they gather in the thousands. They allow themselves occasional breaks in the journey, to feed on the nectar of various flowers. It is essential that they build up their reserves of fat to ensure that they survive the winter, as well as their return journey, which they will make at a time of the year when nectar is not yet available. By sucking this sweet nourish-

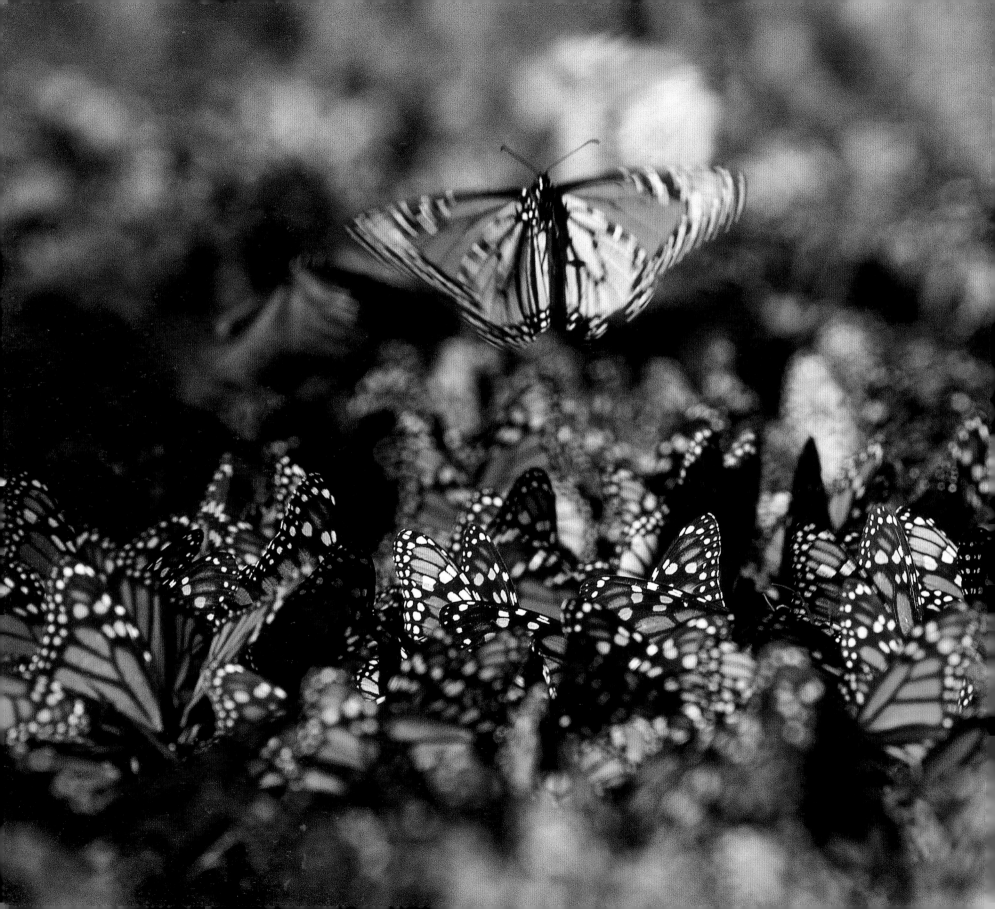

ment, the butterflies may increase their body weight as much as sixfold. Scientists estimate the number of adult butterflies that migrate to a milder climate to be between 100 and 200 million.

A Spectacular Collective Memory

What is most surprising is that each generation takes the same route as the preceding ones, settling on the same trees—to the extent that many of the trees in these areas are now protected by law. However, it is impossible for them to learn the route, since very few individuals live long enough to make the return journey. Scientists have put forward various theories, and they now believe that the necessary information is genetically coded. The solution to this quest for a Holy Grail may be hidden within the insect's very heart, for it contains more magnetic particles in its body than any other known species of butterfly. This bodily compass helps it to maintain a north–south course throughout its long flight.

Off to Conquer New Lands

However, these fragile travelers are sometimes carried as far off course as England. It was long believed that the decks or rigging of ships crossing the Atlantic offered these butterflies a free ride, but the analysis of meteoro-

Danaus plexippus
Monarch
Mexico

When wintering, Monarchs settle on the ground in such numbers that they form a living carpet on the ground at least 4 inches (10 cm) thick.

Danaus plexippus
Monarch
Mexico

So many Monarchs settle on the trees where they winter that the branches bend under their weight—quite a feat for an insect that weighs just one one-hundredth of an ounce! The drop in temperature during the winter makes activity impossible, and they sink into a long period of lethargy that saves their energy reserves. On just a few very sunny days can they make very short flights in the vicinity, but it is only when the days start to get longer at the end of February that they emerge from their torpor.

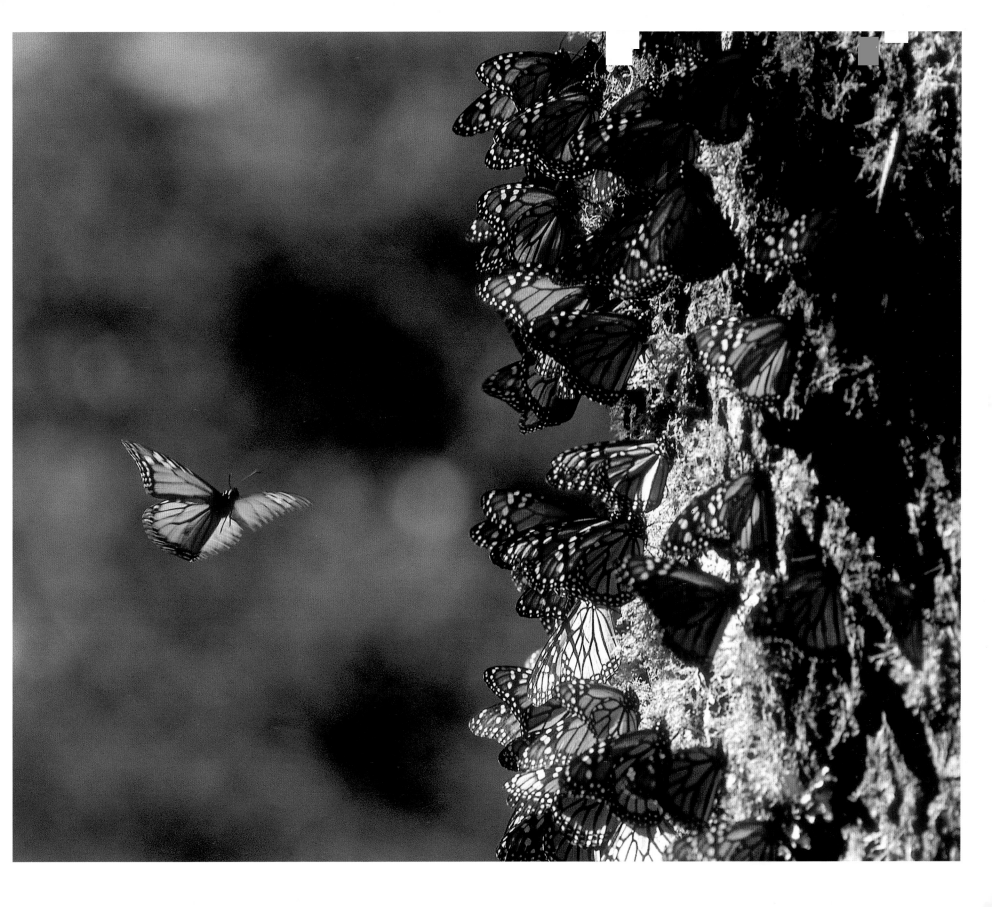

Danaus plexippus
Monarch
Mexico

The lengthening days during March and the rising temperatures arouse the insects, which set off northward once more, mating during the journey. The males die shortly after fulfilling their reproductive function; the females primarily continue the journey, laying their eggs one by one as they come across milkweed plants.

logical conditions has revealed other possibilities. Each time Monarchs arrive in Europe, violent westerly winds have been blowing at the time when they gather in swarms to head for the south of the American continent. The occasional occurrence of this magnificent butterfly in Europe must therefore be attributed to such transatlantic winds. Sadly, the lack of plants suitable for the caterpillars to feed on proves fatal to their survival on the opposite side of the Atlantic.

On the other side of the vast American continent, another phenomenon is occurring. For the last 150 years, the range of the Monarch has been expanding dramatically, extending westward across the Pacific to Hawaii, Tonga, Samoa, and Tahiti, and then stretching as far as Australia and New Zealand, where various species of milkweeds have been introduced to ensure its survival. It appears that this great traveler has been able to take advantage of shipping traffic, which greatly increased during the last century, to colonize new lands. Indeed, it is common to find Monarchs onboard ships.

A Tropical Opportunist

The most southerly populations of this species neither hibernate nor migrate, having no need to escape bad weather. At the southern end of its range, the Monarch breeds year round. It appears that all migratory butterflies were originally tropical or subtropical species, but they were suffi-ciently opportunistic to take advantage of the chance to temporarily colonize northern regions that are rich in host plants, during a very short period of the year. The same applies to migratory birds. The link between butterflies and plants is especially clear in this case: Both the Monarch and the milkweed on which its larvae feed are native to the mountains of Mexico. The plant's expansion into more northerly regions, taking advantage of favorable conditions, led the butterfly to follow. The fact that the species has continued in this habit points to a careful weighing of the gains and losses involved.

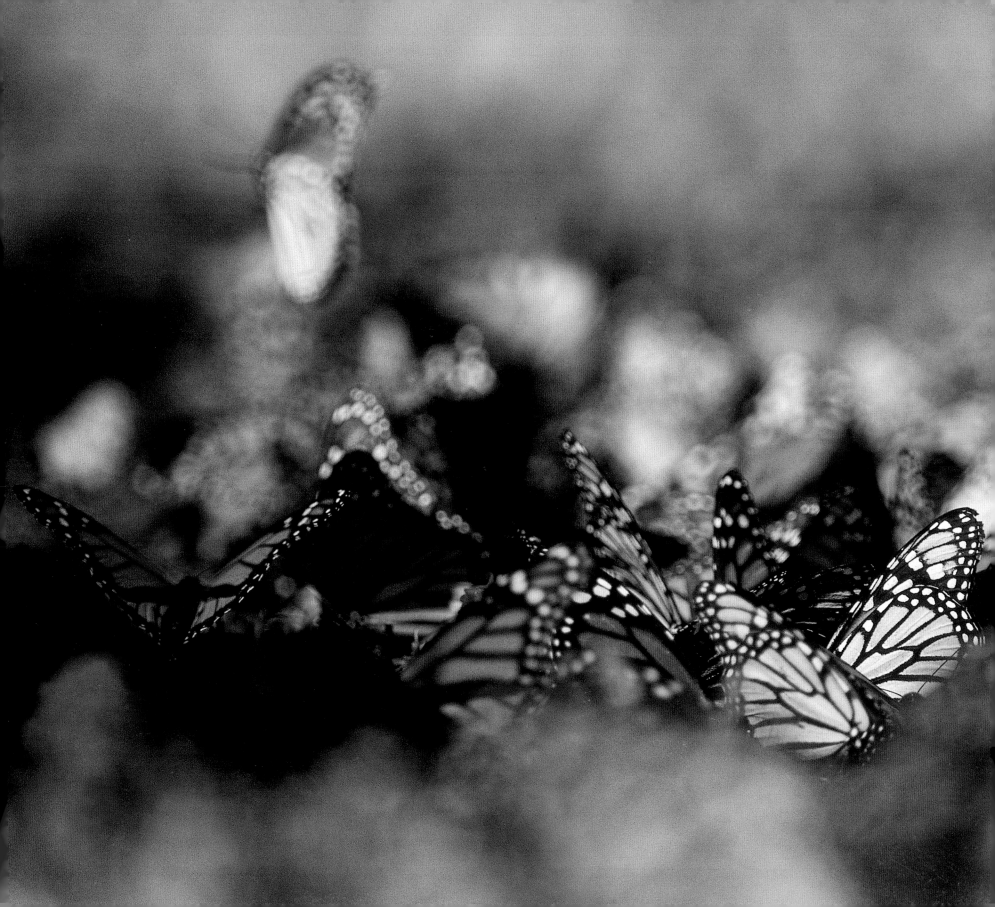

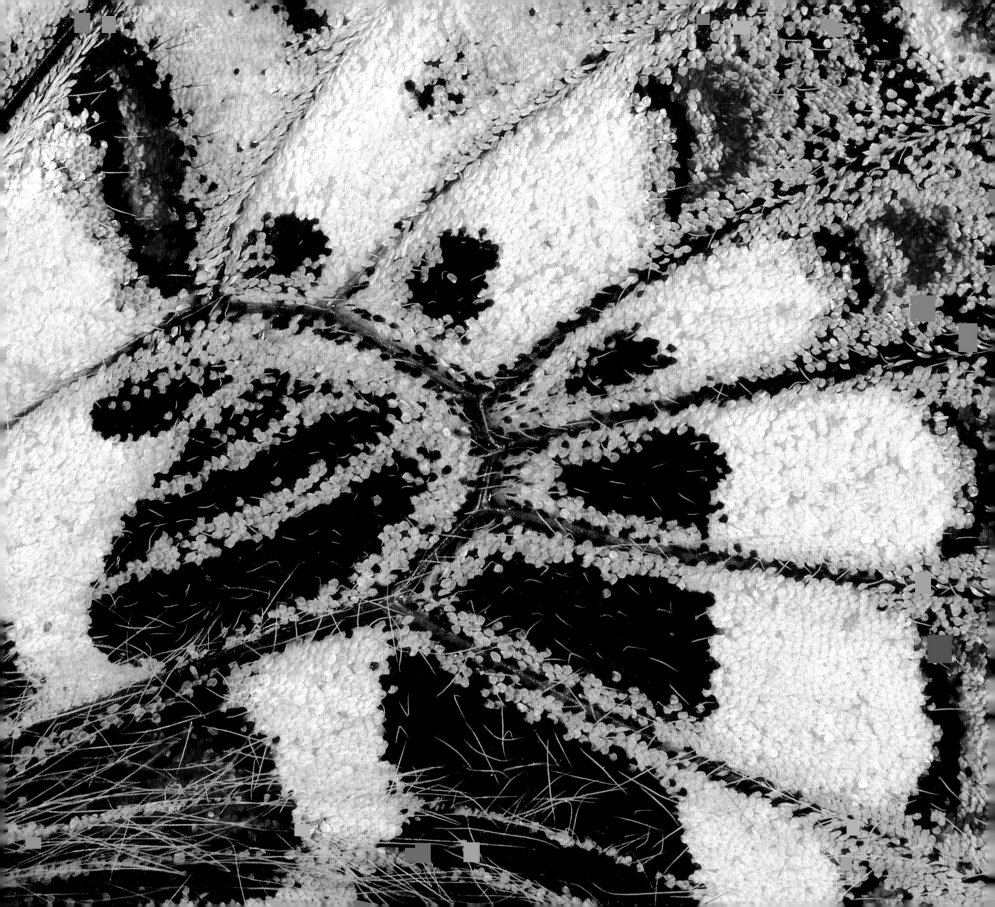

Lepidoptera and Humans

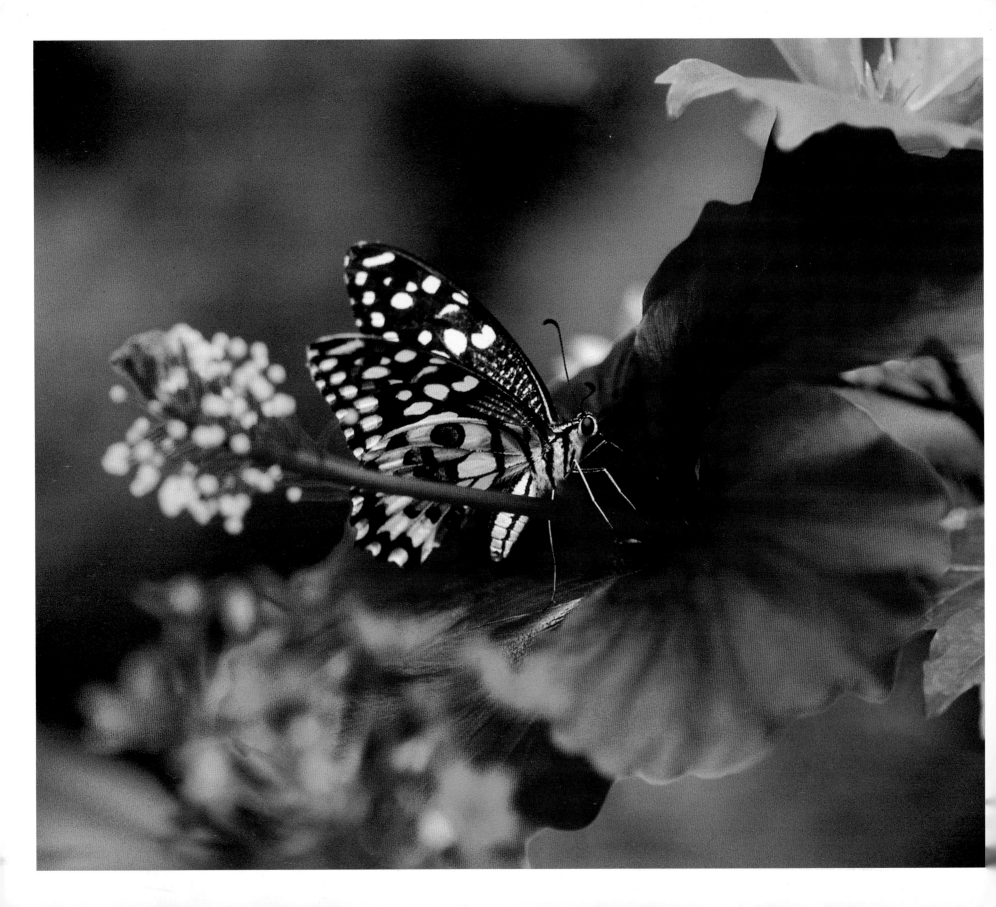

Lepidoptera and Humans

Butterflies and moths have fascinated us for so long because they are both divine and demonic. Divine, like the modest caterpillar of an Asian member of the Hepialidae family, which is parasitized by a fungus, *Cordyceps sinensis*, with great medicinal powers. Divine, like the Silkworm moth, which "oozes" silk, a strange little moth that cannot live without humans, and which humans would have difficulty doing without. Empires have been built and entire societies ruined by this quiet little caterpillar, whose dribble is more valuable than gold and has cemented intellectual, commercial, spiritual, and technological exchanges between the Far East and the West—a fine thread that links 5,000 years of human history.

Every coin, however, has two sides. The brighter the one, the darker the other. Demonic are the invasions of caterpillars that ravage everything in their path. Demonic are the armies of moth caterpillars that have deprived generations of Cinderellas of their clothes. And demonic are the means humans use to eradicate them.

Despite everything, however, it is the transcendent beauty of butterflies and moths that remains most powerful in the collective imagination. But this incomparable splendor creates its own limits. It excites the greed of collectors prepared to do anything, however brazen or excessive, to enrich their booty of rare specimens. And the butterfly, driven away or pursued, goes into decline.

Papilio demoleus
Lime Swallowtail butterfly
Philippines

Long before humans blundered into the delicately ordered interplay of nature, butterflies and flowers already lived together in perfect harmony. What will become of butterflies when flowers are genetically modified? What will become of us humans if butterflies disappear?

Previous pages:
Zerynthia rumina
Spanish Festoon butterfly
Morocco

The whole spectrum of colors is delicately displayed by the scales on the wings of this handsome butterfly. This magnificent example of nature's palette reminds us how fragile the world's equilibrium is, and how important it is to preserve it.

The Birthplace of Silk

Spools of silk thread
Georges Le Manach Factory
France

Silk is a waste product eliminated before metamorphosis. It is the caterpillar's means of ridding itself of toxic substances accumulated in its body. Silk is thus a product of excretion rather than secretion; the latter is the production of a substance necessary to the organism's life.

Silk is not a fabric, it is a world—a universe in its own right. It is a journey from the confines of the Land of the Rising Sun to the ports of the West, stretching across 5,000 years of history. It means unraveling the yarn of wars and conquests, princely marriages, and merchant trading. Silk tells the tale of the history of the world, with its turpitude and greed, its legends and its inventions. This slender but incredibly strong thread has established empires and brought ferocious barbarians to their knees.

Legend credits a single woman with the discovery of this wondrous thread. Two thousand seven hundred years before Christ, Princess Hsi-Ling-Shi, wife of the Chinese emperor Huang-Ti, was taking tea in the cool shade of a mulberry. A cocoon, white and elongated like a small egg, fell into her scalding hot cup. Hsi-Ling-Shi tried to pick it up with her delicate fingers but succeeded only in catching hold of a transparent thread, ten times finer than a human hair. This endless thread wound itself round and round the princess' fingers.

A Silk Veil to Keep the Peace

More precious than gold, more effective than the Chinese empire's armies, silk enabled peace to be kept with the barbaric peoples of the West more effectively than the Great Wall of China. To ensure his vassal states remained loyal, the ambassadors of the Chinese emperor negotiated peace terms by offering magnificent silk fabrics, while keeping the secret of their manufacture. As a result of barter between neighboring peoples, silk soon reached the westernmost lands, which were eager for this sumptuous material.

This treasure that nature gave to the Chinese emperors was jealously guarded for a very long time. Any individual caught at the country's borders in possession of cocoons was immediately put to death. But however closely guarded, a secret is destined to be divulged one day. It is to another Chinese princess, some 3,000 years later, that this leak is attributed. The young princess was to marry the king of Khotan, a neighboring kingdom on the fringes of central Asia, and complained that there was no silk there for her to wear. Before leaving the emperor's court she hid some silkworm moth eggs and mulberry seeds—the caterpillars' food—in her thick hair. The secret went west with her.

Three Partners to Produce a Heavenly Thread

The history of silk is also that of an almost perfect symbiosis among three species: a tree, the mulberry; a moth, *Bombyx mori*; and *Homo sapiens*. The Silkworm moth now no longer exists in the wild and is only bred by humans for silk production. Through this breeding its body has become heavier and its wings have atrophied to the point that it cannot fly; it is now entirely dependent on humans for its survival.

The process begins with an egg: a tiny golden oval that after a few days becomes gray-blue or gray-green, like an angry sea, and is then

Silk-thread shuttles
Georges Le Manach Factory
France

The Georges Le Manach factory, in the
Touraine region, has been designing and
making material for furnishings since 1829.
Tours is France's second great historical
silk town, after Lyon.

referred to as a seed. Hatching must coincide with the growth of the leaves of the mulberry tree, a deciduous plant that is the young larva's only food. Two phases are essential in order to reach maturity: estivation, followed by hibernation. Both are part of the diapause through which the insect must pass. Estivation lasts about four months during the summer, when temperatures reach 72° F (22° C); during this period, the seed's life processes slow down. The embryo only resumes development after hibernation, which lasts between three and six months at a temperature of 41 to 43° F (5–6° C). When the mulberry leaves start to sprout, the sericulturist (silk producer) triggers hatching by gradually warming up the eggs to a temperature of 75° F (24° C). This incubation takes about twelve days. For a long time the rearing of silkworms, which demands enormous care, was carried out solely by women. The seeds were placed in the pockets of aprons worn over the stomach or chest and under clothing, and the women were described as "incubating." An extract from *Mémoire sur l'éducation des vers à soie* (Memoir on the Raising of Silkworms) (1777) recommends: "The seeds shall be given to a woman . . . who must be healthy, placid by nature, not given to sweating, and young—old women perspire too much." Today, of course, incubators with controlled temperature and humidity are used.

A 30-ton Baby

Hatching is heralded by the appearance of a small black dot, which precedes the emergence of the head of the tiny black, hairy caterpillar. This little scrap of a larva—just a tenth of an inch (3 mm) long and weighing half of a milligram (.5 mg)—takes a good fifteen minutes to extricate itself from its egg. It will grow at an explosive rate: In just thirty days it will multiply its weight by 10,000. If a human baby, 6½ pounds (3 kg) in weight and 20 inches (50 cm) long, did the same, as adults we would weigh 30 tons and reach a height of 33 feet (10 m)! The thirty days of the larval stage are divided into five periods of four to ten days, each separated from the next by a molt. During the first two periods, the sericulturist takes care to finely chop the tenderest leaves of the white mulberry (*Morus alba*), to make them more appetizing and easier to consume for the young caterpillars, whose jaws are still fragile. This is no longer necessary as the caterpillars rapidly grow. They can devour everything, and these voracious creatures need to be fed with armfuls of foliage, three to five times per day. During the fifth and last period they eat as much as in all the preceding periods combined. The noise of hundreds of pairs of mandibles tearing and chewing leaves resembles the drumming of rain on roof tiles. In the course of a month,

Spools of silk thread
Georges Le Manach Factory
France

An ounce of silkworm eggs produces 40,000 larvae, which will devour 2,500 pounds (1,200 kg) of mulberry leaves to grow to their full size. About 1,500 pounds (700 kg) of this will be eaten during the last stage of growth. These caterpillars will produce 130 pounds (60 kg) of raw silk, from which only 10 to 12 pounds (5–6 kg) of silk suitable for weaving will be extracted.

what started out as an ounce of silkworm seeds, approximately 40,000 eggs, will consume more than a ton of fresh mulberry leaves and take up a surface of 1 square mile (30 m²). At this point the white larva becomes yellow and translucent, loses its ferocious appetite, and seeks a support on which to pupate.

A Larva Expert in Recycling Waste

For two or three days, the caterpillar weaves its cocoon, turning itself around in a twisting, figure-eight movement. It "dribbles" a silken thread half a mile to 2 miles (800–2,000 m) long. Consisting of two strands joined together—one from each of the larva's glands—it is the sole unbroken thread in all of nature. Inside the freshly woven cocoon remains a tiny larva, less than an inch (2 cm) long—a quarter to a third of its initial volume now that the caterpillar has emptied itself of all its silk. This product of nitrogen metabolism is in fact a waste product of the breakdown of innumerable proteins in the leaves devoured by the caterpillar.

Both sericigenous (silk) glands that secrete this endless thread are 10 inches (25 cm) long. They produce two strands of fibroin, coated with sericin. Each tightly coiled gland tapers at its end into a spinning tube; these tubes join together to form a spinneret, which ends in a sort of trunk on the caterpillar's head, flanked by its powerful jaws. The silk dries as it comes into contact with air, and the sericin

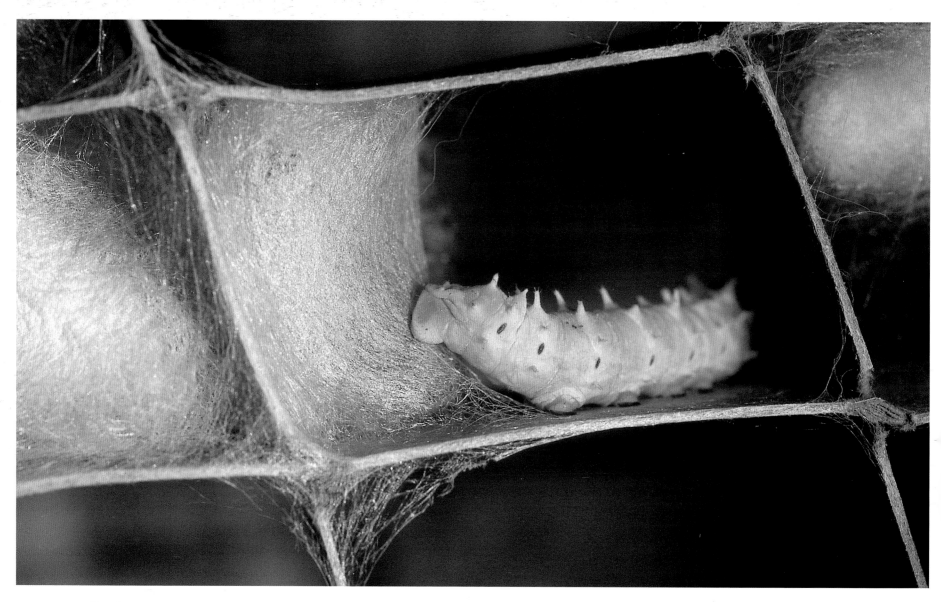

Bombyx mori
Silkworm moth
Silkworm-rearing establishment of Le Coudray, France

Today the ancient art of raising silkworms uses the most sophisticated techniques to maximize production. A powder combination of juvenile hormone and molting hormone is placed on both the mulberry leaves and on the caterpillars themselves, resulting in more uniform pupation: All the caterpillars pupate earlier and at the same time. The cocoons thus obtained yield a finer silk, which commands higher prices—and the caterpillars have eaten a far smaller quantity of leaves!

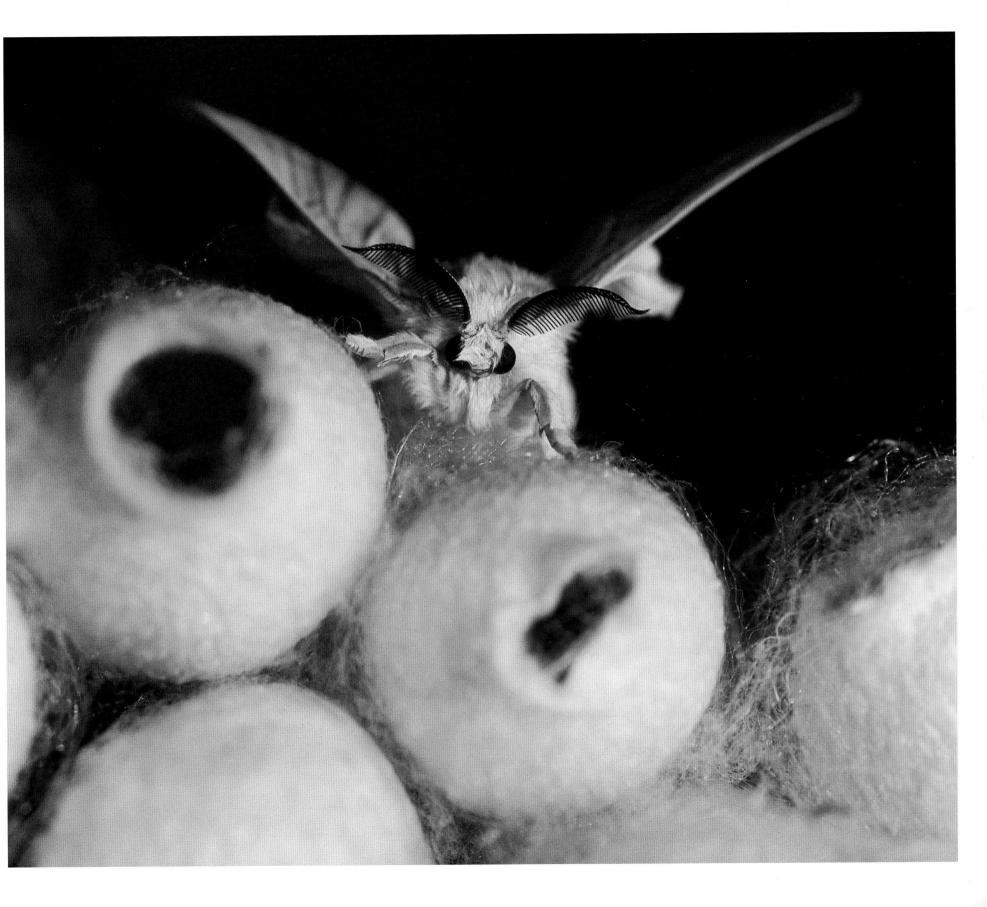

glues the strands together to make the cocoon. Unlike fibroin, sericin softens if immersed in warm water; were it not for this, silk would have no economic value. All that is required is to soak the cocoons at the right temperature—as Princesse Hsi-Ling-Shi did—to detach the virgin silk. Because the thread from an individual cocoon is too fine to be spun, several are combined as they are unwound. When the sericin cools, it sticks the threads together once again. The gauge of the silk thus produced, measured in deniers, varies depending on the number of threads combined in this way. The final stage involves twisting the silk threads, between 150 and 1,500 times per meter, to increase their strength. At this stage the silk is described as raw; it still has its coating of sericin, which gives it a rough appearance. The sericin will be removed by soaking in a bath of hot, soapy water. After this, it is the job of the weaver to render this raw product, with its unique qualities, even more marvelous.

A Thread That Baffles Science

Silk can absorb 30 percent of its own weight in water without appearing or feeling wet. It is much more elastic and stronger than other textile fibers. Soft and insulating, it protects from both heat and cold, and it is hypoallergenic; indeed, for a long time it was used in surgery, under the name of "silkworm gut."

This medical silk was produced by a variety of large silkworm. The larvae, which grew as long as 4 inches (10 cm), were drowned just as they were about to weave their cocoons, then left to soak in acidulated water, which made the silk coagulate. The caterpillars were then cut open and the sericigenous glands extracted—at this stage, the glands took up almost the whole of the caterpillars' bodies and contained a thread of unspun silk coiled within. The invention of nylon sounded the death knell of this specialized industry.

Although for 5,000 years *Bombyx mori* has given itself to the silk industry, it is not the only creature to produce this precious thread. Indeed, among insects and arachnids it is even widespread. Many larvae and adults build shelters and traps made of silk. The best known of these are spiders, whose webs are famous for their transparency and strength. In Madagascar, the silk of the Red-legged Golden Orb Web spider (*Nephila inaurata madagascariensis*)—considered to be finer and stronger than that of the silkworm—was once commercially exploited. However, high production costs quickly consigned this magnificent golden silk to the history books. Nevertheless, science has not yet said its last word about this material, so extraordinary are its properties.

Probably the most exotic type of silk is marine silk, produced by shellfish such as mussels and scallops, which attach themselves

Dyeing of silk ribbons
Silkworm-rearing establishment
of Le Coudray, France

This attractive carmine color is obtained
by decoction of the cochineal (*Dactylopius
coccus*), a small insect originally from
Mexico, which is a parasite of cacti of the
Opuntia genus. The indigenous people of
Mexico have reared them since time imme-
morial for the dye they produce. Before
this insect was introduced to Europe, local
cochineals, whose color was also highly
prized, were used.

to surfaces by means of a tuft of silky filaments
called a byssus. That of the fan mussel, a large
Mediterranean species, has been much sought
after and woven into magnificent fabrics since
ancient times. However, it too has come to be
neglected because of its cost.

There are 400 silk-producing species of
butterflies and moths; some species are used
for the production of wild silk, so called to
distinguish it from the variety obtained from
Bombyx mori. Wild silk is obtained quite dif-
ferently. The caterpillars develop on forest
trees, and most adults are allowed to emerge
from their cocoon, thus cutting the single silk
thread into smaller pieces.

In traditional sericulture the best
cocoons are left untouched, to allow breeding
adults to emerge after a pupal stage of ten to
fifteen days. The adult insects do not feed and
live just long enough to breed. Mating is an
intense business, lasting anywhere from sev-
eral hours to several days. In the process, the
moths' downy white wings lose their splen-
dor, and their torn edges are a sign that mat-
ing is over. The female takes just a few days to
lay between 400 and 600 eggs, and then she dies.

Then the cycle is repeated—unless it is
interrupted by disease, such as pebrine, which
ruined silk production in Europe at the end
of the nineteenth century.

Great Public and Private Collections

Heliconius melpomene
Postman butterfly
Ecuador

Private collection

The timeless beauty of butterflies has inspired dreams since the dawn of humanity. Out of a total of about 175,000 species discovered to date, only about 5,000 are actively sought by collectors, and just a few hundred appeal to the wider public.

Because of their magnificence, tropical butterflies attracted the attention of the first collectors when European explorers first discovered other regions of the world. As they discovered an exotic, teeming world, the rich Western travelers of the seventeenth century began to put together "curiosity cabinets," amassing natural treasures picked up on their journeys to distant lands. The most famous curiosity cabinet of the time is the collection of the king of France in the Jardin des Plantes, Paris, which after the French Revolution became the Museum of Natural History. The excitement produced by the evanescent beauty of specimens brought back from the tropics soon led enthusiasts to take an interest in their local fauna, and butterfly collectors sprung up all over Europe.

When Money Comes to the Rescue of Science

Today the world's biggest butterfly collection is in the British Museum in London. The next largest is at the Smithsonian's National Museum of Natural History in Washington, D.C., followed by the collection of the Museum of Natural History in Paris. After these come countless private collections, some of which are extremely valuable, both in aesthetic and in scientific terms. The growing number of private collections means that many trades are made via "insect exchanges," which sometimes leads to the discovery of species unknown to science. Private collectors sometimes have immense financial resources, far greater than public institutions.

Today software programs are used to manage collections, and many trades are made via the internet. In former times, rich collectors used to embark on long journeys to the tropics, where they would train the native people to capture (or "gently gather") the most beautiful butterfly specimens. In response to the Westerners' fascination, the inhabitants of the countries involved soon became masters in producing pictures and decorations with butterfly wings. The collectors of past centuries were rich, but few in number; now, however, the tourist boom of recent years has offered an inexhaustible supply of buyers, as greedy as they are blind to destroying nature. It is futile to point out to these buyers that this type of "art" ravages butterfly populations. The better a butterfly's condition, the higher its value, and so they are often caught before the frenzy of mating has damaged their wings—thus, not only is the individual butterfly killed, but it is unable to

reproduce. In the West thousands of magnificent Blue Morphos (*Morpho menelaus*) end up in jewelry or in the faces of watches manufactured by a prestigious Swiss company.

When Collectors Are Not Destroyers

Contrary to appearances, collections are not there only to delight the eye; they are also indispensable research tools. Their first role is to enable species identification. This is often very difficult out in the field, where an observer may have to make do with a quick glance. After an insect has been caught and properly mounted, however, it can be minutely examined. This is why it is important to display insects in excellent condition, and prepared according to strict procedures.

Insect collections bring together many specimens of different origins, both from the local fauna and from the most distant and inaccessible lands. They also bear witness to the former richness of the regions from which their specimens were taken. Sadly, these riches are under attack everywhere because of the three great evils afflicting our planet: deforestation, pollution, and urban expansion.

It is increasingly obvious that the Number One enemy of butterflies and moths is not

Parnassius nomion
China

Private collection

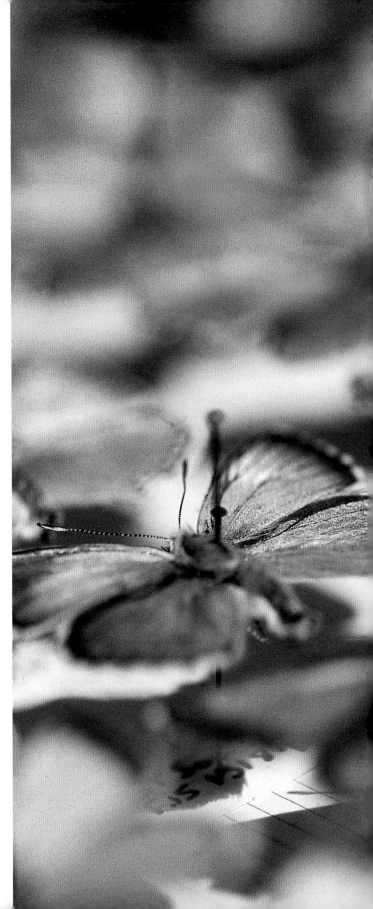

Lycaneidae family of butterflies

France

Private collection

collectors, whose activities have a limited impact. Industrial-scale agriculture, excessive deforestation, draining of wetlands, climate change—the list is long, and the consequences disastrous—are far more harmful to the survival of butterflies and moths than the sometimes excessive greed of some individuals.

A 1993 study established that in France car drivers kill thirty million times more insects than all the entomologists, enthusiasts, and scientists put together. These countless drivers include many passionate defenders of nature. It is true, however, that certain fanatics of the butterfly net, rampaging in a small area in pursuit of a limited number of insects attractive to collectors, can do spectacular damage, as the following demonstrates.

The Small Copper butterfly (also called the American Copper, *Lycaena phlaeas,* Lycaenidae family) varies greatly in appearance, and this variation excites enthusiasts, who are keen to hunt the most extreme forms. Most of the time the variations are in the black patterns of lines and patches on the wings, but a rather rare mutation transforms the wings' copper-colored background into a silvery white, as attractive to collectors as powerful sexual pheromones are to potential mates.

Its cousin, the Great Copper (*Lycaena xanthoides*), met a terrible fate. Discovered in

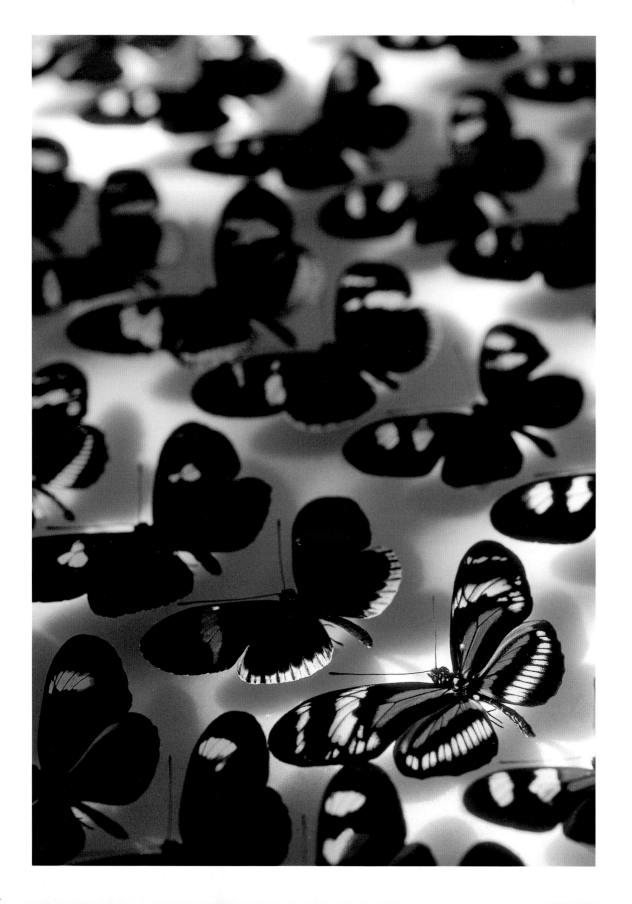

Heliconius sp.
Ecuador

Private collection

about 1800 in Britain, it immediately excited the passions of collectors, fueled in some cases by commercial greed because of the price it commanded. Before half the century had passed, all Great Coppers had disappeared from Britain, as a result of the drainage of marshes. A subspecies that was extremely similar was discovered in the Netherlands in 1920 and introduced soon afterward to a British nature reserve, where every year specialists ensure that it breeds under artificial conditions so that its magnificent copper wings can continue to enhance summer days.

Classification Is Not a Game

All classification of butterflies and moths has been carried out using adult specimens in collections, based upon wing shapes and patterns. This is not surprising, given that what most strikes us, and leads some to cross jungles and seas, is the beauty of these wings. But if we look at Lepidoptera as a whole, we see that the adult is only one of the forms the insect takes, and it is often the briefest one. Moreover, evolving in an environment that is much more olfactory than visual, butterflies and moths attach little importance to their wing patterns, preferring to focus on their fellow insects' sexual scents. Thus, early researchers made many errors in classification, categorizing dimorphous males and females as different species. Similarly, species that are polymorphous are sometimes given different names even today, whereas distinct but visually similar insects are lumped together under the same name.

Jacques Pierre, an eminent lepidopterist at the Museum of Natural History in Paris, noticed that the genus *Neptis* of the Nymphalidae family, which consists of butterflies with black-and-white markings, contained many surprises. He began to collect and raise the caterpillars, and, in the process, discovered that many of them were totally different in their habits and way of life. He thus discovered distinct species that appeared identical as adults pinned into a collection box. Minute study of genitals, claws, and many other subtle or hidden features confirmed these differences. Modern methods of DNA and enzyme analysis are also powerful tools for classifying insects.

In addition, while collections teach us a great deal and are essential to research, they cannot tell us how the animal behaves when alive. Is it territorial, gregarious, aggressive, or timid? These are the details that make life so fascinating and mysterious.

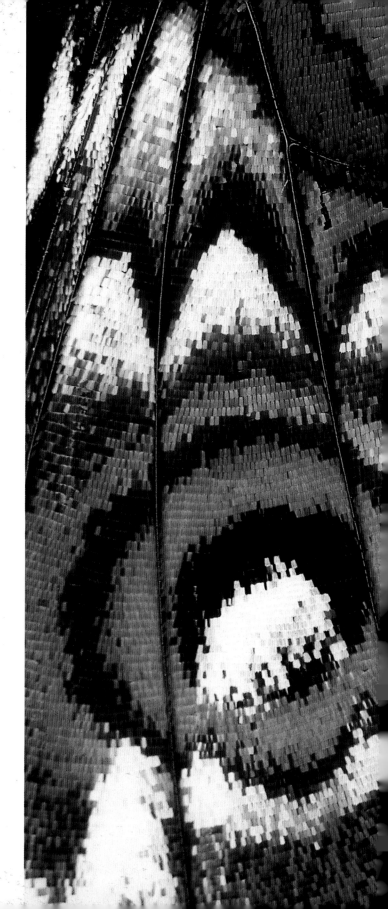

Morpho hecuba
Sunset Morpho butterfly
Brazil

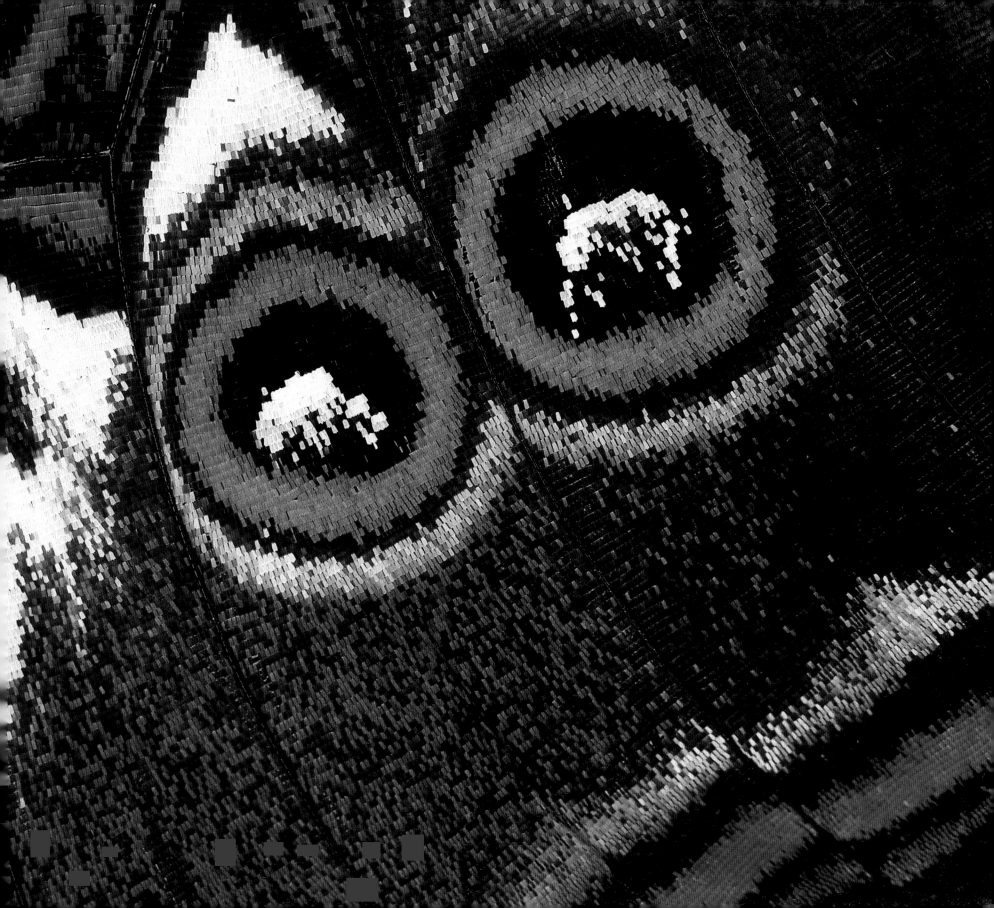

The butterflies and moths on the plates on pages 189 to 193 are shown life-size. They come from the Museum of Natural History in Paris and some of the world's largest private collections.

Opposite:

1. *Urania leilus* (Urania moth), French Guyana
2. *Anaea clytemnestra*, Ecuador
3. *Hebomoia leucippe*, Indonesia
4. *Aglia tau* (Tau Emperor moth), France
5. *Brahmaea tancrei*, China
6. *Ornithoptera rothschildi* (Rothschild's Birdwing butterfly), Papua New Guinea
7. *Diaethria clymena* (Cramer's Eighty-eight butterfly), Peru
8. *Delias splendida*, Indonesia

Pages 190–91:

9. *Morpho hecuba* (Sunset Morpho butterfly), Brazil
10. *Elzunia humboldti*, Ecuador
11. *Pierella sp.*, Brazil
12. *Heliconius melpomene* (Postman butterfly), Ecuador
13. *Parnassius apollo wiskotti* (Apollo butterfly subspecies), Sweden
14. *Anaea archidona*, Ecuador
15. *Gonepteryx cleopatra* (Cleopatra butterfly), France
16. *Agrias beatifica*, Ecuador
17. *Vanessa cardui* (Painted Lady butterfly), France
18. *Papilio paeon*, Peru
19. *Graellsia isabellae* (Spanish Moon moth), France
20. *Hamadryas februa* (Gray Cracker butterfly), Peru
21. *Papilio rumanzovia* (Scarlet Mormon butterfly), Philippines
22. *Morpho helena*, Peru

Pages 192–93:

23. *Archaeoprepona demophoon antimache* (Two-spotted Prepona butterfly), Peru
24. *Ornithoptera priamus poseidon*, Papua New Guinea
25. *Attacus atlas* (Atlas moth), Thailand
26. *Parnassius nomion*, China
27. *Hyles euphorbiae* (Leafy Spurge Hawk moth), France
28. *Heliconius sp.*, Ecuador
29. *Prothoe calydonia*, Malaysia
30. *Rothschildia aurota*, French Guyana
31. *Agrias sardanapalus lugens*, Peru
32. *Dictyoploca simla*, Madagascar

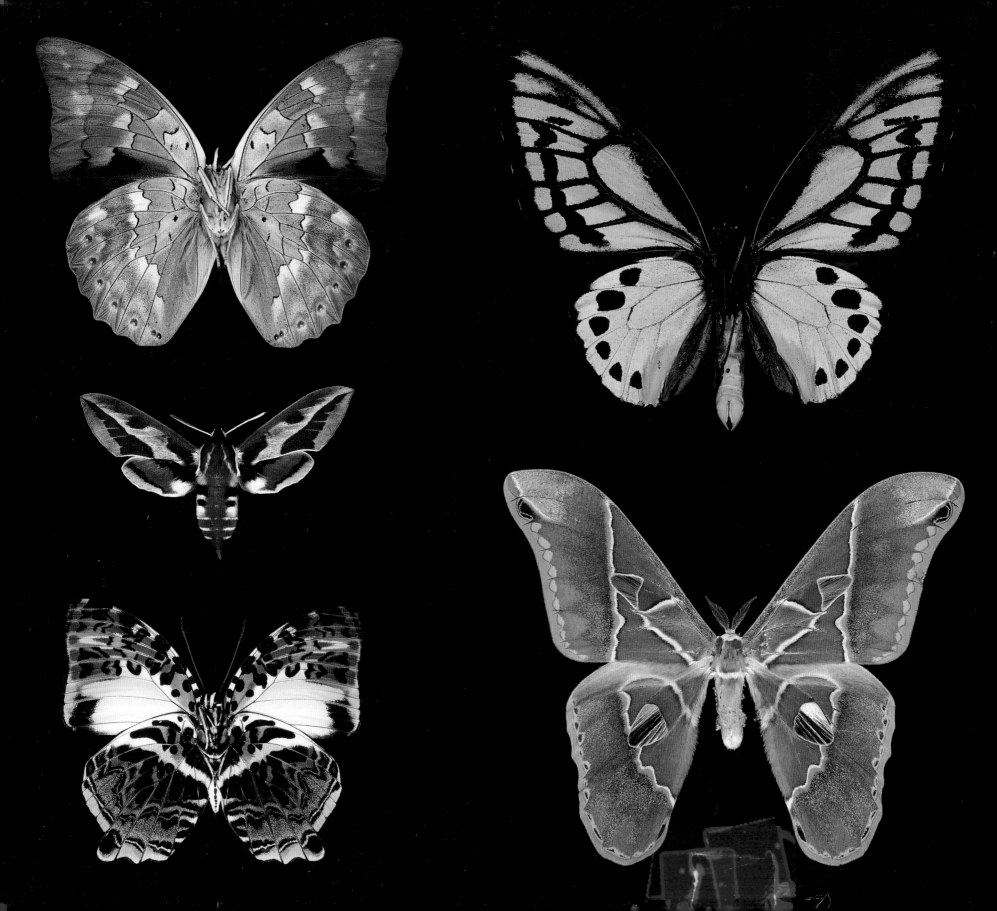

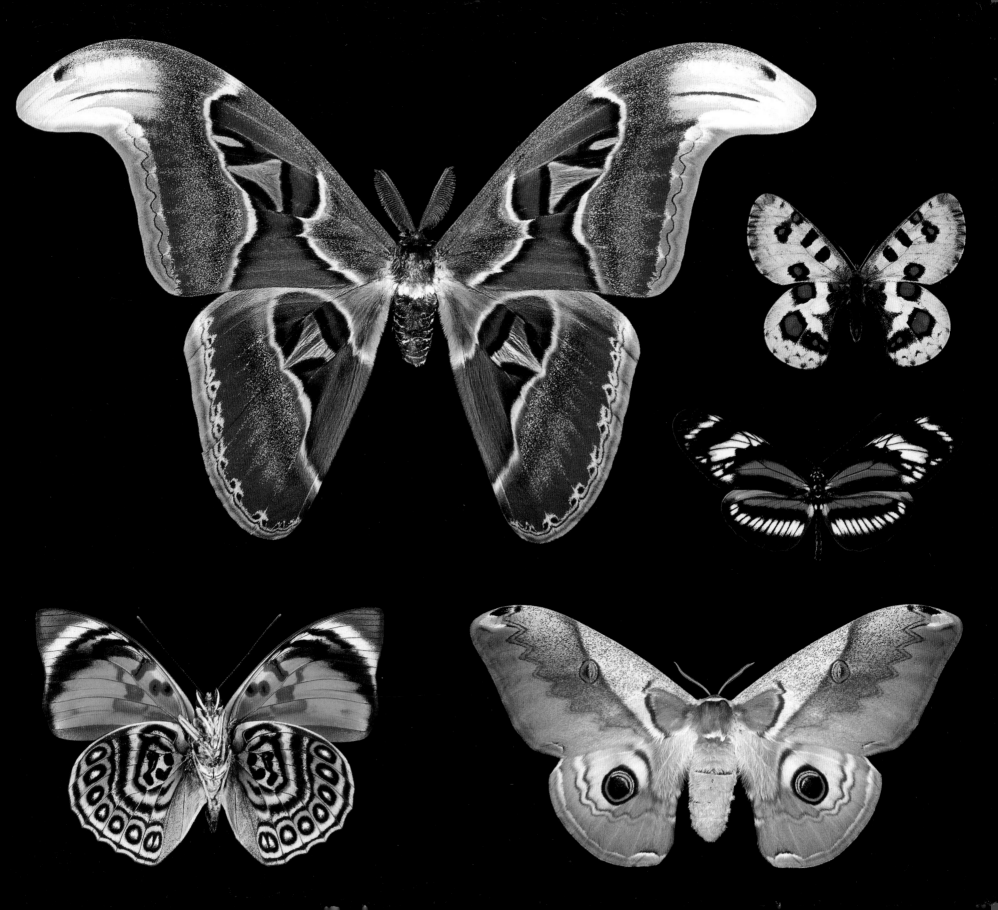

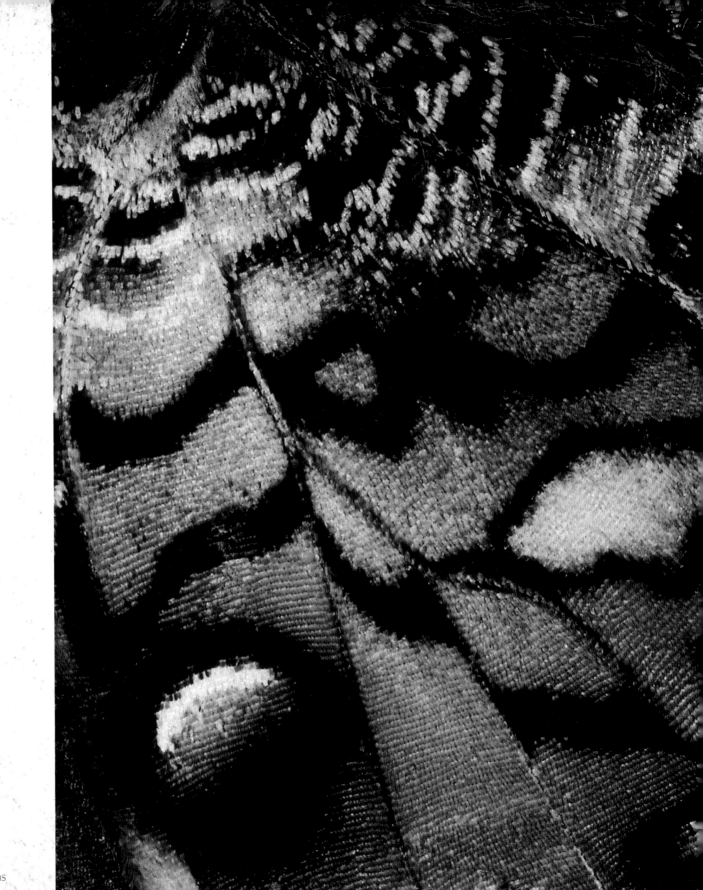

Caligo sp.
South America

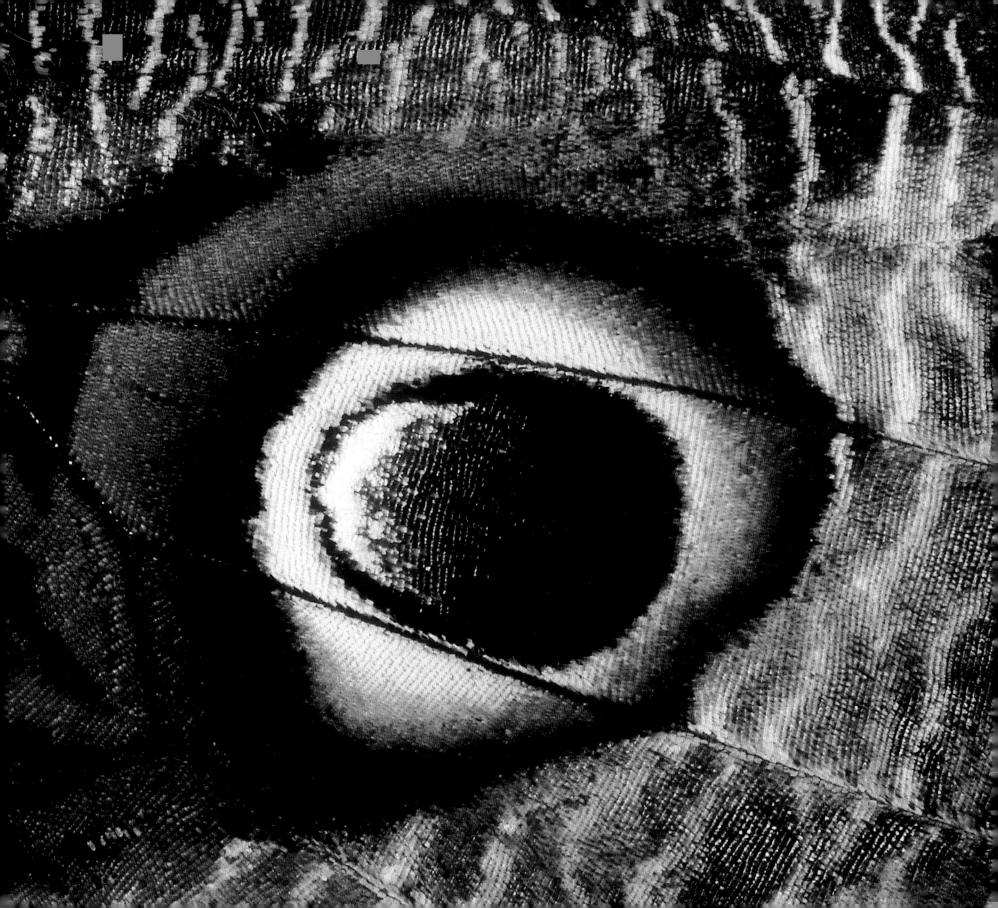

Conservation and the Future

As both enemies and allies of humans, butterflies and moths—and especially their larvae—have a high profile in the battle against pests by organic means, both as a target and as a means of pest control. In the United States, biologists at the University of North Carolina have used Soybean Looper caterpillars (*Pseudoplusia includens*, Noctuidae family) to devour kudzu, a plant introduced from Japan that has proved so invasive that nothing has been able to control it. In order to retain complete control of the operation, researchers expose the caterpillars to a parasitoid wasp that lays its eggs in their bodies. The parasitized caterpillars are even greedier than healthy ones, and their larval stage lasts longer to allow the parasitoid wasp larvae to develop fully. The caterpillars then die just before pupation, preventing the development of an adult insect that would reproduce. This illustrates that it is in our interest to learn more about nature and harness its genius, rather than combat it with chemicals.

Fearsome Invaders

Caterpillar invasions can be incredibly destructive, and they strike without warning. In June 2004 the inhabitants of the Hérault gorges, in France's Languedoc region, were invaded by billions of Gypsy moth caterpillars. In a few days they had devoured several thousand acres of forest.

They were so numerous that village inhabitants could hear caterpillars chewing the leaves. The first trees to be devoured were holm oaks (*Quercus ilex*), after which the caterpillars attacked everything that remained, including conifers and orchards. The valley began to turn yellow, as if the mountainside had caught fire. On the roads, carpets of caterpillars were crushed under the wheels of cars, causing accidents. The hapless inhabitants, holed up in their houses, had the impression that the walls were moving, as everything, from floor to ceiling, was covered in carpets of red and blue, extremely hairy—but not stinging—caterpillars. Although shovels were used to try to clear them away, nothing defeated the invaders. Specialists from France's national forest agency have been unable to understand, or explain, the vast scale of this natural cycle. Some say that invasions occur in years following a very hot summer.

However, the hot days of summer cannot be blamed for the immense damage done by the notorious Spruce Budworm (*Choristoneura fumiferana*, Tortricidae family), a kind of leaf roller moth, in Canadian forests. Between 1968 and 1990 this insect destroyed the equivalent of ten years' timber harvest in Quebec. To combat this scourge, foresters used an organic insecticide that uses bacteria. However, this brought only a brief respite. The moths, which have been

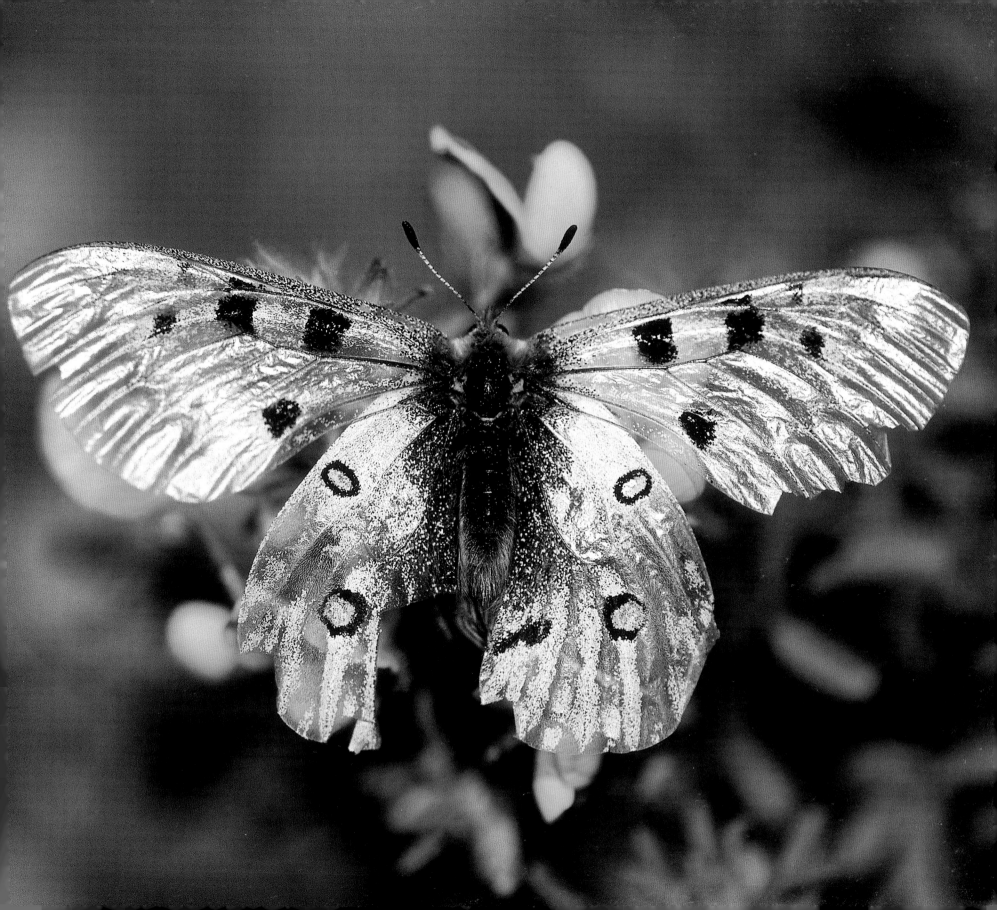

adapting to new environmental conditions for thousands of generations, soon found an answer. As soon as the insecticide's effects began to make themselves felt, the caterpillar would stop feeding for a day or two, long enough for it to recover and for the insecticide to wear off the leaves. The caterpillar then went back to causing damage. Canadian foresters have been working on a new weapon in high-technology laboratories. Researchers have succeeded in inserting a gene from the bacterium *Bacillus thuringiensis*, known as BT, into the genome of the spruce tree; this gene triggers the production of a protein that is toxic to the moth. The first transgenic spruce trees in Canada were due to be planted in the summer of 2005. However, researchers want to go further and introduce a genetic "on/off switch" into the treated trees, starting and stopping production of the toxic protein to match the precise time and place when the insects strike.

A National Emblem

Although the leaf roller moth has a bad reputation in Canada, not all butterflies and moths do. At the end of the last century the province of Quebec adopted a magnificent black-and-white butterfly as its emblem. The White Admiral (*Limenitis arthemis*) is well known throughout the province for its beauty and prowess in the air. The males lick the sap of cut trees as well as rotting fruit, droppings, and other decomposing matter, while the females are content with the nectar of flowers. This beautiful insect also has a place in folklore, for it was believed that the souls of lumberjacks would come back as butterflies to haunt the dark, damp woods.

The contradictory nature of our relationship with butterflies and moths is due to the fact that the insects are both admired and feared. Although Quebec has celebrated the White Admiral, and the great majority of North Americans feel interest and pride in the splendid Monarch, not everyone agrees. The Monarch is considered a pest by organic manufacturers who make pillows from the plants on which the Monarch caterpillar feeds—these very few are certainly the only people interested in milkweeds. In Mexico inhabitants did not object to the caterpillars but to the adult Monarch butterflies themselves. The state of Michoacán, one of the country's poorest regions, has set up sanctuaries where the butterflies hibernate, prohibiting the felling of trees. The region's inhabitants, who opposed these conservation measures, recently made headlines when they were sus-

Palaeochrysophanus hippothoe
Purple-edged Copper butterfly
France

It appears that the growing of genetically modified crops affects more than just the plants themselves. The butterflies and moths that feed on them are showing changes in their reproduction, with severe consequences for their survival. But the diktat imposed by transnational corporations has stiffled the voices of objectors. When a code of silence rules, silence itself speaks volumes.

Butterfly artwork
Brazil

Countless pictures of this type are sold in hundreds of shops in Brazil. Several dozen, sometimes as many as a hundred, butterflies—in this case, magnificent Morphos, with their azure sheen—are needed to make a single one of these "artworks." This type of craft is practiced using other tropical butterfly species as well, not only in South America but also in Africa and Asia—a veritable disaster.

pected of having deliberately poisoned approximately 22 million butterflies. The Mexican authorities immediately mounted an investigation.

All these examples show that as long as butterflies do not harm humans' prosperity, they are praised to the skies. But as soon as they nibble away at a tiny part of our income, they are immediately classed as a harmful species and hunted down. The same process is repeated indefinitely, whatever the country and whatever the species. And although agriculture has much to fear from butterflies and moths, it is above all the insects that suffer from agriculture; for wherever agriculture has become intensive, the insects have declined. Alarm bells rang in Belgium, where a veritable slaughter has taken place in the north of the country. Over the last 100 years, the region has lost one-third of its butterfly and moth species, which were once common—the result of extensive urban expansion, coupled with agriculture that grows more intensive every year.

Agriculture and Urban Expansion— The Two Great Evils

All over the world, the vast majority of butterfly and moth species are declining. Galloping urban expansion is one of the chief causes. A dozen butterfly species have vanished from the area immediately surrounding Paris in the last 100 years; eight of these disappeared since 1970. The phenomenon can be attributed partly to pollution, but also to habitat loss. Species that are restricted in diet are more vulnerable when their favorite plant disappears, as in the case of many wetland species. Wetlands—considered inhospitable, even sterile—are frequently drained and "reclaimed" to make them suitable for agriculture. Sometimes this does not affect butterflies or moths directly, but such operations have terrible consequences for these fragile insects. For example, the disappearance of ants' nests inevitably leads to the death of the Large Blue (*Maculinea arion*, Lycaenidae family), whose larvae find food and shelter among these tireless workers. And yet, how beautiful were those flights of hundreds of pairs of wings the color of the summer sky, over the meadows of my childhood! Even more than galloping urban growth, modern agriculture has proved deadly to many species, due to its great ally: chemicals. The use of chemicals has inexorably turned countryside that was once idyllic into a factory where nothing matters more than crop yields. If woodland species are less endangered than their farmland counterparts, it is precisely because forestry does not use chemicals.

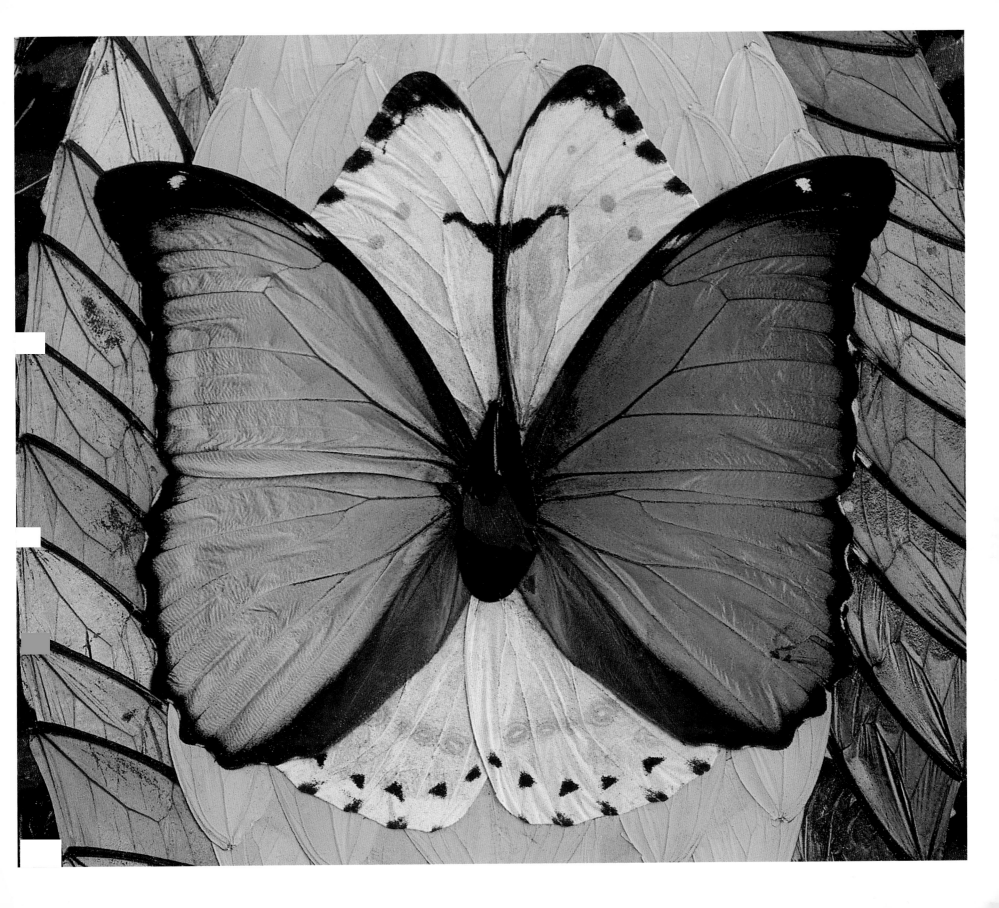

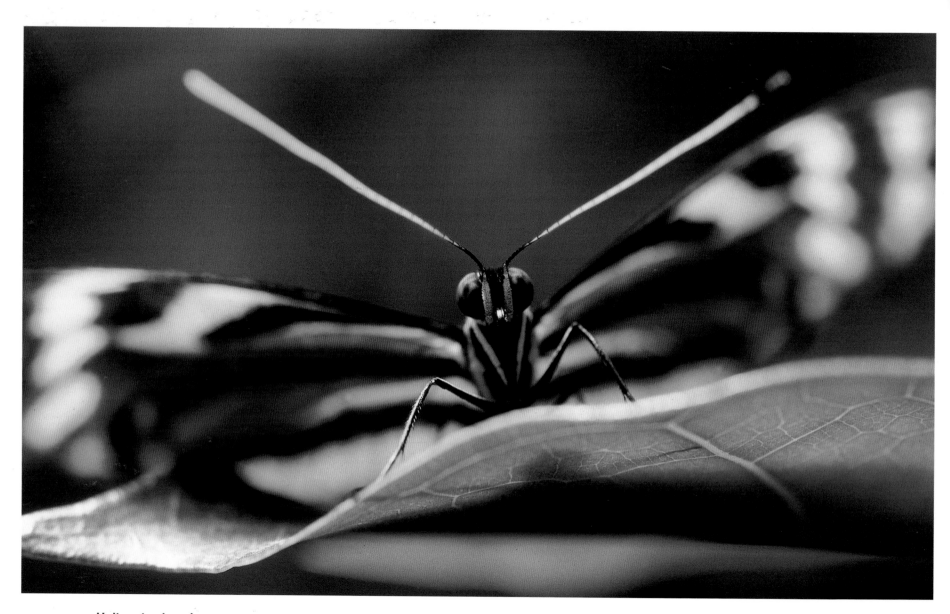

Heliconius hecale
Tiger Longwing butterfly
South America

Although they account for only 7 percent of the earth's land surface,
tropical forests are home to almost half of its species. Of these forests,
the Amazon rain forest is exceptional for its biodiversity, which every day
is under increasing threat. This decline can be forecast using the theory
of insular biogeography, according to which a number of species increases
in proportion to the overall surface area: If the surface area of a habitat
is multiplied by ten, the number of species living there is doubled.
Conversely, the habitat's progressive disappearance leads to the disap-
pearance of most of the species that live there.

Dryas julia
Julia Heliconian or Julia butterfly
South America

The last 500 million years have seen five
episodes of mass extinction; all were due
to natural disasters. This is the first time
in the history of life on earth that mass
extinction is due to just one species.
The destruction wrought by humans in
one hundred years will take several million
years to be repaired.

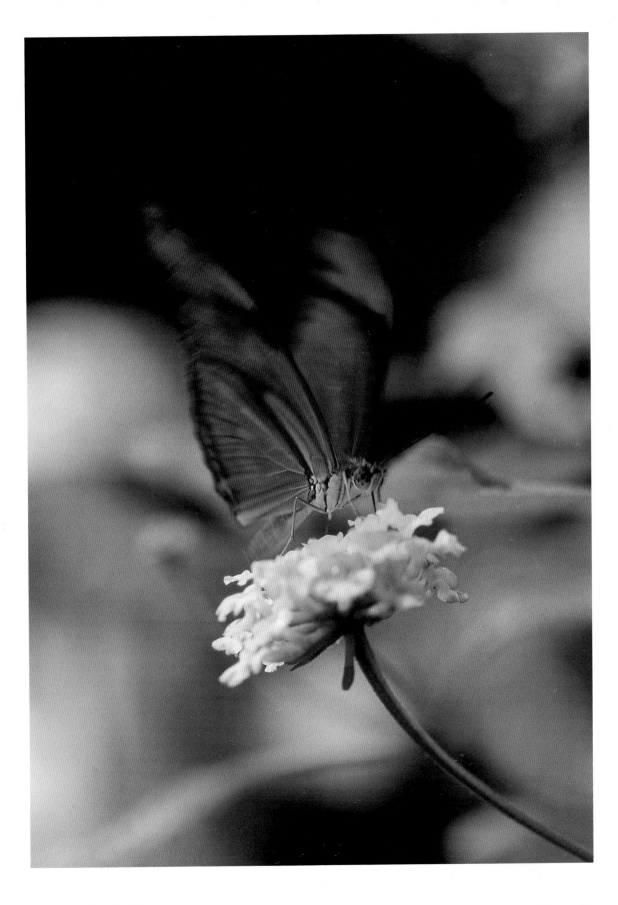

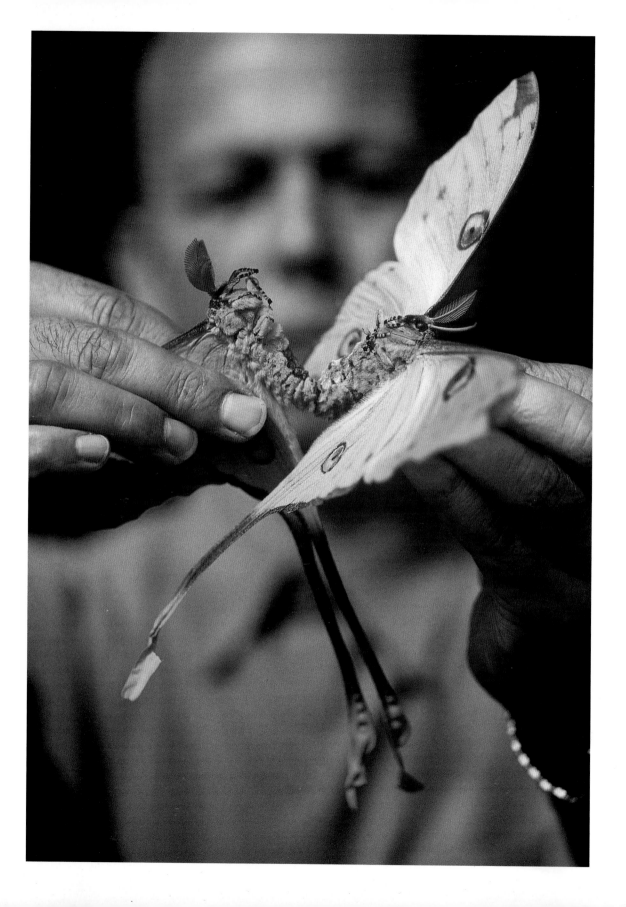

Argema mittrei
Madagascar Moon moth
or Giant Comet moth
France

This is one of the delicate operations carried out by the biologist Mesut Kasikci in the butterfly house of the Orléans botanical gardens. "Mating by hand" ensures that this giant moth's reproduction—which is almost impossible to achieve naturally in captivity—can take place.

Worldwide Destruction

The gradual disappearance of a species leads to a vicious circle, because the reduction in populations produces inbreeding, which in turn produces weak individuals and renders them more or less sterile. For this reason, below a certain threshold preserving a species becomes a highly uncertain exercise. Although we are powerless before the growing number of extinctions, the reality is even more alarming than it might at first appear. We know nothing about the extinction of species that have not yet even been described. Now that we know how rich tropical forests are in spectacular species, we can only be profoundly dismayed at their systematic destruction—to which, despite countless warnings from scientists, governments pay not the slightest attention. If anything, their irresponsibility is speeding up the annihilation of the last shreds of virgin forest. Although approximately 175,000 have been identified thus far, we have absolutely no idea how many more Lepidoptera species are hidden in the depths of the world's forests. If we remember that in 1988, in the forest of Fontainebleau, a strange butterfly was discovered that had wings as if scratched by claws, we can only dream of the treasures concealed in the remotest corners of our planet. As Edward O. Wilson, the celebrated entomologist and father of sociobiology, eloquently wrote: "Each species is a library of information acquired through its evolution over hundreds of thousands, or even millions of years. We are burning entire libraries. We have no idea of the value to humanity of the information we are losing."

A Cure Just a Wingbeat Away

For this reason, researchers are already specializing in insect chemistry, hunting tomorrow's antibiotics and anticancer agents in the heart of the bodies of butterflies, moths, and other arthropods. Several species are looking very promising. The splendid Morpho does not interest scientists for its iridescent finery but for its extraordinary ability to fight opportunistic infections. Two moths have also attracted researchers' interest for their ability to attack microbes and bacteria. But the most eagerly watched of all these "insect remedies" is a French butterfly whose name remains a well-kept secret, and whose intriguing anticancer properties have been the subject of many experiments.

Even without these extraordinary capacities for healing human illnesses, the world's butterflies and moths must be safeguarded in

Vanessa cardui
Painted Lady butterfly
France

The Painted Lady is one of the best-known migratory species and could aptly be described as a symbol of the resilience of butterflies and moths in the face of the assaults of humans. Migrating every year from North Africa to beyond the Arctic Circle, the Painted Lady establishes colonies over a vast range. It matters little that the arrival of cold weather kills almost all the new generation. The species as a whole is well placed because, in the event of global climate change, there will always be a colony in a favorable position.

all their diversity. The reason is extremely simple: If they disappear, the whole of humanity will follow them. How could we do without pollinating insects? No more pollination—no more fruit. What would the earth's future be without organisms that feed on carrion or on wood? No more recycling of dead animals and plants would mean no more fertilizer or humus. If butterflies and moths disappeared, the equilibrium of the entire planet would be upset—an upheaval that would send us back to the Palaeozoic era, 500 million years ago when only the wind ensured that plants were pollinated, before flowers and insects came to adorn our wonderful planet with their brilliant colors. This is a nightmare evocation of the delightful Asian saying that a butterfly's wingbeat in Japan can trigger a storm in California.

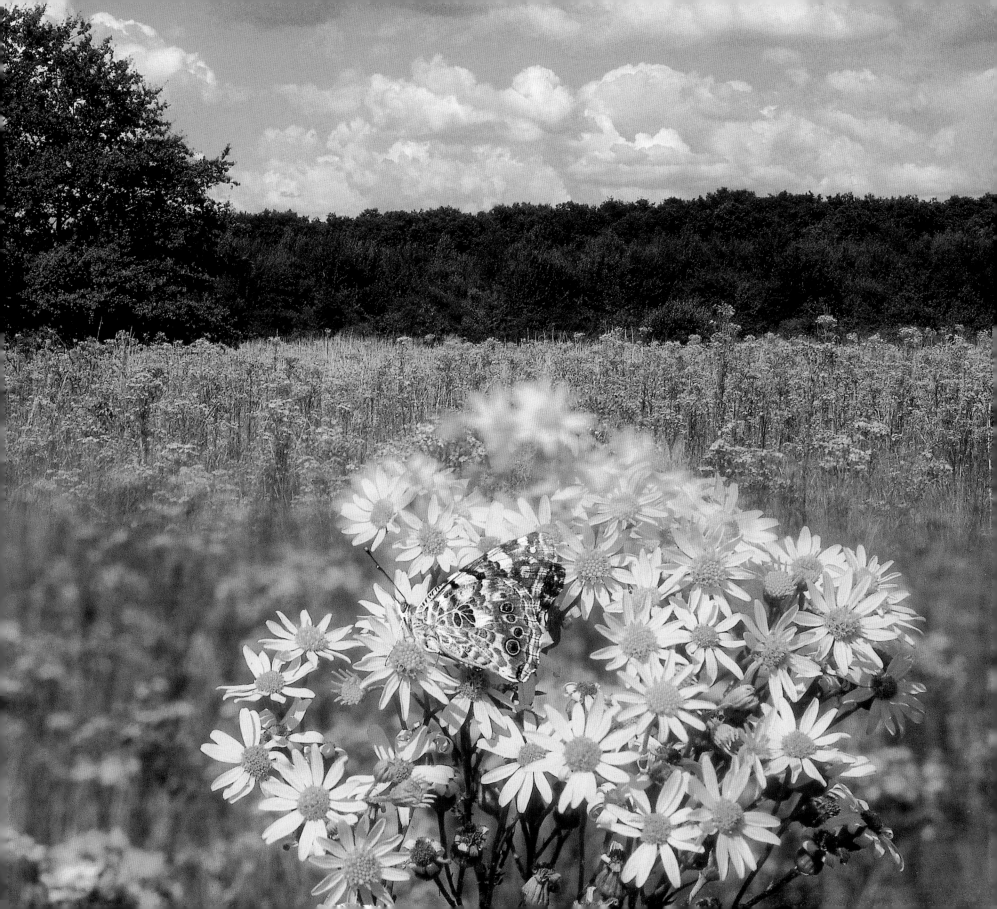

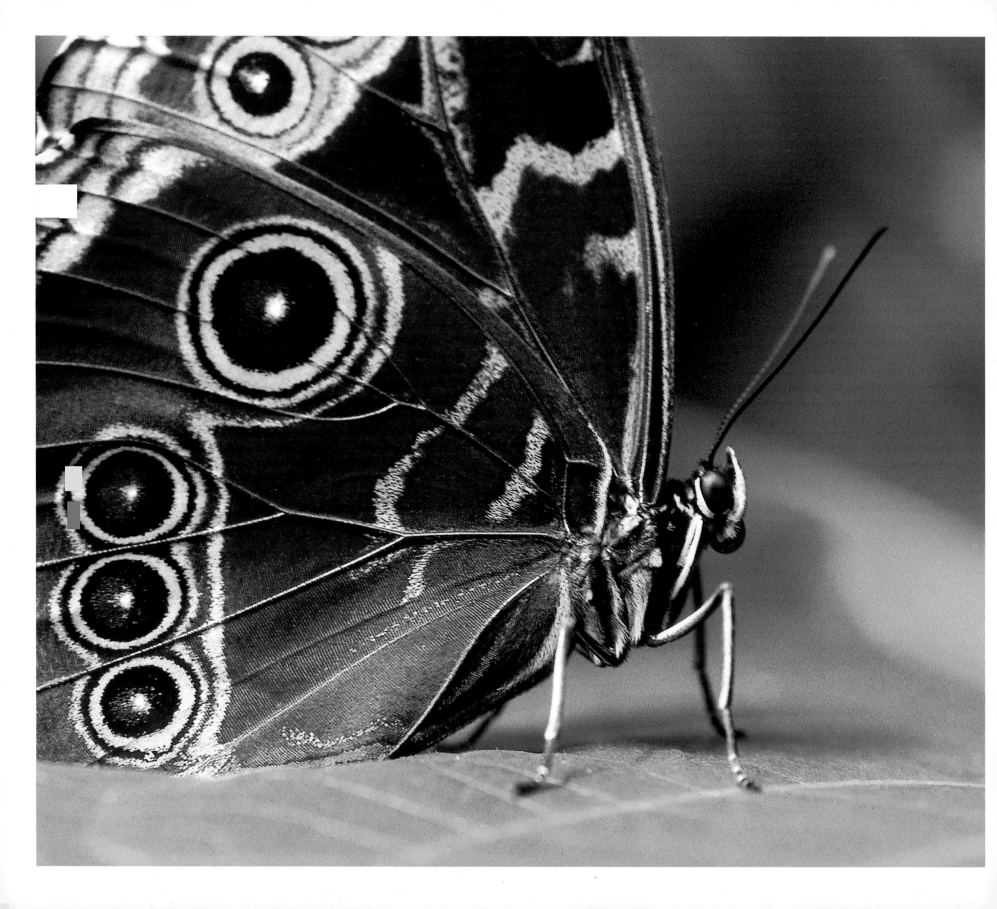

Conclusion

With the exception of the Silkworm moth and the extraordinary epic of silk, which has crossed frontiers and spanned the ages, humans have made remarkably little use of butterflies and moths. Collectors have been avid consumers for a long time, but collecting is a rather simple process, even if its results may look sophisticated. In essence it consists simply of catching the butterfly and mounting it with a pin. In truth, our relationship with butterflies and moths is too loaded with passion to be rational. There is passion in the way collectors devote their lives to their pursuit, traveling all over the world. There is passion, too—of a different kind—in the way farmers react to invasions of caterpillars that devour crops.

And yet, if passion ceased to cloud our judgment, we could discover a multitude of benefits in the small, plump bodies of caterpillars. The caterpillar that lives on the shea (*Vitellaria paradoxa*), the West African tree that produces shea butter, is well known to make dogs immune to rabies for life. In addition, this caterpillar, which the local people call "shitoumou," has unparalleled nutritional value: It is 63 percent protein, as compared to 55 percent for dried beef and just under 48 percent for dried, boned fish. Some ethnic groups eat these caterpillars with relish, whereas others disdain them, but their consumption would be beneficial to people's diets. Children in particular would benefit from this source of good-quality protein. All that would be needed would be not to sell it as caterpillars, which would put off many people, but as purée, flakes, or cakes. Small

Morpho peleides
Common Morpho butterfly
Costa Rica

organic concerns could be set up in the countryside to collect and process this raw gold, which would provide a wonderful source of income for the rural people, who are often very poor.

Even more advantageous would be the consumption of forest-dwelling caterpillars. Agricultural systems in tropical forests are extremely fragile and involve a balance between animals and plants that needs to be carefully preserved, or the entire system risks collapse. A reliable study carried out in West Africa demonstrated that the biomass of edible caterpillars was equivalent to that of a single forest antelope, which is often sold as "bush meat." A given amount of biomass will be replaced infinitely faster if caterpillars are harvested than if large vertebrates are hunted. If half the antelopes in a forest are caught, it will take several years for the population to recover. This is not true of caterpillars, because the adults lay a large number of eggs. Moreover, it is far less damaging to a population of Lepidoptera if the larvae, rather than the adults, are harvested. The most important point is that these edible caterpillars, which belong to at least a dozen species, need at least twenty different species of trees to feed on. Thus, the peasants who can live by collecting and selling caterpillars will also contribute to preserving the forest's diversity. And here lies the attraction of this system: It allows humans to live *in* the forest and *off* the forest.

Similarly, the exploitation of wild silk could be an environmentally sound option, because the hundred or so species of butterflies or moths concerned are specific to as many different tree species. This activity too would contribute to the preservation

and management of the forest, exactly where it is most needed. Exploitation of this specialized resource, which would be economically viable for some developing countries, could also be a source of income.

If humans can come to have an economic interest in the harvesting and preservation of wild butterflies and moths, these frail creatures, lighter than a breath of wind and so short-lived, could well contribute to saving the centuries-old giants of our planet's tropical forests, which are dwindling like melting snow. And butterflies could come to represent the future of humankind.

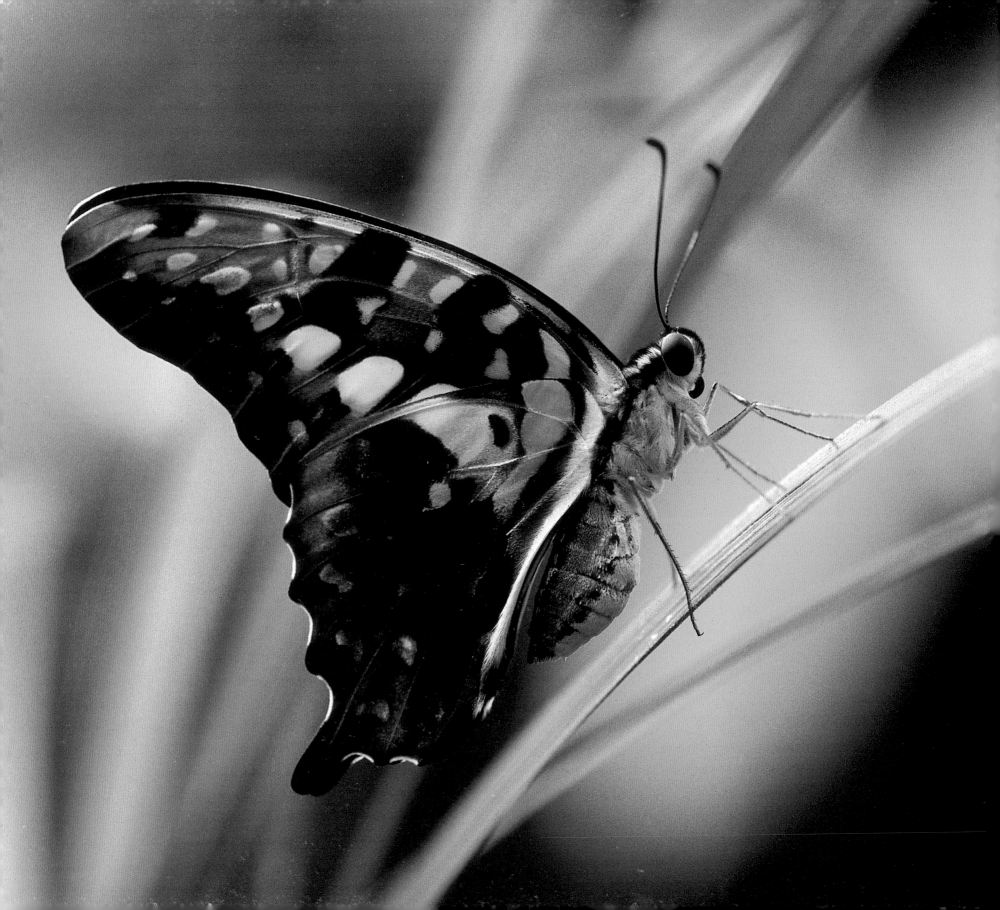

Graphium agamemnon
Tailed Jay or Green-spotted Triangle butterfly
Asia

Index of Latin Names

Index of Common Names

Bibliography

Acknowledgments

Papilio rumanzovia
Scarlet Mormon butterfly
Philippines

Index of Latin Names

Numbers in *italics* refer to the photographs.

Index of Common Names

Papilionidae family of butterflies
Africa

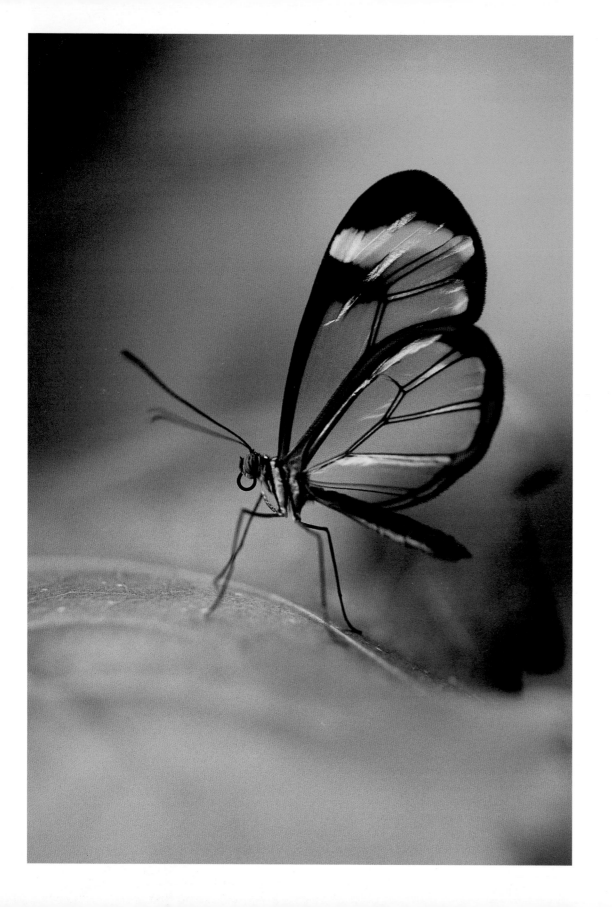

Greta otto
Costa Rica

Bibliography

Books

Michael Chinery, *Predators: Killers of the Wild*, New York: Riverrun Press, 1990.

Jean-Pierre Drège, *The Silk Road Saga*, New York: Facts on File, 1989.

Linda Gamlin and Gail Vines (eds.), *Evolution*, Gardners Book, 1998.

Richard Lewington and Tom Tolman, *Butterflies of Britain and Europe*, London: Collins, 2004.

David MacFarland (ed.), *Animal Behaviour: Psychobiology, Ethology and Evolution*, Prentice Hall, 1998.

Websites

www.butterflies.freeservers.com

www.butterfly-guide.co.uk

www.cbif.gc.ca

www.leps.it

www.npwrc.usgs.gov/resource/distr/lepid/bflyusa/bflyusa.htm

www.npwrc.usgs.gov/resource/distr/lepid/moths/mothsusa.htm

Acknowledgments

Heliconius hecale
Tiger Longwing butterfly
South America

Gilles Martin would like to thank:

Jean-Claude Biemont
Olivier Boilly
Fabrice Chaulet
Martine Coulange
Jean-Michel Drezen
Ewout Eriks

Marie Foyer
Patrick Glaume
Mesut Kasikci
Micheline Martin
Benoît Mery
Quentin Meunier

Didier Morrissonnaud
Jacques Pierre
Éric Sansault
Jean-François Souchard
Jean-Pierre Vesco

as well as the Georges Le Manach silk factory, the silkworm-rearing establishment at Le Coudray, and Alexandre Delassise for their invaluable help.

Grateful thanks are also due to Houria Arhab, Marie-Laure Garello, Audrey Hette, Richard Lippmann, Georges Plot, and Juliette de Trégomain for their contributions to the making of this book.

Myriam Baran would like to thank: Aurélie Ramel, for the informational materials she so kindly lent; Jackie Aubrée and Thierry Édet, curators of the Musée Secrets de Soie (Museum of the Secrets of Silk), for their warm welcome, their enthusiasm, and their impressive volume of materials on the subject; the Marquis of Goulaine, director of the Haute-Goulaine butterfly house, for the afternoon he kindly devoted to her and the marvelous world to which he introduced her; and Professor Jacques Pierre, of the Museum of Natural History in Paris, for his vast knowledge and help with the text.

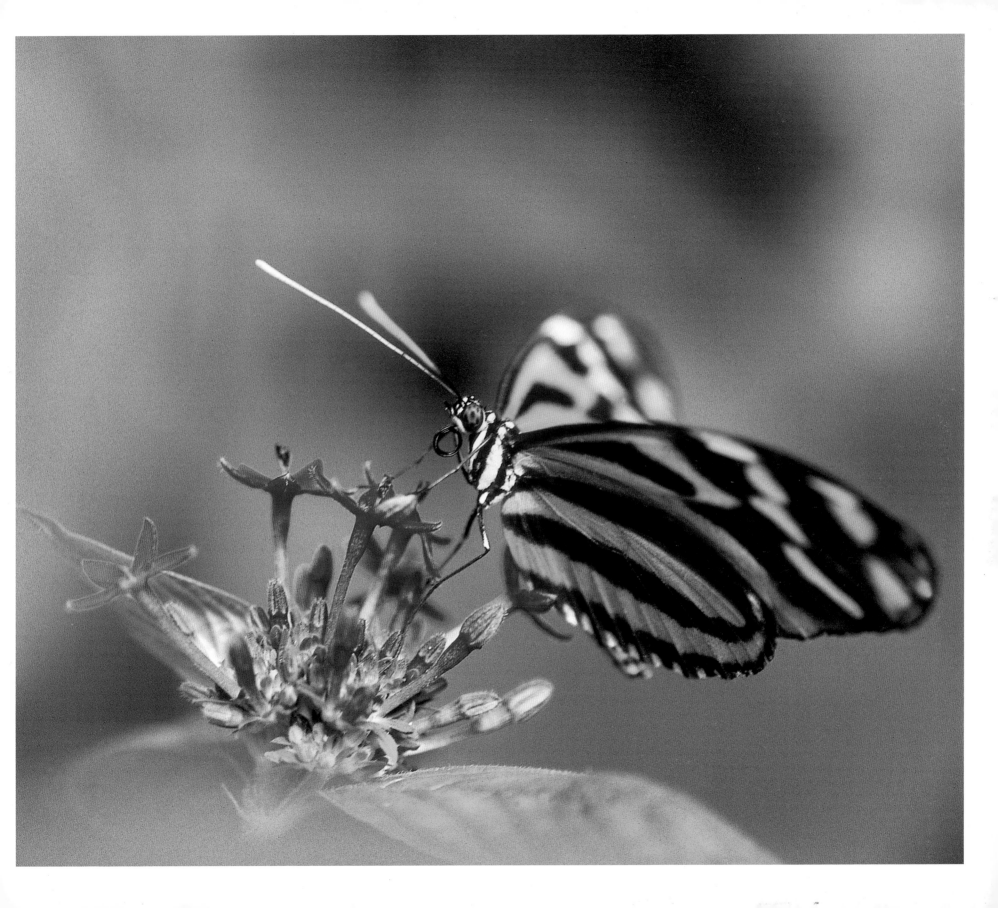

Siproeta stelenes
Malachite butterfly
South America

Project Manager, English-language edition: Céline Moulard
Editor, English-language edition: Nikki Columbus
Design Manager and jacket design, English-language edition: Eric J. Diloné
Designers, English-language edition: E. Y. Lee and Miao Wang
Production Coordinator, English-language edition: Colin Hough-Trapp

Library of Congress Cataloging-in-Publication Data
Martin, Gilles, 1956-
[Papillons du monde. English]
Butterflies of the World / photographs by Gilles Martin; text by Myriam Baran; translated
from the French by Simon Jones.

p. cm.
Includes bibliographical references (p.) and index.
ISBN 0-8109-5953-4 (hardcover : alk. paper) 1. Butterflies. 2. Butterflies—
Pictorial works. I. Baran, Myriam. II. Title.

QL542.M37213 2006
595.78'9—dc22
2005027651

Printed and bound in Italy
10 9 8 7 6 5 4 3 2 1

HNA
harry n. abrams, inc.
a subsidiary of La Martinière Groupe

115 West 18th Street
New York, NY 10011
www.hnabooks.com